Grabeland

Grabeland

a novel

eteam

Nighboat Books
New York

ISBN: 978-1-64362-013-8

Cover Image by eteam

Typeset in Times New Roman and Courier
Graphic Design: Brian Hochberger

Cataloging-in-publication data is available from
the Library of Congress

Nightboat Books
New York
www.nightboat.org

For Mara Miranda
and Louis Leopold

Contents

"My encounter with another world and another culture and the beginnings of an attachment to them had set up an irritation, barely perceptible but incurable – rather like unrequited love, like a symptom of the hopelessness of trying to grasp what is boundless, or unite what cannot be joined; a reminder of how finite, how curtailed, our experience on earth must be."

Andrei Tarkovsky,
Sculpting in Time

The Layout of the Plot

Towards the end of the year 2005, on a gray November day, with two right hands stacked up on the same mouse sitting on a desk between digital cameras, roasted almonds, USB sticks, memory cards, external hardrives, books, bills, and a bottle of water in a one-bedroom apartment in New York City, we bought a piece of land off the Internet. It was the cheapest plot in Europe we could find for sale that day. We had only searched in Europe, but the reason the land ended up being in Germany, the country we had grown up in, was as much a coincidence as the fact that this particular piece of land came with people.

The property, an allotment garden containing fifteen parcels, was located on the outskirts of a village called Dasdorf. The publicly available satellite images of the area were very low resolution. They looked grainy, outdated and dull, as if nothing in them justified more detail. Our purchase appeared to be a crooked rectangle, a few hundred pixels defined by a dozen shades of green and brown anchored between the reddish squares of row-house rooftops and the straight gray line of the

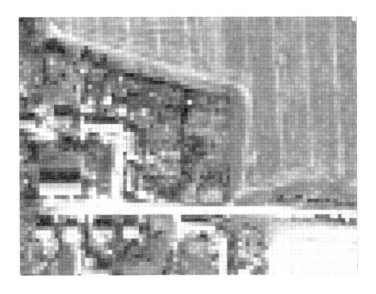

road. The patterns beyond continued as bigger patches of yellow, beige, and light green fields.

There was no blue, and for that reason the visuals reminded us of a screenshot we had recently made of our computer's hard drive to be used as a diagnostic tool, in order to find out why the computer was running so slow. Our data's physical location on the hard drive was pictured by a few big colored blocks and lots of smaller ones, irregularly scattered throughout a horizontal rectangle. Red was for video, green for photos, yellow for applications, orange for text documents.

We tried to make a connection between the diagnostic image of our harddrive and the satellite image of the land we just had bought online, and started reading about fragmentation diseases. While the saving and dividing files into smaller and smaller units is an efficient way to utilize disk space, we learned online, it slows down the computer's performance enormously. Fragmentation diseases increase with age, it said. The more information is stored, the more complicated, less reliable, and slow its retrieval. "At a certain point it becomes unbearable," one of the commentators stated on the thread, in which amateurs and professionals, identified by either letter-driven descriptors or purely numerical usernames, discussed the maintenance, avoidance, or improvement of the problem. Our computers are impaired by this, our lives, our time, we thought, sitting in our ergonomic office chairs as quietly as we could, zooming in and out of the satellite images. Based on the visual evidence, the German landscape had been plagued by this for centuries.

Two weeks earlier our downstairs neighbor had called the police because he could not stand us rolling around the wooden floors in those office chairs anymore. We had told the two officers who had entered our apartment at one a.m. in the morning, that the rolling around wasn't much more than a couple of inches forward and a couple of inches backward every time we got up from our working desk in order to use the bathroom or go into the kitchen to find a snack. The police officers looked tired when

we suggested wrapping old socks around the wheels of the office chairs, and they looked bored when we took off our socks and turned the rolling chairs into stationary ones.

Then, a week after that first incident, our downstairs neighbor called the police again. We opened the door at one twenty a.m. Two different officers entered our apartment in heavy shoes. They seemed less tired and more determined. We showed them the socks we had wrapped around the wheels of our office chairs the week before. They nodded and then one of them started knocking on the table top of our desk. Our neighbor, he said, could not live with us typing on the computer keyboard any longer. To him it sounded as if we were playing drums. They asked us to sit down and type. We sat down, opened a blank Word document and started typing random letters. As they stood behind us and watched over our shoulders we started to worry, if we were supposed to write actual words, so they wouldn't get offended by having to stand there and watch us type baloney. We turned around and offered them a glass of water. They said no and left without saying another word. The next morning, when we got up, we placed the computer keyboard on a folded towel on our desk.

Dasdorf

Three months later, in February 2006, we received an envelope from Mr. Blitz in the mail. It contained a contract signed by Mr. Blitz and his lawyer; a map of the allotment gardens, in which a few quickly sketched horizontal and vertical lines crossed each other, seemingly placed on the paper by intuition rather than measurements; and a handwritten note that stated: "The garden consists of fifteen plots, nine are currently rented, the rest is vacant," followed by a list of eight names, addresses, and annual fees.

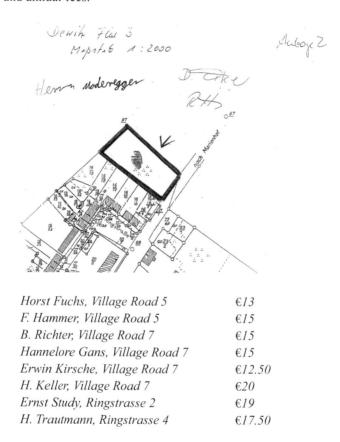

Horst Fuchs, Village Road 5	€13
F. Hammer, Village Road 5	€15
B. Richter, Village Road 7	€15
Hannelore Gans, Village Road 7	€15
Erwin Kirsche, Village Road 7	€12.50
H. Keller, Village Road 7	€20
Ernst Study, Ringstrasse 2	€19
H. Trautmann, Ringstrasse 4	€17.50

We pinned the map on the wall, signed the contract, sent it back to Mr. Blitz and started typing a letter to our tenants. We introduced ourselves as the new owners of the land. After that first sentence, we didn't know how to proceed. How much or how little information should the letter contain? What degree of German formality was appropriate? We sat there and stared at the towel. Even though we washed our hands several times a day, the folded towel underneath our keyboard had become dirty from the heels of our hands. How was that possible? We put the towel into the laundry basket and took a new towel out of the closet. The new towel was a very old one from the bottom of the stack, one of the few objects we had brought with us from home. At some point every member of our family had dried their hands on that towel. Surprisingly it had become very fragile and thin at the bottom of the stack. Or maybe that's how old towels appeared in comparison to new towels, thin and fragile?

"We are currently residing in New York City, USA," we continued our letter and then stated the information necessary to transfer the annual renter fees for the gardens into a German bank account. We finished the letter by expressing our anticipation about meeting the recipients of the letters soon and printed out one copy. We looked at it. It contained the information we wanted to convey, but it felt like a punch in the face. We sat down on the kitchen table, took out our fountain pen and copied the letter by hand. Our cursive handwriting hadn't changed since second grade. We produced eight copies. The legibility was superb.

On March 26, 2006 we received a gray, pictureless postcard with two lines of neatly written text. The letters were small but sharp. "I am terminating my lease. Hannelore Gans."

The postcard was followed by a letter from Mr. Keller in which he informed us that Mrs. Hammer had died, and that he would take over her lease. The words were written sloppily, the spacing was inconsistent, and the letters didn't adhere to a baseline. We sent a letter back to Mr. Keller in which we expressed our condolences about Mrs. Hammer's death and then asked him

if he could draw a map of how the garden was currently subdivided. Mr. Keller's map arrived within two weeks. He had used a ruler and a pencil to construct his rectangles, but like Mr. Blitz's map before, his map was also missing measurements and cardinal directions, to provide a sense of scale or orientation.

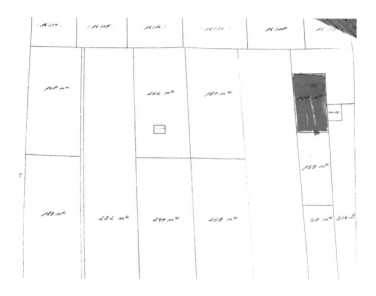

Mr. Keller sent us another letter in July to inform us that a Mrs. Kirchheimer, who was not on our list, had died from heat stroke right on her garden plot, the one neighboring his, and that we should find a new renter for it quickly – otherwise the weeds would take over. Three weeks later he was dead himself. We found out about it through an email with the subject: "Regarding Mr. Keller's death." The email was from a woman who introduced herself as Mrs. Schmidt and stated that Mr. Keller had driven his car into an elm tree on L33 and that she would like to take over his parcel, the one he himself had just taken over from the deceased Mrs. Hammer.

Another six weeks later, at the end of August, she sent us a second email terminating her lease, because she had found something

nicer near a lake. After that, silence. We received no other letters or emails from Dasdorf.

Every time the Americans showed up, they parked a different car in front of the gardens. The first time they came with a Nissan Micra from Hamburg, then a blue Fiat from Switzerland, then it was a Fiat from Dresden, then a white Mazda with a Frankfurt license plate, then a white minivan that had a license plate from Leipzig. I wrote all of that down in my yearly kitchen calendar, just to have a record.

Fuchs's mouth dropped open like a floodgate. He ran down Village Road, arms in the air like a flushed goose when he finally met them. He hadn't paid a cent since the land was sold to them. For two years not a penny from that nickel-nurser. "How can I pay my rent if I don't have your address?" he yelled. But how come we knew the address and the bank account and he didn't? How come we always paid our rent? For forty years we made our payments. To whoever asked for it. Always on time. Never missed a year.

We started in early spring, 1967. We paid 5.25 East Marks a month and in 1974 we got running water. In the fall of 1990 the water was cut off and we still had to pay 5.25 West Marks, and so it was until 1996 when the village sold the gardens. Of course we hadn't been told anything. Out of the blue we got a note from a Mr. Blitz in Saarbrücken telling us that from now on, we would have to put 16.50 West Marks into his account. After the introduction of the Euro we got another note, saying we must now pay eighteen euros. And in 2006, when the letter from the new landlords

from America arrived, we thought, now we'll have
to pay in dollars. But they had an account in
Germany, so we kept paying in euros.

On April 28, 2006 we visited Dasdorf for the very first time.
Following the directions of a German speaking GPS device that
came with the rental car, we drove through Dasdorf and then stopped
at what felt like the end of the village, next to the actual manifesta-
tion of the virtual piece of property we had bought online. "This is
the original," we said. "This is the hard-copy. In case all our digital
data is gone one day this is where we can go back to restore. This is
where we can eventually recover everything that's lost."

The plot sat to our left. Suddenly too shy to look at it, we
remained in the car and stared straight ahead through the wind-
shield. "It's like we've come all the way from America to meet the
foreign spouse a matchmaker chose for us," we said. A little bit
further down the road stood the kind of standard metal sign offi-
cially marking the village's boundary. We got out of the car and
walked towards it. The sign was very German. Well built, stiff,
strong, and divided in the middle. The upper half was white and
announced the next village, Marterhof, as two kilometers away.
The lower half was yellow and bore the black word DASDORF
crossed out with a thick red diagonal line.

There is no Dasdorf beyond Dasdorf, we thought, standing
in front of the sign. For centuries Dasdorf has imagined Dasdorf
as being Dasdorf and nothing else. For nine hundred years or a
thousand, there has never been any geographical flexibility in
that matter. Dasdorf is faithful to its coordinates. We knocked on
the metal sign in the same manner the police officer had knocked
on our manufactured wood desk in Queens, on which stood the
computer, with which we had bought the property behind us. Our
knock sounded metallic, while his knock had sounded wooden. We
turned around and walked down Village Road.

Village Road was wide enough for two cars to pass each other,
but only the right half was paved. Due to austerity measures, the left

side was still a dirt road, and stretched through the whole village and beyond. We passed by a row of crumbled garages too narrow and short for the current dimensions of a midsize car. Each of them had a different door, and each of those was falling apart in its own way.

Across the street were eight gray, generic housing blocks, each three stories. Most likely farming collectives built them in the sixties to house workers for the stables and fields, we reasoned, until we saw the numbers, first Village Road #5, then Village Road #7, on blue enamel signs right next to the respective entrance doors.

These were the addresses we had sent our letters to – Village Road #5 and Village Road #7. We had written those letters on our kitchen table, we thought, and folded them and stuffed them each into an envelope, and then sealed those envelopes with the spit from the top of our tongues, and then we had slit them through a narrow opening underneath a thick bullet-proof glass window that had separated us from the clerk in our local post office in Queens and then, we assumed, those letters had landed here. In Dasdorf. Village Road #5 and Village Road #7. We scanned the façade for human features related to the names of Richter or Fuchs or Kirsche and discovered a stout silhouette, which stood behind a slow-moving curtain, itself unmoving, even when we made a half-hearted attempt to wave. It was hard to guess who it could be. Kirsche? Fuchs? Richter? Or someone else? When we waved again the figure behind the curtain stepped further into the background. People are hiding behind curtains while their senior citizen underwear flutters openly in the breeze on the clotheslines, we said to each other, before we lowered our heads and continued walking. We neared a small church protected by a thick, natural stone wall, which we immediately recognized as the thirteenth century church from the only picture of Dasdorf we had found online.

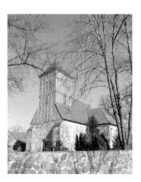

"We are standing in front of what has secured Dasdorf its entry in the World Wide Web," we exclaimed. We took a picture with

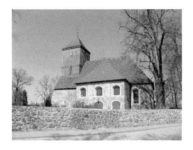

our digital camera, turned around`, walked back to the rental car, drove to Berlin and flew back to New York City.

Four months later we returned. We parked next to the gardens in the same spot, walked up to the metal street sign again, knocked on it, turned around, walked all the way down Village Road, entered the cemetery through a gate, walked up a few worn-out stone steps onto the elevated plateau of the cemetery, and looked around.

A chest-high brick wall enclosed a compost heap, a freestanding faucet and two green watering cans, that hung on a large hook. There were two old chestnut trees and several younger linden trees, shadowing no more than thirty graves, all decorated with red geraniums doomed to draw their seasonal nutrients from seven hundred years worth of Germanic bones buried underneath their shallow roots.

We stepped closer to the wall and looked into the opposite direction we had come from, away from the intersection that made up the center of the village, away from our rental car, away from the piece of land we had bought site unseen online. There was a house that for at least thirty years had not been plastered or painted and beyond that house spread an aching, choppy ocean of brown fields mutilated by farming machinery. The gray sky was heavy. Mist and fog kept dragging it down and the sky would certainly have suffocated the landscape below if there hadn't been a tall, freestanding wooden pole with a big round nest balanced on its top, holding everything in position. A white stork stood in this nest, long-legged, long-necked, motionless, proud,

maybe even arrogant. One could tell from the long red beak that it had seen the world, that it had flown from Dasdorf to the Straits of Gibraltar or East across the Bosporus through Israel to Africa, along the Nile into Sudan and then further East or South. Every fall it left Dasdorf and spent six weeks flying about ten thousand kilometers South to forage in the meadowlands of Zimbabwe or Botswana or Zambia or Mozambique for beetles, frogs, locusts and crickets. And then it turned around and came back to this pole in Dasdorf. The faithfulness to this nest, that looked like a crown on top of an abandoned circus tent pole was stupefying. "Why?" we asked, but like all storks it was without a syrinx, rendering it almost mute.

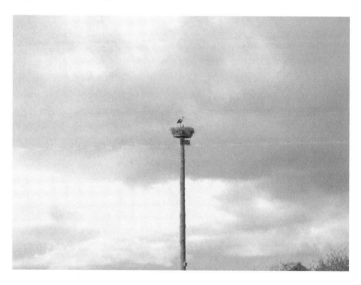

We retraced our steps down the stairs and went across the street. An elderly woman was waiting for us on the sidewalk, her left hand was resting on the heavy handle of a massive iron gate. We had noticed her earlier, watching us coming down Village Road from behind the gate, but had avoided her gaze. The gate was imposing; almost triple the size of the gate to the

cemetery and painted black. The woman wore a headscarf and a long apron. The moment we made eye contact she started speaking. "Look! This used to be the mansion," she said, pointing toward two identical-looking houses that couldn't be older than ten years. "Mr. Bülow owned most everything and everyone in Dasdorf before the war. He fled when the Russians came. They expropriated him in his absence and then used the mansion as a lazaretto for a while. Later it was turned into a daycare center, and then a home for difficult children," she said, and moved her right hand in front of her face back and forth like a windshield wiper to indicate that on top of being difficult, those children were also intellectually disabled. Behind the gate was an ancient oak tree, and behind that was a long wall, part of a one story building with a flat metal roof, that depicted stylized strong men and diligent, good natured women harvesting fields of golden wheat using baskets, wheelbarrows, scythes, hands and tractors.

"After the reunification, the difficult children were loaded into a bus and the property was sold to a man from the West, together with the cow stables and most of the land around Dasdorf," the woman went on. "The mansion, the garages, the shack – everything was torn down. Only the wall on the east side was left standing. The new owner turned out to be a great nephew of the original owner. The little thieves get hanged but the great ones escape, and eventually they return," she said, paused, groaned, and then slapped the air next to her hip two or three times. She then closed her eyes, shook her head and sighed, before she continued. "When the new Mr. Bülow returned he fired two hundred people and got a milking machine and one thousand new cows. It was the right thing to do, that is the truth," she said. "People look at me for saying it out loud, but that stable was already out of control by 1985. The cows played cards while the workers napped in the hay. Everybody had a good time, but how can that last? Life is hard and mean," she said and paused for a while, before she picked up the thread again and added, "it's only bearable because it doesn't make exceptions. Eventually even Mr.

Bülow got his share," she said. "When he got to Dasdorf, he was a normal man. But then the ghosts appeared. They tortured him. Every night they dragged him into the attic of the old mansion and made him pay. We could hear him scream," she said, widening her eyes and covering her mouth with her hand as if to muffle the screams. "That's why he tore the mansion down and built these two twin mummies over there, all blocked up. It's like a high security prison. I've been the cleaning lady for nine years, but I never washed the windows because the shutters were never opened."

One disaster rarely comes alone. Rain all April long. The stork hatchlings drowned in their nests. Then the chickens got the roundworms. I slaughtered half of them, and a week later the ducks got the tapeworms. I slaughtered all of those. The freezer was already stuffed with the chickens, so the Mother had to can the ducks. They were boiling on the stove when I walked into the kitchen and

suddenly saw this woman through the kitchen window stalking in the gardens like a pink flamingo that had escaped from the zoo in Neubrandenburg.

Erwin was the first one who talked to them, he found out who they were. I never bothered. What is there to talk about with a bunch of American milk mustaches? We paid our rent and that was all that was of concern at the time.

Erwin said that when he showed them his garden, they said they liked his work. But who knows what it means if they like something? On what grounds do these people place their judgments? They don't even know how to use a scythe. What a catastrophe when they tried to mow the plots. We watched it from the dormer window, the Mother and me. "Don't meddle with things you don't understand," the Mother said. With every cut they rammed the scythe deeper into the ground. Blunting. All they did was blunting, blunting, blunting. In the end they trampled the grass down like a bunch of lumpish pigs.

Everything was overgrown. It takes a year for weeds to spread and seven to get rid of them. What productive gardens these were until the wall came down, these city slickers had no idea! We had the best carrots year in and year out. Potatoes, beans, sugar peas, radishes, cucumbers, onions, garlic, beets, lettuce, Brussels sprouts, squash, celery, black roots, rhubarb, cabbage, black currants, red currants, gooseberries — everything. But without the water line it has been like playing Skat. The weather acts as the dealer and we are supposed to come up with tricks to defend against what we are dealt. If it rains, we are lucky, and if it does not rain, everything goes to hell. The Braustube closed down, the Schenke

closed down, the Kindergarten and the Konsum and the club and the post office closed down. One death blow after the other. We stood in line waiting for the next disaster, heads down, one old stubborn ox next to the other.

"Without exception, every vegetable we've eaten for the last forty years has come out of that piece of soil," Erwin told them. "That's a miracle," the Americans said. As if our lives were a phony fairy tale.

I carried thirty watering cans a day from my kitchen sink to the garden for almost three weeks when we didn't have a single drop of rain. I got up at six a.m. — that's the miracle. The Mother goes every day, loosens the soil and pulls out the weeds. There is nature in the garden. But they don't understand things like that. They don't touch any dirt. They drive to the supermarket, get their cucumbers for thirty-eight cents a piece, and think all the work it takes to grow a cucumber costs exactly that.

How do you end up here from America? From New York to Dasdorf? They told Erwin it was a coincidence. As if the two of them had fallen out of an airplane. They never even saw the gardens before they bought them, only an aerial photo on the computer. Our garden was supposedly the cheapest plot available. I still don't believe that. What about Poland?

The Mother is convinced they bought the land because of the pending flood. That's what they showed on TV. In 2032 New York will be gone. Erased. There will be nothing left of that city. Even the tallest skyscrapers will be underwater. Thank goodness I won't be around anymore. What a rotten mess. Everything will be infected. The fish will grow fungus, like in the Weihers' pond. That's how they found the body of that Pole. That rancid hole has been cursed for centuries. It must have been strangers in a rush at night. Locals

wouldn't throw a dead body in the Weihers' pond. Everybody knows the Weihers' pond is no good for such a thing. It's not deep enough anymore to dump a body. Even in the newspaper they wrote: IT MUST HAVE BEEN STRANGERS.

The Inconsistency of
Always the Same

A year later they came back. Just two days earlier, the Mother had told me that she planned to make jam with the black currants. She said what was hanging on the bushes would make at least twelve jars of black currant jam, and then the Americans showed up and that was the end of that.

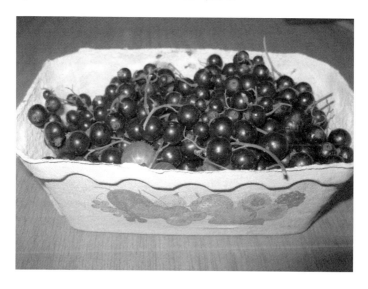

They always arrived completely unannounced, parked a different car next to the fence, got out, and ate whatever was ripe on the bushes or the trees. First they ate, and then they proposed some outlandish idea, but they left it to us to see that we wouldn't miss out. Such was their strategy. They didn't look left, they didn't look right. They walked around like proud horses with blinders. What they didn't know didn't concern them. What didn't suit them didn't exist. I still don't get it — nobody understood what they wanted from us. Why Dasdorf? Why not Lindetal or Klein Nemerow?

Why the black currants? Of course it was their land — theoretically they were the landlords — but theory never fed a hungry stomach. Who took care of the black currants all year long? Whoever cut the grass around the black currant bushes should get the currants, they could have reasoned. Maybe it was better this way. If I had insisted that I kept the currants free of weeds, what would these milk mustaches have concluded? If Mr. Study comes over to cut the grass, he's also probably the one who dumps the trash, and who dug out the peonies, and who stole their amateur scythe. "Let them have all the black currants," I told the Mother. "Let somebody else be the scapegoat this time."

When we returned in July of 2007 the stables across the street from the gardens had burned halfway down. The stone walls were still standing, but the doors and windows were gone, and the remains of the roof looked like the ash covered rib cage of a big cow suspended in time after a volcanic eruption. We parked the car next to the fence again. Across the street a bunch of brown and white chickens was tearing apart a heap of kitchen garbage comprised of carrot and potato peels that someone had thrown over the fence next to the burnt-out stable. We walked over. Whoever had thrown the leftovers, had been either very short or had done it in a very sloppy manner, we reasoned, as a significant portion of the peels had landed outside the enclosure on the small strip of grass between the fence and the paved half of the street, now forcing the chickens to squeeze through a hole in the fence, one after the other. When they discovered that the peels outside the fence tasted like the ones inside the enclosure, they lost interest and started spreading out. A car approached, we stepped to the side, heard a dull pop, and when the car had passed we saw a brown chicken lying on the paved side of Village Road. There was a drop of blood next to its head. It was dead.

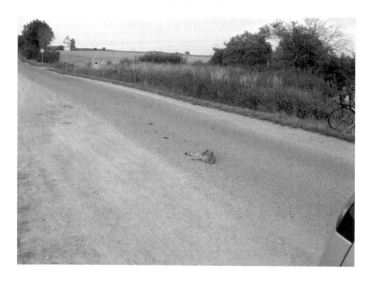

The surviving chickens seemed indifferent. We scanned the road and surrounding area for human witnesses. Not a soul was in sight. Not a sound of human activity was to be heard. In the distance, behind the burnt down stable, was a radar tower of the military air control and reporting center sticking its round head out of the monocultured fields. All is well, it signaled. That chicken would have been killed sooner or later anyway.

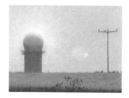

We grabbed a rock from the side of the road, crossed the street and entered the gardens. Hoping, without knowing what the hope was for, we noticed that the berry bushes on the abandoned parcels had grown taller from the last time we had seen them. A kind of tall weed with heavy, seed-laden flower heads had started to suffocate the

former diversity of plants. On the east side, the fence had collapsed. There were some freshly dug holes in the ground, a few empty beer cans, two heaps of cut grass, and weeds and branches starting to compost. The shovel and the scythe and a few buckets we had bought the year before in Neubrandenburg and then stored in the abandoned shack for future projects were gone. The little glass window had been smashed in. An old flowerpot lay turned over on the ground.

"You! Do you want to know why I never sent you the money for the rent?" He approached the gardens on Village Road from the center of the village in heavy black rubber boots and pointed his index finger at us from a distance. "There was no account number, that's why! Everybody got a letter from America with the account number. I did not. How can I send you money?" We dropped the rock and started walking toward the agitated old man

"What a shame!" he cried, hands in the air, when we stood across from each other, he on Village Road, we inside the gardens.

"It's the landlord's responsibility to stop things from falling apart. Who is the landlord here? Trash everywhere. In Burg Stargard, they sell trash bags by the box. Fifty in a box. If you buy a hundred it's even cheaper. Look at that. Half of the fence posts are falling over. The concrete wasn't meant to last more than thirty years, and that was sixty years ago. Nothing lasts forever but my troubles with those fence posts. Two years ago one just broke in the middle. They always say Gorbachev was responsible for the fall of the Wall, but I say it was simply the cheap concrete. Who are the landlords here? You can also get a container for all the trash. Get a container. The pipe has been disconnected for almost twenty years now. The faucet has rusted away. Last year it did not rain for six weeks. As if we were living in a desert. Unheard of. Six weeks without rain during

the growing season. Where are the landlords? What about my carrots? They need water to grow. Ever heard of that? Every day I ride my bike six times back and forth between the pond and the garden to fetch the water in my buckets. I am seventy-eight years old. How much longer do you want me to ride my bike to that pond to get my water in buckets? The only thing that thrives here now is the thistles. Have you seen the thistles? Do landlords look at thistles? They will start spreading next week. One needs to get those thistles under control before they start seeding. Whoever owns the land, is responsible for the thistles! One can't call oneself a landlord for nothing. If you put in new fence posts, put in higher ones and use quality concrete. The fence needs to be higher. My spade is gone. Two weeks ago I hung it on the inside of the fence and the next day, when I came back, it was gone. Where is my spade? Some bastard reached over the fence and grabbed it. People have grown taller with all the hormones they put into the food. I had this spade for twenty-five years, and now, it's gone. Where is my spade? I am raising my arms, my hands are up in the air, where is my spade?"

From the way he addressed the situation without making eye contact, we knew that he had watched us walking down Village Road, most likely from behind the curtain and drawn his conclusions. From the way he yelled at us, we knew that the style of our shoes and the way we set one foot in front of the other had given him a concrete idea of what kind of people we were and how to deal with us. It was obvious that he had meticulously counted the instances we had taken pictures, and deciphered the ways we held on to our photo cameras as a clear evidence, that we didn't know why we were in Dasdorf and what exactly we should do here. He could smell that – *that* – made us very uncomfortable. We could tell that the way we stood in front of him, slightly bent behind the fence, assured him beyond any doubt, that we had arrived with nothing else but questions, questions so ambiguous they had turned us into question marks ourselves. We knew, with the same unshakable certainty as he, that the moment he had laid eyes on us from behind his curtain in the apartment block #5 on Village Road, he had seen us not as humans, but as question marks, and therefore had righteously reasoned in his straightforward village logic, that we would do questionable things. Whatever a human does, is human. Whatever a question does is questionable. Very questionable! He knew, we knew it was his right to yell at us for showing up unprepared and unannounced and uninvited, intruding on his space and wasting his time. And therefore he went on:

"I am seventy-eight years old. Seventy-eight! How much longer do you want me to ride my bike to that pond to get my water in buckets? Where are the landlords?" It had taken him one look from behind his curtain to know exactly how to attack our soft spot and now he shamelessly took advantage of it. Landlords! He kept yelling for The Landlords. Over and over again he conjured the exploitive master part of the word, simply because he knew very well, that already the sound of that word would make us feel guilty enough, to not ever dare asking him about the thirteen euros he owed us in yearly rent. He made our relationship sound feudal. Medieval. Ancient. Raw. Right away he could tell that whenever

we entered the remote parts of a rural countryside, we bowed to the customary rights of the local people, out of respect – and out of fear. One glance from behind the curtain in his living room, and he knew that he could intimidate us with his old iron rake, that he could use his old iron rake to simply rake away the applicability of national, formalized laws, most importantly the financial part of our landlord and tenant relationship. The thick black hairs sprouting in his nasal cavities clearly detected the smell that came from our armpits. He kept screaming and shouting and we did not say a word in response, and that led him to conclude, we assumed with a high degree of certainty as we saw ourselves standing there, slightly bent and sweating from under our armpits, that we were cowards. And that's how it went. He kept shouting and shoving his thick red fingers in front of our faces without looking us into the eyes, and we stared at him in a sort of disbelief without interrupting his vocal outpour. He kept itemizing our duties and responsibilities as landlords, until eventually he kept repeating the same phrases over and over again. When the repetition formed a recognizable pattern, it felt somewhat safe to half-way tune out.

A house of straw appeared in front of our inner eyes. There were Three Piglets and a Big Bad Wolf who huffed and puffed. The house of straw fell down and from the debris a voice emerged and shouted, "Be tough. Be true. Play less, work harder, use better materials." The Little Pigs did. They stopped thinking and playing and started working, they cut down a whole forest and built a house of sturdy sticks. Once they were finished, the Big Bad Wolf came by again, and he huffed hot air and puffed hot air, and blew the house down. The voice lectured with more urgency: "You failed. You did not put enough effort into this undertaking, you did not dedicate yourself fully, stop being whiny, face reality, you need to invest in better materials and work harder. Much harder. Toughen up." And the Pigs did. They built a house of bricks. Ten hours a day, no weekends, no vacation, no time with their friends. When the house was finished, the Wolf came by again and he huffed his

stupid hot air nonsense and puffed his bad smell intimidations and again the house of bricks couldn't stand up to the pressure. The voice started booming. "What are you fools doing?" The next step, the Pigs knew, was a matter of life or death.

"First the thistles, then the tar. They are going to tar the whole road. It will cost you twenty thousand euros. Your land, your responsibility," the old man screamed.

The Pigs got frightened, overeager, frantic. They took out an emergency loan, invested in steel, and took on a night job to pay off the high interest rates for the loan.

"You think because you come from America you can do what you want? If you want to take my parcel away from me because I did not pay my rent, go ahead. I will survive."

For the next thirty years the Pigs worked night and day, and during lunch breaks they studied the history of sturdy steel construction. And then, one day, they were finished. The house was indestructible. Finished! We are finished, the Pigs said. The Wolf came and he huffed and he puffed, the house held up. The Wolf got angry, his huffing became ruthless, his puffing stretched the capacities of his lungs. Eventually his body gave up on him and he fell down and died. "See!" the voice boomed. "See what?" the piglets said. By now they hated the voice as much as the wolf.

"You know how much the water costs? You know how much I had to co-pay for my hearing aid, how much they charge for a postage stamp to America, how much it costs to take the bus to Burg Stargard to go to the post office and buy the stamp?"

"Please excuse the interruption," we finally said, "but we don't even know who you are." He said his name was Fuchs. "I am the Fuchs," he said. We didn't know what to reply. Given our difference in age, it felt awkward to use Mr. and Mrs. and our last names to reciprocate the introduction. But it would be even stranger, we figured, to just use our first names. We definitely were not on a first name basis with Mr. Fuchs and most likely would never be. He looked us in the eyes. For a brief moment it was as if he smiled, as if he forgave the world for harboring people who

did not know who they were supposed to be. We felt relief. Thank you, we wanted to say, for not insisting on nailing us down. "It's very nice to meet you Mr. Fuchs," we said. He laughed out loud, free from pretense, or hypocrisy, free from sarcasm or irony. His laugh sounded like that of a happy man. It made us happy too, so happy we immediately wanted to pull down the fence, hug him, pat his shoulder, play-punch him in the belly and then grab his ears and shake his head, back and forth and back and forth, so we could keep laughing about this outrageous idea, that we had gotten into a yellow cab in Queens and boarded a plane at John F. Kennedy airport in Brooklyn and then a train in Frankfurt, and rented a car in Berlin to come to Dasdorf in order to collect our thirteen euros rent, pull together the holes in his fence, replace his broken lock, make a fire to burn spreading thistles, and chase down the village people who had been eating artificial hormones for the last twenty years so they could eventually grow tall enough to reach over the fence and steal his spade. What if, we thought – while Mr. Fuchs excoriated a dirty crook named Roger Ralf for shoveling contaminated cow's manure from Bülow's stable into the back of his truck in order to sell it as organic fertilizer – what if we told him that we had not come to Dasdorf to correct or fix anything. What if we told him that we didn't believe in the 1933 Disney version of the Three Piglets that was meant to inspire the American people during the Great Depression to pull through and become bigger and better, that we didn't trust in wood carvings over hallway doors that exclaimed that one first needed to tidy up one's room before one could go out into the world and save it. We just wanted to see. Spend some time. Instead of the screaming, we could re-stage the *Endgame*. Make it all somewhat bearable by performing it together. It, being the misery, der Weltschmerz. We could be Hamm and Clove and you and your wife could be Nagg and Nelly, we wanted to say to Mr. Fuchs. They are Hamm's father and mother. They live in two separate dustbins and they have no legs. Do you have a wife? Do you know Samuel Beckett? We could take you and your wife and see that play. Probably in Berlin.

Would your wife be interested in such a thing? Hamm is blind and unable to stand. Look! Like us. We are very unstable. We have this existential instability in us that keeps fracturing with everything we do. The world is almost gone. Climate Change shooting through the roof. But there is still hope. That's what's so crazy about it. Hamm finds a flea, and before Clove exterminates it, they consider that humanity may be able to be reborn out of that one flea. Do you see how absurd that is, how desperately hopeful? What, if we had come all the way to Dasdorf to ask: Would you kill that flea or would you let it sit in the basket of your bike and sing a song, when you ride to the pond to fetch water for your carrot seedlings? What does it mean to persevere? How do you do it? You know as well as we, that one day we will disappear into that ten feet by ten feet by ten feet kitchen. Can we survive? Can we be happy there? To some degree? As happy or as miserable as you are riding your bike to the pond every day? Could you teach us how to handle it? Is there a way?

"The thistles first! The thistles have priority! Then the fence. Get the trash bags in Burg Stargard, they sell them by the box, fifty in a box!" And then, he abruptly turned around, spit on the ground, and walked away. Simply walked away. What an idiot, we thought. What a waste of cosmic energy – his accusations crashing against our beating hearts, his bitter screaming hammering against our incapacity to be practical and rational, his pointless pessimism against our stupid hope, us being such thorough fools we could not find another way to reevaluate our so-called "German culture" – we had to fly four thousand miles across the globe so we could be with the kind of people who knew "how to get through to us," who knew how to stir our inner cores, whirling up that special pain we feared the most. Fortification? Was that the idea? We did not know. We only knew, whatever it was, it had to be overcome. And when it had been overcome, we reasoned, suddenly feeling a calming numbness as Mr. Fuchs left us standing there exposed as foul-smelling garbage bags who had not even managed to say one reasonable word in response to this outrageous rant, which he had ended strictly on his terms in this

typical, rural people kind of way by spitting yellow snot on the ground, turning around and walking away in rubber boots – one day, we thought, we will bake a cake and set up a little table with a nice cotton tablecloth and a couple of folding chairs and sit down with a cup of freshly brewed coffee and a bowl of slightly sweetened whipped cream and tell Mr. Fuchs our version of the story.

In November of 2005, we will say to Mr. Fuchs, we sat in our one bedroom apartment in Queens, an outer borough of the city of New York. We hadn't left the apartment all day, had stared into the never changing light of our computer screens and filled out applications to get funding for art projects. The process had been tedious, the language required to describe our ideas had nothing to do with how we thought, and the most likely result of our efforts to comply with the aggravating word count restrictions for every paragraph we needed to submit online would be, so we predicted, a standardized rejection letter. The highway hummed, the neighbor to the left sang a Romanian folk song and cooked cabbage. The familiar smell of cabbage cooked with caraway seeds, we would tell Mr. Fuchs, mixed with the smell of the weed our neighbor below smoked before he had sex with another man, which we hoped would turn the night into a nice night for our downstairs neighbor, one where he wouldn't be sitting there alone and paranoid with his video camera pointed at the ceiling, waiting for us to step on the floor when walking from our desk to the bathroom, so he could call the police and then upload the evidence of the police coming to our apartment "DOING NOTHING!!!" to a publicly available video channel called 60-15 #3C. Living in NYC

is not easy, we would tell Mr. Fuchs. For several hours a week our upstairs neighbor had fervently vacuumed his apartment. The required new cleaning routine had been the result of a massive bed bug invasion that our eighty-unit brick building had endured over a period of one year prior to the time we were describing, we would tell Mr. Fuchs. About two months before we had purchased the allotment gardens in Dasdorf, we would tell Mr. Fuchs, the residents and pets of our building had voluntarily evacuated, and a crew of five exterminators in white hazmat suits, part of a pest control company called "AA Action," smoked out the entire building with a poisonous gas so powerful it killed some potted plants. After the fallout had settled, the superintendent of our building went from apartment to apartment to sell dog flea collars for five dollars a piece to be placed into the dust bags of resident's vacuum cleaners. Management had explained in a letter preceding the superintendent's temporary transformation from the one who on Thursdays waxed and polished the linoleum floors to the one who now sold flea collars, that the flea collars would minimize the possibility of sucked up bed bugs surviving and spreading in the dust bags of our vacuum cleaners. Besides vacuuming in regular intervals, it was now also mandatory, the letter from management further instructed without starting a second paragraph, to let a German Shepherd, his assigned dog handler and a note taker with a clipboard enter our apartment every three months, so the highly trained and reliable German Shepherd sniffing dog could do its job and detect surviving or newly moved-in bedbugs in their hiding places. If the dog wags its tail, "AA Action" will come and drop another smoke bomb.

During the one-year invasion of our building the bedbugs had never physically entered our apartment, we would tell Mr. Fuchs, but the fact that they might potentially move in had prompted a bedbug paranoia. We had wrapped our mattress in several layers of big black trash bags and used a sticky resin to draw one-centimeter-wide slime lines around the four legs of our platform bed, which we hoped, would trap the bedbugs, if they ever attempted

to crawl up into our sleeping quarters. At night, when we couldn't sleep because of how the plastic trash bags crunched, and when we tossed around on them, we often thought of "The Princess and the Pea," we would tell Mr. Fuchs. And that was not all, we would tell Mr. Fuchs. Not all at all. Living in New York City is very intense. There was the chronically ill cougher from the halfway house across from us, who was out in the yard several times a day chain smoking and coughing up layers of tar so thick one could fix Village Road with it. There were the ever-urgent sounds of the New York City Fire Department trucks, staffed with the bravest on the highway behind our building blowing their horns in antic-ipation of yet another disaster, the steam pipes in our apartment banged up high-pressure steam, the dripping faucet kept chipping off the paint in our bathtub hoping even more desperately than we, it seemed, for the plumber to finally show up and make true on his big, manly promise to fix the faucet. The trash bin smelled like fish, and when we were about to open the window to regulate the heat in our apartment, a skinny man with a mask and a hammer walked down the fire escape and stopped in front of our window. He was part of the NYC Local Law 11 brick pointing work crew hired to make sure that all our building's bricks were securely fastened and wouldn't fall on pedestrian's heads and kill them, like other bricks from other NYC buildings had done before. He smiled shyly, pointed to the hole in the wall reserved for an air conditioner, put his hand on top of his penis and turned his knees inwards. The day before, when he had articulated his need to uri-nate this way, we had taken out the metal plate that closed the hole in the wall and gestured him to come in. He slid through the hole, fast and swift like a tiger, and then disappeared into our bathroom. About ten minutes later, when he came out of the bathroom again, he crossed the room and opened the door of our built-in closet. He looked in, made a long face, and then closed the door again. Without saying a word he then turned around, walked back to the window, looked at the hole, then turned around again, squinted his eyes and then darted towards the entrance door of our apartment,

while we kept synchronizing his movements by rotating in our office chairs. Our entrance door was locked with two locks and it took him a while to figure out the left turn/right turn combination, but eventually the door opened, he stepped out, the door shut closed with a bang and we stopped rotating in our office chairs. The fact that he had come in from the fire escape through the hole for the air conditioner and left through the entrance door without saying one word, in addition to the dust tracks he left mapping out his movements in our apartment, we would tell Mr. Fuchs, had an upsetting effect on us. "No," we therefore articulated through the window by slowly forming a big NO with our lips. We closed the curtains, we would tell Mr. Fuchs, dragged a folding chair in front of the hole with the metal plate and put a stack of heavy books on the seat of the folding chair. We checked that the locks to our entrance door were locked, and then went back to our desk, put on our noise-canceling headphones, hunched over and searched the Internet for "outside." "OUTSIDE!" "Outside Online, Outside Lands, Outside Definition, Outside In, Outside Television, Outside Inn, Outside Counsel, Jill Outside, Just Outside, outside.in, Outside My Window, Outside the Lens, Outside Summit, Art Outside."

When it popped up on our screen, we just clicked. That was all. We bid on the allotment garden in Dasdorf during an online auction on eBay, because it seemed the most reasonable thing to do that day.

We had done it before, we would tell Mr. Fuchs. In 2001 we had placed a bid at an online auction house and won an acre of land in Utah, sight unseen, for five hundred dollars, and then, a year later, ten acres in Nevada for two thousand. Both properties had come as generic squares; part of Jefferson's geometrical grid, the colonial pattern that had been imposed on the American landscape after the American Revolution in order to occupy, imagine, subdivide and sell stolen land. Since the Land Ordinance Act of 1785 was passed, we would tell Mr. Fuchs, land as a commodity was traded, in parts, as disembodied squares and buying land online, sight unseen, naturally felt unreal and unresolved. American land-ownership was like

a riddle, that could be owned – as a vehicle, to get some place else, we thought. Why was there only a one-letter difference between owning and owing, for example?

We started the engagement with our lot in Utah as a long distance relationship, we started looking from New York City, we zoomed in and out of satellite images, and scrolled through digitally stitched image maps. We looked at coordinates, the projected layouts of divisions and subdivisions, smaller squares within bigger squares, townships, grids and section lines, talked about the properties of a square in relation to the world being a sphere. We thought about "longitude," the distance of a place east or west of the meridian at Greenwich, England, expressed in degrees and minutes, connected that to "longing," and then to "belonging," as expressed in "attitudes," settled ways of thinking or feeling.

We printed a picture of the lot in Utah on a letter size paper, let it fly from the sixty-third floor window of a high rise apartment building and watched how the representation slowly descended into the density of Lower Manhattan, eventually claiming a space. It touched us strangely to see the piece of paper landing on the concrete. We talked about speculation and leaving a footprint, we wrote a text called: "Give that Lot some Privacy," and then we sat down at our kitchen table and produced a salt dough stop-motion animation that showed the land's uplifting transformation

into a flying carpet. We argued, about whether this flying carpet should have fringes or not.

Eventually though, we would tell Mr. Fuchs, the hypothetical nature of such ideas created a real hole, and when that hole began to suck us in, we realized that it was time to get out there, smell the earth, feel the wind, see wild horses and antelopes and talk to people, who would show up with shotguns in their trucks in response to the dust clouds our rental cars would generate driving down the dried out desert dirt roads.

And, you know, we would say to Mr. Fuchs, most likely fixing our gaze on the checkerboard tablecloth in order to lower the awkwardness of saying such things in German to a man like Mr. Fuchs, that's what we did. We went, and had a love affair. An intense one. Very strange.

The American West, we will say to Mr. Fuchs, is very different from the landscape around Dasdorf. The expanse of the desert is deceiving. Especially the "empty" part of it. The absences are haunting. Overwhelming. Shocking. You have to come one day and let it turn you into a persona you didn't know was part of your psychological repertoire. There's no comparison to anything we know from Europe in spatial and mental terms, we will say, before it's Mr. Fuchs's turn to finally speak and ask: "Did you build a house there or what?" his mouth half-full of strawberry cake when asking the question. "No we didn't," we will reply. Mr. Fuchs will say, that the cake we had baked and served wasn't terrible, even though he would have preferred less sugar in the glaze and was used to a much softer, spongier crust and that he would like to have a second piece.

When the allotment garden in Dasdorf popped up on our screen, we would say to Mr. Fuchs, while scooping a second piece on his plate, we needed to give it another try. Imagine, we would say, after the big, open desert lot, now a small fenced-in, subdivided garden plot. After a perfect square, suddenly a crooked rectangle, after the American West now the German East. And then we thought of you, the people, we would say to Mr. Fuchs. "There will be trees, there will be fence posts and there will be living tenants," we said

to each other on that day in November of 2005, when we placed our online auction bid for the allotment gardens in Dasdorf. It will be a good place to figure out what is going on between man and nature. We will go and plant a variety of seeds, we said to each other, and then observe what sprouts and which idea will emerge as the most likely one. We will tend to the outcome and help it grow, and then, if the people in Dasdorf engage and show us how to turn that sprout into something beautiful, and if the bees of Dasdorf come and pollinate, and if the soil keeps nurturing and the climate is right, then the experiment will produce new hybrid seeds. We will collect these seeds and store them over the winter in a dry and cool place and then distribute them the next year, so more people can sow them and more ideas will grow. And every time we perform an action, we will get a reaction; every time we take a step forward, we will push the earth backward; every time we start the car in Dasdorf, stones will fly into the air from under our spinning tires and that energy will contribute to the spinning of the world. And isn't that what we want – to keep the world spinning?

"She smelled like East. He smelled like West. She laughed when Erwin told the joke with the 'Abschnittsbevollmächtigten.' He remained uptight. Like a walking stick with a brass knob," the Mother said. "The uptightness is what makes the Wessies such stiff sticklers. You can see it from miles away. They will never double over about a joke and beat their flanks and wet their pants because they have that stick shoved up their asses. Look at his professor glasses. People don't wear glasses to tell jokes. They wear these kinds of glasses so they can count money. The thicker the pockets stuffed with bills, the worse the eyesight. They fly back and forth between America and Dasdorf as if America were Cölpin, as if America was a stone's

throw from here. They cover a lot of territory. They are a mile wide, but not even an inch deep."

They photograph everything. It doesn't matter if it's an earthworm or a crack in the road. They took a picture of each of his tools, Erwin said, one after the other, as if they were working for the Stasi. They took each tool from its nail, put it on the ground and photographed it. The fan rake, the shrub rake, the weeding fork, the shovel, the scythe, the spade, the pick ax, the cultivator, the pruning saw, the shears, the trowel, the twine, the gloves, the bucket, the watering can, the dibber — it went on and on, Erwin said. And when he asked them if the Secret Service had sent them to do this, they said, if they worked for the Secret Service they obviously would do this in secret.

After Mr. Fuchs had left us standing behind the fence we drove to Neubrandenburg and bought gardening tools and materials and then went into a café to discuss what we should do with them. We got into a disagreement and due to that disagreement we didn't return to Dasdorf for the next two days, but kept driving around Dasdorf in bigger and smaller circles trying to figure out what

would be too much and what would be too little. On the third day
we went back, parked the car next to the fence, opened the trunk,
took out cameras and some tape, followed the little path into the
back of the gardens and started taking pictures of the things that
stood on a piece of the earth we supposedly owned. We photo-
graphed the little tool shed on the abandoned parcel on which
Mrs. Kirchheimer had dropped dead from her heat stroke, and
took a close-up of an old cement block in front of the shed, on
which, we imagined, she had sat many times.

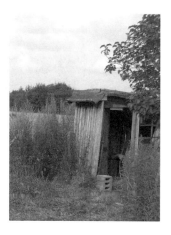

We started taping the remains of the broken glass window in
the shed. First we taped a layer of vertical transparent strips over
the empty hole between the pieces that had remained inside the
frame, then we taped another layer of horizontal strips. It made a
pattern. "It's not a symbol, but a pattern," we said to each other.
It looked nice against the light, especially when Mr. and Mrs.
Richter appeared, blurred and fragmented behind the bandaged
transparencies. They opened the lock to the gate of their garden
parcel with a key and waved us over to the fence. "We need to
speak among four eyes," Mr. Richter said with a voice so coarse
it made our own mouths salivate. "As soon as we heard that a
car with a license plate from Hamburg had parked in front of the

gardens, we started to get dressed," he said. Mrs. Richter, one step behind him, nodded. "We came as fast as we could, which under these circumstances took us almost an hour."

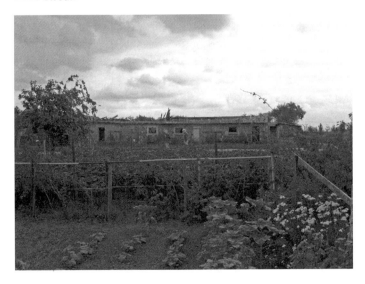

"You cannot tell anybody, nobody needs to know about this," he continued, his red, glassy eyes staring through ours into whatever was behind our heads, "but I've got the cancer real bad. I have to give up the parcel. I am doing the chemotherapy once every two weeks now, but it's not going well. The doctors don't even see me anymore. It's always just another nurse who puts the plastic bag on the hanger. I lie on the bed and watch how that yellow poison drips down into my blood, and afterwards I feel worse than before, every week I feel worse, and every time I tell the nurse I am feeling worse she says, 'That's normal.' I never believed in God, but recently I started to. You know why? Because I think it's God's piss in that plastic bag. The piss bag is God's revenge because I never believed."

Mrs. Richter stood behind him like a statue as her eyes filled with tears. We wondered if she would overflow, if she would

actually start to cry; but when her eyes reached their capacity she put both hands behind her back and started rotating a small umbrella away from her body, and the tears remained in place – as if rotating the umbrella behind her back was creating a sort of underpressure in the part of her system that prevented her eyes from spilling over.

Death, dying, they didn't just talk about it, they actually did it. When Mr. Richter reached over the fence to shake hands "for the first and very last time," as he put it, he wasn't adding any drama. He delivered the reason for an upcoming change in our rental agreement, and since he was never a letter writing man, he preferred to do it in person. "Goodbye."

He left the garden using the little path between the vegetable beds, closely followed by his wife, who was still spinning the umbrella away from her body. Once on the street, he halted for a moment so she could catch up, and then they linked their arms together and removed themselves from the scene in lockstep. We stayed behind the fence and watched, beginning to feel unwell and disturbed by the fact that this stranger's upcoming death was putting us in an unexpected state of panic. What

47

if his death turned out to be more than a period at the end of a sentence? What if the world couldn't exist without Mr. Richter? What if Bernhard Richter from Dasdorf in Mecklenburg-Western Pomerania, Northern Germany was the final drop, which would push the earth to its capacity and cause the globe to break apart into a million pieces, which would drift off randomly without any meaning into the blackness of the universe?

The thoughts hammered against our brains in rapid succession. Our hearts raced. Was there no way to save him? Was it really too late to run over and be a little gentle, we kept thinking, as we stood behind the fence holding on to that crumbling concrete post, that felt tender and stiff at the same time. The weakest go to the wall, an inner voice said, and then we sagged down to seat ourselves among them, our eyes still glued to the couple as they walked away down Village Road.

Mr. Richter, slowly but steadily stepping forward, was wearing black rubber boots, a dark blue boiler suit, and a kind of faded Mao hat that did not go well with the swollen baldness of his head, we had thought, only a few moments earlier, and now already regretted thinking it as we replayed the scene. While he had been talking to us over the fence in this final stage of the disease that would ultimately shut down his body a couple of weeks from now, it had occurred to us, that the dark blue Mao hat of the proletariat did not go well with the side effects of a Western chemotherapy. They just do not belong together, we had thought, and now reflected upon, sitting on the ground next to the crumbling fence pole, becoming aware of the inner turbulence in our stomachs, which we knew, usually started to bubble up in tandem with a certain kind of ur-guilt. Instead of wishing this dying old man good luck or at least saying something cheerful to his agonized wife, showing some sort of human decency, we had simply stood there in cold silence and reasoned that the visual discrepancy between Mr. Richter's chemotherapy-inflicted baldness and the proliferating abundance of green nature surrounding us all looked very unnatural, while the drug

or alcohol-induced redness of his eyes made a lot of sense in a place like Dasdorf. Green and red are complimentary colors, we had thought, we kept reflecting now. We are so removed, we thought, so detached, it's frightening. But what kind of help could we offer? Painting the coffin, making flower garlands and weaving them around the posts of Mr. Richter's deathbed, setting up a record player and playing "Schicksalslied," a choral work by Brahms, Bach, a poem by Hölderlin, a poem by Goethe, a quote by Nietzsche, how can one offer help to a dying stranger? Maybe he wasn't even dying. One never knows with cancer, we had thought, and then fallen to staring at Mrs. Richter's red, hand knitted cardigan. We wondered if the enormous number of popcorn shaped balls incorporated into the tightly knit pattern had the power to transmit some kind of answer; if the wreath-like ring of embroidered flowers in aqua, tan, and pink, with dark green leaves around her tired shoulders looked like a life preserver around her neck, because the embroidered flower ring actually was a sort of emergency armor that helped Mrs. Richter hold herself up, specifically her head. It's probably her best cardigan, we had thought. She probably put on her best piece of clothing to come out here and deliver the news. It's obviously a Bavarian cardigan, or even a Swiss one, we had thought, definitely not a Mecklenburg-Western Pomeranian one; and maybe that was the point, maybe she purposefully had chosen to wear a foreign cardigan in order to remove herself from what was going on at home, maybe wearing a bright red cardigan was her way of combating the gravity of her husband's situation in the dullness of Dasdorf. It's all so absurd, we thought. So incompatible. The artificially clean, white baldness of Mr. Richter's head in contrast to his muddy black rubber boots, next to Mrs. Richter's ceremonial red sheep's wool cardigan. It's all very unnatural, especially the unpaved side of Village Road in contrast to the paved one. And then the Richters were gone. We got up, cleaned our hands on our pants and walked toward the fields in the back of the garden. If the German government can afford

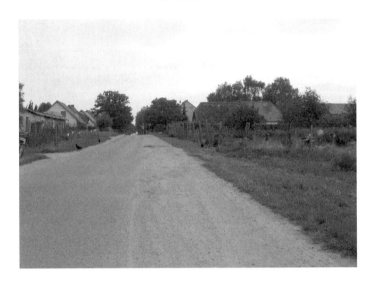

to send a taxi to Dasdorf every week, pick up Mr. Richter, drive him to Neubrandenburg and inject an expensive mix of cyto-toxic anti-neoplastic drugs into the body of this old dying man, we said to each other, shouldn't it also be able to afford to tar Village Road, so one would not constantly have to remind one-self that even though it looked like 1950 and everybody acted as if the war had just ended, the year was actually 2007? Couldn't the German government fly over Dasdorf and drop leaflets from the sky to explain to the people of Dasdorf that cancer doesn't spread by uttering the word, that cancer is not necessarily an outward reflection of the inward rottenness of a person, that the shame felt when witnessing the damaging side-effects of a fail-ing treatment is a very normal reaction amongst civilized peo-ple? Hens will lay eggs whether or not they've seen a rooster, the leaflets could say on one side, and humans get cancer whether or not they were good or bad, could be written on the other.

Villages had been flattened by bombs. Villages had been burned down in forest fires. Villages were flooded by tidal waves, drowned by reservoirs; villages had been suffocated by bubbling

lava, erased through genocides; villages have been murdered by real estate and swallowed up by mines. But what about Dasdorf? Was this place removing itself from the map as if by natural causes? Were there no successors, nobody to replace the infertility, the agedness? Was the site less and less frequented because the information it stored was less and less valuable? Was there no knowledge that needed to be passed on? Was that the reason why the resolution of the satellite images was so low, and why there was no Internet connection and no cell phone signal?

Mr. Kirsche was working on his plot, cutting down rows of lettuce with a scythe. "Too much rain in one day," he said, when we were close enough to hear him. "The lettuce shot up too fast. All that rain for nothing," he continued, bending his legs in small increments in a slow manner. Once he was close enough to the ground for his right hand to grab the next decapitated lettuce head, the downward movement came to a halt. He picked up the lettuce, straightened his legs again, rotated his arm forward around his shoulder joint, and, at an eighty-degree angle, released the lettuce head, so it could enjoy a short flight through the air. Mr. Kirsche's arm then slowly dropped down, and his body moved back into the starting position to take one step forward and repeat what he had just done. One after the other the lettuce heads disappeared behind the bushes.

"How is it going otherwise?" we asked, since we had not seen each other in almost a year. "I am going to die soon," he answered. A rooster crowed three times and a dog started to bark somewhere in the far background; a tractor passed by on Village Road. It seemed as if the driver, a man in a dark blue boiler suit, looked at us, not only in our direction, but directly into our eyes. We looked away and then we looked at Mr. Kirsche. He shrugged, turned around, walked to his tool shed, hung the scythe on a nail, locked his cat into the tool shed, and then left the gardens without saying another word.

Things had continued to break apart and they would continue to do that in the future, we thought. That was what the Dasdorfian future was about – a space in time for things to break apart, a place for facts to lose their integrity. And now we were part of it. Part of the neglect, the falling apart, what were we doing here? Trying to hold on, or let go? We bought this piece of land online because it was so cheap, and now we were paying the price for it. If nobody wants a piece of Germany for that little money, money must have lost its influence in that part of the world, we had thought, back in New York, placing our bid in the online auction. Something other than money must rule in Dasdorf, we had thought. What that was, we wanted to find out; we were curious to see how people lived outside the money-driven marketplace. Yet, we realized now, people didn't actually live, but rather died here.

It had been cheaper to buy land with people than without them. We had bought the gardens with tenants in Northern Europe like one buys a pair of pants with pockets made in China, when pants with pockets are cheaper than pants without pockets. It is a global thing, we had thought. Nothing personal. By total coincidence we had ended up on that virtual dirt road junction where Dasdorf met the Internet. We had felt a tickling, we had laughed, had produced some sweat in our armpits, had clicked a button and gotten pregnant from this one-night stand.

We thought of Miner John. We met him the first time we visited our ten-acre lot in Nevada. In July of 2002 we flew from

The Inconsistency of Always the Same

JFK into Salt Lake City, rented a four-wheel drive SUV and two hours later we were in Wendover, a town split in half, the state line separating Utah and Nevada running right through the middle of town. We checked into the cheapest available room in the Rainbow casino, put our bags on the luggage rack, took the elevator three floors down to the buzzing casino floor, put a few quarters into slot machines, won fifty dollars, took those to the blackjack table, ordered free cocktails, played roulette, and later that night ate a 99-cent breakfast special that included scrambled eggs, two pieces of whole wheat toast, a small glass of orange juice from concentrate, coffee, milk, sugar and ketchup, a beige plastic bowl with pieces of butter wrapped in silver, and a beige plastic bowl of grape and strawberry jelly in small plastic containers, which was served by a waitress in a miniskirt and heels who had, she told us proudly, six children, eighteen grandchildren, and four great-grandchildren, while our then twelve-year-old daughter Miranda, who as usual accompanied us on our land-related trips, was sleeping with one of our bulky cell phones next to her on the nightstand upstairs. When the sun came up, we went out into the casino lobby, polished our cowboy boots under a rotating brush, drove across the street to a gas station, filled our car's tank with gas, bought a chocolate glazed donut, an orange juice, a pair of sunglasses and a little pink pig on a key chain that could be

squeezed until rubber poop came out of its anus for Miranda, and drove into the desert to find our property, which was at the base of Pilot Peak, the highest elevation in the area.

Once in proximity, we estimated the coordinates of our land's corners using a map printout and a GPS device, and walked

around the parameters of our sagebrush-covered square of the earth. Miranda started to pile up a few stones as corner markers and stuck plastic windmills in the piles, while we attached a small wireless surveillance camera to a kite we had bought in Chinatown in Manhattan and let it fly high.

The wind, the string, the kite – none of them cooperated. It was impossible to stabilize the camera and get an overhead recording of our lot in which we could see the dimensions of ten acres in relation to our bodies and measure ourselves against the immensity of the expanse of the American Dream. When after hours of fruitless attempts to hoist the kite with the camera attached, a man came by in his rattling pick-up truck, we were so immersed in the frustrations of our failings that without any intro-duction we marched toward his truck, showed him our orange flag, and asked if he could get out of his vehicle, walk to the mid-dle of our property and stand there waving our flag, so we could hurry to the top of Pilot Peak, which rises 6,400 feet above the

Great Salt Lake Desert, and take that overhead picture of our lot from there. The man wished us luck and drove away. The next day, though, he came back and invited us to visit him. "I need to show you something," he said.

Two days later we honked in front of his gate. A dog with three legs leapt up and down the fence and wagged his tail. Miner John opened the door of his light blue trailer and when he walked toward us, in a brownish cloud of dust, he looked like a floating spaceman on a foreign planet, his steps dainty and soft, much too small for the length of his legs. His white hair was like lambswool, it had a nice waxy coating that we assumed was water-repellent. His skin was dusty like the desert, and while we tried to quietly figure the fundamental difference between a man being dirty and a man being dusty, Miner John covered the glaring ball of sun that hovered in the sky above us with his left hand and, using his silver spoon as a pointer, swung his right arm toward Pilot Peak.

"I can.

Move that mountain.

With my spoon.

All it takes.

Is a daily routine," he said.

We looked at the spoon and then we looked at Pilot Peak and then we looked at Miner John. He opened the gate and led us in. "This is my hole," he said and pointed to a hole in the ground that was about fifteen feet long, twenty feet wide, and ten feet deep. "Every morning I go down there," he said, "and I loosen the soil with my hammer, and then I shovel the dirt into my magic bucket, and then I walk up the ramp and dump it into the wheelbarrow. And then I walk back down into the hole and I loosen more soil and when the magic bucket is full, I dump it into the wheelbarrow. It takes about twenty-five buckets to fill the wheelbarrow. And when the wheelbarrow is filled, I push it over there, to the sorting station." We walked over. The sorting station consisted of about ten pieces of metal or plastic mesh screens of assorted sizes nailed onto wooden frames that lay on the ground. "These are my sifters," he said. "I

start with the biggest mesh. I take a stick and push it under the sift-er's frame and then I shovel the dirt onto the mesh. What doesn't go through the mesh, stays here, whatever goes through I shovel up and throw onto the next sifter, which has smaller holes. I do this ten times and by the end I have very fine sand. And then I bring the stuff over there. See the fields of pebbles," he said, and pointed toward the other side of his fenced-in property. We walked over to what looked like an out-of-scale pebble display in the outdoor garden section of a building supply store. There were ten rectangu-lar fields, each one evenly covered with same-sized pebbles, from walnut-, to hazelnut-, to bean-, to peanut-, pea-, lentil-, buckwheat-and quinoa-sized pebbles down to grainy, fine and very fine sand.

"I rake them every day," he said. "I've been working on this since I came out here, three years ago, six hours a day, except on Sundays." Miranda sat down at the edge of the pebble field and started pushing dirt into a small heap. We slowly walked down the row and when we came back, Miner John bent down, picked up one of the bigger pebbles and gave it to Miranda. "For you," he said. She smiled, said, "Thank you," and stuck it on top of her little sand castle.

And now he is gone, we thought, as we felt Miner John's hole materializing in our stomachs, in the middle of Village Road. "Yet not completely," one of us said. "We still can go online, zoom in on his property on Google Earth and look at the dark-grey, ten-acre square that so clearly stands out from its surroundings."

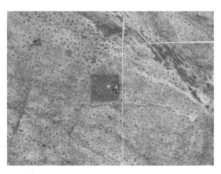

We never spent a night in Dasdorf. Sleeping in Dasdorf, we told ourselves, would mean being taken in by Dasdorf, and to be taken in by Dasdorf meant to be ingested by Dasdorf and become part of its system. In the summer of 2007 we rented a small apartment in a house in Cammin, twelve miles away, an even smaller village than Dasdorf and much more romantic looking. A five-hundred-year-old chestnut alley led over rolling hills down into the small hamlet on a kidney shaped lake, where the former landowner's mansion, we were told, had been purchased and renovated by the CEO of Burger King in Northern Germany.

Mrs. Steiner, our temporary landlady, was in her sixties, we guessed, and her house was roughly half that age but equally gray. It was a properly-kept cinderblock box with an appropriate amount of small, double-paned, energy-efficient windows and a steep roof that dutifully complied with every possible German environmental standard and building code. The house was surrounded by an expansive, beautiful flower garden. We complimented her on that and Mrs. Steiner said, "It's therapy. Every flower that blooms in here is an apology to my daughter. She committed suicide when she was sixteen. Park your car behind mine in the driveway. I have nowhere to go."

We parked the car behind hers in the driveway and carried our luggage into the house and up the staircase, where we tried to

avert our eyes from several black-and-white family photographs that accompanied each step. "That's where my daughter was supposed to live," Mrs. Steiner shouted from downstairs, once we had reached the top of the staircase. "My ex-husband is an architect, the house was built after his design and with her future family in mind. He cheated on me with my own sister, that's why I kept the house. Please always close the doors though, otherwise you will smash them into each other and then I have to charge you for the damage. My ex-husband made a mistake with the width of the hallway."

Once we had closed the door behind us, the narrow hallway, a dark enclosure with three more closed doors in front of us and a silver hook for the keys next to the light switch, looked like a trap in a first-person-shooter computer game. The first exit strategy we tried was a door to our left at the end of the corridor. It led into the kitchen: a small, clean room with a tiled ceiling. A beige row of laminated cabinets hung above a laminated kitchen counter with a stainless steel electrical stovetop. On the wall behind dangled two potholders featuring chubby-faced 18th-century children from Holland in wooden shoes in front of a windmill. There was a white refrigerator with a white microwave on top of it, a white radiator under a white plastic window with white curtains. We pushed the curtains aside, looked out of the window, and lowered our heads.

On the laminated kitchen floor sat a dark green rubber tree plant in a light brown plastic pot. Two folding chairs accompanied a kitchen table covered with a crudely cross-stitched tablecloth. The brown ceramic vase, filled with a bunch of apologies to Mrs. Steiner's dead daughter, was from Bulgaria. We knew that because we recognized the peacock-eye pattern that wrapped tightly around its neck like a dripping collar. We looked up again. Two items hung on the wall, left and right of the insulating window: a glossy calendar from the local bank and a kitchen device that contained a roll of plastic wrap. One could pull the transparent sheet straight out with both hands and then perfectly rip it along a line of sharp metal teeth without the sheet bunching up. We cut four sheets and put them on a small stack on the windowsill.

This is it, we thought. We are in this "ten feet by ten feet by ten feet kitchen" now. We will do something with this plastic wrap. We will pull it out of the dispenser, cut it, and use it. We cut two more sheets and stared into the air. Nothing happened. We turned around, moved the Bulgarian vase to the edge of the table, pushed the tablecloth aside and unpacked the butter, the cheese, and the heavy six-grain whole wheat bread we had bought in the supermarket in Burg Stargard.

In search of a bread knife we opened the first drawer in the kitchen counter. Two knives, two forks, two small spoons and two big ones, all made out of aluminum, the most common metal in the Earth's crust, were neatly lined up on a light pink piece of plastic. This is what they call the empirical evidence, we thought.

We opened the second drawer and there, on a neatly folded piece of small, blue-and-white checkered cotton cloth, lay a big bread knife with a worn wooden handle next to a potato-peeling knife with a black plastic handle. There is a fundamental reality, we thought, and these are its symptoms. How banal, how random. We refrained from touching anything, closed the drawer carefully, and opened the third drawer. On the pristinely white, laminated bottom of the drawer lay an ordinary beer bottle opener next to a generic wine bottle opener with a wooden handle. They are displayed like artifacts in a natural history museum, we thought, but could not picture under which category these specimens would be filed. These object's lack of awareness about themselves is crushing, we thought. They touch us with their fundamental ignorance, that's what's so strange, we thought and opened the fourth drawer. A white virgin of a candle lay next to a box of matches. "Look at that," we whispered, and took a photo, which was, like almost all the snapshots we took at the time, unable to capture the aura of what it pictured.

We stepped into the hallway, closed the kitchen door, and opened the bedroom door. Equally small and burdened by the same oppressive tilt of the ceiling as the kitchen, the bedroom was occupied by a huge bed. The white, sterile cotton covers were stretched tightly and at the head of the bed towered two starched pillows. In the precisely formed groove of one of them sat an ill-looking teddy bear with a red heart around his neck, on which "I love you!" was written. Squeezed between the wall and the stiff whiteness of that bed – basically inaccessible unless one was climbing over it – stood a garish orange chair with big blue dots and green, thundering streaks that could possibly have done great work cheering up hormonally unbalanced young people in the lobby of a youth hostel. On us, equally unbalanced hormonally, but no longer young, it had the opposite effect. Touching the revolting chair was a hobnailed glass table, a piece of garden furniture under house arrest, and a wooden closet whose doors got stopped either by the bed or by the glass table before they could open even halfway. The material

outcasts in the room had come together to exude the vibe of a children's cancer ward and when we reminded ourselves that we had rented this second floor cluster of airtight, isolated cells for two weeks, the walls closed in. We wanted to open the window, but by then our energy level had dropped so low, it was impossible to remove our shoes and cross the seemingly endless whiteness of that bed, which suddenly looked as dreadful as the Salt Flats of Utah might to a bunch of tourists who haven't brought enough water to survive the breakdown of their car on a deserted back road. We slowly stepped out into the dark hallway, closed the bedroom door behind us, took two steps forward, opened the door to the kitchen, stepped into the kitchen, closed the kitchen door behind us, took two steps forward and folded the tablecloth into a skinny rectangle which we hung over the back of the third empty chair, carefully, as if the tablecloth was a flag we had just pulled off a soldier's coffin who had died senselessly in a country far away from home. We sat down, ate our bread and cheese, and once we had chewed it thoroughly and swallowed, we shaped our left hands like a bowl, placed them on the edge of the table, used our right hands to wipe the bread crumbs on the table into our hands, got up, threw those crumbs into the trash bin lined with a new white trash bag, drank a cup of anise-fennel-cumin tea in small sips, opened the kitchen door, stepped out into the hallway, closed the kitchen door, took one step to the right and opened the door to the white floor-to-ceiling tiled bathroom, closed the door behind us, went to the toilet and brushed our teeth, undressed, opened the sliding door to the shower cubicle, turned the faucet until the red dot on the movable part lined up with a short, black line on the outer ring and the water temperature was consistently thirty-nine degrees Celcius, showered, opened the sliding door, took a neatly folded towel from a shelf, toweled off, opened the bathroom door, stepped out into the dark hallway, closed the door to the bathroom behind us, walked five steps to the left and checked if the entrance door was locked, walked five steps back, opened the door to the bedroom, entered and closed the door behind us, put on white t-shirts and fell asleep at eight p.m. The next

morning, after we had repeated the action of opening and closing the doors into the dark narrow hallway in order to use the toilet, get dressed and eat breakfast, we made our way down the stairs. Mrs. Steiner was already waiting at the bottom. "I heard you getting up, so I thought you might be ready for an adventure," she said, handing us a set of keys that shared a chain with five little impish gnomes. "The rowboat hasn't been used in many years."

We walked down the path behind the house to the kidney shaped lake, and a dilapidated pier, unlocked the boat's rusty shackles, checked for holes, got in, and started rowing into the middle of the lake – which we reached at 7:15 a.m., approximately fifteen minutes after we left Mrs. Steiner's house. We stopped rowing and looked around. The banks were lined with weeping willows and a few ducks glided above the surface of the water. There was a fly that had come with us in the boat from the shore. Otherwise everything was still. At 7:15 a.m. the adventure of the day had already happened. What would we do with the rest of the days we had booked for ourselves?

The Inconsistency of Always the Same

We thought of Miner John. The summer before, we had honked our horn in front of his gate and Tripod, his three-legged dog, started jumping up and down behind the fence wagging his tail. It wasn't he who opened the door of the light blue trailer and climbed down the few steps. Instead, it was a heavy man with an exposed wooden leg and a beard. He held a shotgun in his hand, and stumped toward us, followed by four ostriches.

"Where is Miner John?" we asked.

"Gone," the man answered.

"And what are those?" We pointed toward the ostriches.

"And who are you?"

"Your closest neighbors."

"And where is the accent from?"

"From Germany."

"Well, those ostriches are from South Africa," he said.

He had been on cargo ships for more than forty years, the last twenty-three of them as a captain, he told us. He had crossed every ocean and circled every island and now he was retiring in the middle of the desert. His logic was sound and he was somewhat likeable, yet there was an invisible barrier between us. Miner John's truck was parked near the gate. His little bucket lay in his hole, his hummingbird feeder dangled in the wind, the pebble fields looked raked. The compound looked more or less as it had one year ago. Nothing was gone, except Miner John. Was it possible that he had been reincarnated, that his spirit had decided to live on in the form of four ostriches from South Africa and a captain with a wooden leg? Or was he in there, in his trailer, tied to his bed that looked like the nest of a big mammal? "Nope," said the captain, "he died in the hospital."

We had only once been inside the trailer, we remembered now sitting in the rowboat in the middle of the lake. It had been dark inside. The windows were covered with dark striped curtains and black trash bags, and most of the interior was evenly laid with a thick layer of dust, which gave the place the aura of an otherworldly, ancient cave. Occasionally the seamless blanket of dust was interrupted by a clean swipe, or little, colorful patches of mold. White, upward-reaching mold grew on slices of Wonder Bread sealed in a plastic bag that lay on a pile of old magazines, and greenish, mossy mold grew on a leather bag squeezed between rows of canned beans, split peas, corn, beef, peanut butter and sardines on a shelf. The shower stall was stacked, bottom to top, with plastic soda bottles Miner John had collected at highway rest stops and filled with water

from the rest stop water fountains. We stood there and looked and listened to each story that came with each object, until eventually Miner John sat down on a chair, his only chair, and we sat down on his bed, where he slept with Tripod. A black cat lay curled up on a bucket and stared at us with her yellow eyes. Another black one with white paws, much more fearful and anxious, sat high up on a shelf next to a radio whose solar-charged batteries had the capacity to transmit radio waves for about sixty minutes a day. Miranda sat down on the floor right next to the stove, crossed her legs, and started laying out geometrical patterns; mandalas, grids, and spirals with the wood pellets she found in the metal bucket next to the stove. The radio, the pellet stove, the solar panels, his two-seater outhouse, the way to purify water in transparent plastic bottles by letting them sit in the sun for two days, the natural refrigerator he had built and kept improving using an old free-standing freezer he had found at a recycling center in Salt Lake City, his Bible, his cats, the mice, the apple-tree seedling, the outside fire pit with eight small stools around it, for the day when Miner John would have people over and they would spend the night sitting around the fire telling stories like old times . . . It took a few more hours to go through his list of items and the actions a man needs to have and do in order to survive in the desert, not only because there were many items to cover, but also because long pauses started to stretch the time in between Miner John's explanations. First the pauses occurred between paragraphs, then between sentences, and finally between words. The longer they grew, the deeper they sucked us into the world of this hermit, who had withdrawn from society for reasons we knew he could not share, otherwise he wouldn't be there. The winter before he had not seen another human for two months in a row.

> "It was hard.
> to not lose.
> IT,"

he said so slowly, the words formed a face that looked at us. Each pause was different. Sometimes the intermissions spread gently like the dust in the trailer, emphasizing that there was basically no difference between cans of beans with an expiration date and petrified pieces of wood, once they were covered by the same dust. At other moments the silence felt heavy, like metal plates that sealed our thoughts with such intense quietness, the only thing we were still able to recognize was Miranda, who at one point had fallen asleep on our laps in Miner John's bed with the dog curled up next to her. We heard the wind outside the trailer and realized that it had a form and a character, that the wind was an actual being rather than a large-scale flow of gas, as we had been told by our German teachers in school. By now all the wood pellets were back in the bucket. The two-dimensional patterns were three-dimensional chaos again. Miner John turned off the flashlight that hung from the ceiling to conserve battery power. Eventually, in the pitch-black darkness of the night, he said:

"You.
Would think water.
No.
I survive without water.
But. Wouldn't. Last out here.
For an hour.
Without my dream."
"What's your dream?," we asked.
"The hole.
I am.
Digging.
With my spoon."

They always stayed somewhere else overnight. They stayed in Cammin, they stayed in Marterhof, they stayed in Burg Stargard, they stayed in Tschechendorf. They even stayed in Neubrandenburg

in the hotel "Am Ring" once, Kirsche had told the Mother. Every time they came, they stayed in a different place. They made us nervous with their restlessness. They were always running around, driving back and forth. As if they would die a shameful death if they didn't try and test everything within their reach. Every day a new thing captured their attention. They caught butterflies, they picked flowers, they jumped up and down after they found some wild strawberries as if they were five years old and had discovered the Eighth Wonder of the World. "Typical Americans," the Sister said. But one could tell nothing would ever last with them. No commitments. These fluff balls looked at a thing with big eyes, clutched it to their hearts, but while they talked about loving it, one could already see their eyes scanning the horizon for the next thing. And if there was no next thing, then they got bored and morose, and squatted in front of Kirchheimer's old shack on a stone, held their heads in their hands and did nothing. Nothing all day long.

"Don't be a fool!" the Mother yelled at me when I told her I would go over and talk with them about the piece of land we use for the ducks. "We won't say a word. If they are interested in discord, let them find out by themselves that the part we use for the ducks is actually not part of our parcel. And even then . . . if they want us to pay for that piece of land, you will tell them that they should rather thank us for the favor of keeping the ducks! What would three euros or five euros more mean to these spoiled brats? There is no need to charge us extra. No need at all. If there is a need for anything, then it should be gratitude on their part! Why doesn't the area where we keep the ducks look like the rest of their rundown gypsy colony? Thankfully our ducks are doing the work that these worthless wretches are not capable of doing. What would it cost those greeders to buy a lawn mower? Brauner's Inge told me that the hotel in Neubrandenburg costs sixty euros a night. A night! They spent all the money they collected from all of us in rent last year in one night. We won't contribute another penny to this kind of waste. Not one penny!"

Every morning around eight we arrived in the gardens with the intention of doing something, but once there, we did not know how to proceed. We threw a stone and it landed nowhere. Everything in Dasdorf was familiar, yet we felt surrounded by nothing but incomprehensibility. The world had abandoned us; we had cast ourselves out far beyond the limits of knowing what to do, we weren't even sure what year it was, what century. We blamed the Internet. We blamed each other, the stoic, stifling, unspontaneous Germanness in us. Nothing is more

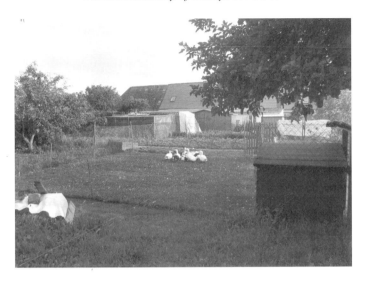

hindering than being a German among other Germans in a country like Germany, we said. In every German sits a slave and everything in this country is a burden. Every German activity means obeying, hence it is accompanied by a groan. Remember how the saleswoman in the supermarket bakery groaned when we told her we wanted to buy a loaf of whole wheat bread, we said to each other.

To be burdened is the state of German normalcy. To constantly suffer from one's own inborn obedience is what makes a German a German. The Americans can't handle their obesity and the Germans can't handle their obedience. Everything we do is like fulfilling an order. Everyone suffers from it and we are stuck, we said. Stuck, stuck, stuck, we repeated. We are stuck in an overgrown garden that is ruled by nature. We are intimidated by her power, we said, as we trampled down the little path. She is always ahead of us, always ahead of us growing something new or letting something die. We have no time to figure out what to do, because we are always busy comprehending what she has done, or predicting what she will do next, while

she just keeps doing and doing and doing and doing. It's unfair. The only thing we can do is to put the key into the ignition and drive away.

The biggest town in the region was fifteen miles away. Neubrandenburg was praised in a travel guide in the local bookstore for the preservation of its incredible medieval fortification, built around 1300, which consists of a circular structure with a diameter of roughly eight hundred meters, comprising three moats, two earthen walls, the city wall, two towers, fifty-five defensive houses set into the wall, and five ring roads. The city wall, still entirely intact, is seven meters high and two kilometers long and strengthened by four gates: the "Friedland Gate," constructed around 1300; the "Stargard Gate," constructed in the early 14th century and housing nine mysterious life-size terracotta figures; the most impressive "Treptow Gate," thirty-two meters high, finished in the 15th century; and the "New Gate," built after the others in a Neo-Gothic style with eight more mysterious terracotta figures between its bricks. For seven hundred years there has been no entrance to the center of Neubrandenburg other than through these narrow, Gothic, brick gates, regardless of whether one was a merchant with a cart full of potatoes or a soldier in a tank, as happened in May of 1945, when the Russian Army liberated the town – or occupied it, depending on the version – and almost everything inside the ramparts was burnt down. In its formative years the German Democratic Republic rebuilt. Since then it seemed (at least to us who had been living in New York for the past fifteen years), not so much had happened.

The center of Neubrandenburg looked like an East German town of the seventies. And it felt like one too. Beige, uniform, and practical. The facades of the buildings looked like the people in their comfortable cotton clothes, that halfway hid, halfway accentuated the complacent extra meat around their aging bodies, as they walked in sturdy, well ventilated shoes across the cobblestones, most of them probably stabilized by a monthly early

retirement or unemployment check from the government. Across from the only high-rise building, a crumbling sixteen-story skyscraper that the locals called "The Culture Finger," or "The Finger" was a small outdoor café that served beer starting at ten in the morning. Almost every morning we went to this café in Neubrandenburg to drink coffee, eat cake, and browse the Internet. One morning, wondering if we could make sense of the situation by writing it down, we stumbled upon a website called "Storyboardthat," which led us to wonder which of the Big Four

types of literary conflict we were entangled in. "Man vs. Man, Man vs. Nature, Man vs. Society, or Man vs. Self". There was a small comic strip on the website that explained the Man vs. Nature conflict as exemplified by *Moby Dick*. It ended with the sentence, "Captain Ahab's obsession leads to tragedy."

"Tragedy," we said, "if at least we could have some tragedy." But no, the black currants would never be to us what the white whale was to Ahab. The green of the gardens would never be that insulting. Our vengeance would be, at most, the pleasant smell produced when we ripped leaves off bushes and trees and ground them between our fingers.

We had spent uneventful days in Dasdorf, but we hadn't, like Santiago, gone eighty-four days without catching a fish. Dasdorf was not an island populated with cannibals or English schoolboys. There was no majestic mountain to climb, no volcano to erupt and no crater to get stuck in for days. Unfit for adventure, our presence in Dasdorf was as dull as Dasdorf was flat.

When we are back in New York we will have some distance to see it more clearly, we said, and took another sip of the drip-coffee, whose acidity we knew would later change the smell of our urine to a noticeable degree. We will sit down with a really good espresso in New York and then it will be easy to figure it all out, make a plan, come back, execute it, and go on. Neubrandenburg is no place to come up with a plan. "One can't even get a decent coffee here, or a drink," we said and reminded ourselves of how a year ago we had taken the steps up to the sixteenth floor of "The Finger" where we spent an evening slurping the house special – a sweet, thick, bluish-red, banana-beige striped one liter cocktail-shake served in a flower vase with a straw.

On a tourist website the bar had been described as Neubrandenburg's "top cocktail bar." Hence, one of us wore high heels and a vintage cocktail dress with a little bit of glitter, the other wore a shiny beige shirt. But, already on the way up to the sixteenth floor of the socialist-realist steel-framed tower, when we realized that the elevator was out of service and that the first

fifteen floors of the former House of Culture and Education were either abandoned or being squatted in by teenagers and homeless people, it became clear we were heading in the opposite direction of what the website had promised. Every step toward the top got us another step deeper down, and when we finally entered the bar, we were back where we would have been if East Germany hadn't dissolved twenty years earlier. Is it impossible for this place to exist? we thought. Despite its improbability it was alive, breathing and smelling like a damp basement club where people smoke cigarettes, discuss politics, make out, spill beer and sometimes vomit on the floor, even though for the most part, tricks from the theater world had been employed to keep the illusion alive. The windows on top of the tallest building within a fifty-mile radius in the State of Western-Pomerania were covered with heavy, dark red curtains; and instead of living humans, the room was filled with porcelain, bronze, and gypsum busts of Vladimir Ilyich Lenin, Karl Marx, Friedrich Engels and Rosa Luxemburg, who mingled with olive-drab military coats from the Soviet Army and the parade uniforms of the National People's Army that casually leaned against the walls.

Grabeland

The proof of love among communist brother states hung above
a little sofa in the form of a reproduction of a 1979 photograph
taken during the 30th anniversary celebration of the foundation of
the German Democratic Republic. It showed how Erich Honecker,
the General Secretary of the Socialist Unity Party and Head of
State of the East German State Council, kissed Leonid Brezhnev,
the General Secretary of the Central Committee of the Communist
Party of the Soviet Union, on the mouth. Many had been sure it
was a French kiss.

There were five little tables and on each little table was a vase
with a red carnation in it. The carnations weren't artificial, nor
were they dried. They were real. "Amazed?" the bartender asked,
when he noticed that we had noticed.

The bartender, who was probably in his sixties and wore cut-
offs so short it made us worry for his penis, insisted that we try
his one-liter cocktail special. "Otherwise," he said, "you don't
understand the difference between my philosophy and that of the
greedy bandits from the West who have taken over every other
drinking spot in Neubrandenburg. They serve cocktails as if it was
medicine one has to portion like a nurse in a hospital, while I
serve them ritualistically like Dionysus."

"Not worth the headache you get from it the next day," said
one of the other two customers at the bar that night, not to us
but seemingly to Ernst Thälmann, the leader of the Communist
Party in Germany during much of the Weimar Republic, who was
present in the form of a black-and-white photograph. Like a flash
it came back to us that Ernst Thälmann had spent eleven years in
solitary confinement in Buchenwald before the Nazis shot him
dead on August 18, 1944. He had always been there, present wher-
ever we went, smiling the smile he had always smiled in that one
particular picture. "Ernst Thälmann is my role model, I promise
to learn, to work and fight as Ernst Thälmann teaches," one of us
had pledged with heartfelt sincerity during an official ceremony,
when we had been eight or nine or ten years old; and then after
that, every time we had put on our uniform, we stood straight up,

stiffened our right hand and placed it against our foreheads with the thumb closest and the little finger facing skywards and said "For peace and socialism be ready – always ready!" We had not thought of that pledge for twenty or thirty years, had not recalled in such a long time how proud we once were to be charged with the task of keeping up the revolutionary traditions of peace and socialism, hadn't been even aware of the fact that these words were still engraved in our brains.

Startled, we sat down at the bar next to the only other two customers and agreed to try the house special. After half an hour sipping, staring and listening to GDR pop songs from the early eighties we had slurped enough sweet liquor mix to break the Cold War silence. We cleared our throats, and then, casually like an East German border guard, asked the two men at the bar: "What do you do for a living?"

The first one said he had lost his job one month before the currency reform in July 1990, so he had never earned one West German Mark, "which ethically is the right thing to do," because the idea of "earning a living" is capitalistic and religious, and he doesn't believe in either. The second man said that in the GDR everything had been better. "At least you are hitting bottom at the top," we responded, referring to the site specificity of the situation, but that kind of art world humor was the wrong approach and the night on top of The Finger ended promptly at ten p.m. with us feeling stupid and alienated. Back at the hotel, which was right across the street, we tried to reach out to other people on the Internet, but the connection was repeatedly interrupted. We went to the lobby and talked to the night attendant, who stated that in order to prevent hotel guests from illegally downloading music or movies, he had been instructed by the manager to manually turn on and off the router in short intervals.

We went back to our room and shut down our computer, unscrewed the showerhead in the bathroom, crawled under the sink, and after an hour of trying, were able to connect the shower hose to the drainage of the sink. There were a couple of floods in

the early stages of this undertaking, but when the construction finally worked, we were thrilled. The fact that we could now turn on the water in the shower and watch how it automatically bub-bled out of the drainage hole in the sink like a magical fountain kept us entertained enough to forget about the Internet that night.

At least in Neubrandenburg connecting to the Internet is a pos-sibility, we said, looking at The Finger. In Dasdorf the Internet isn't even an option, we said. As long as Dasdorf identifies as Dasdorf it will be self-contained like a biosphere that main-tains its own interconnected network, self-assured in its own Dasdorfian dimensions. Dasdorf will always believe that every phenomenon, every creature, and every creation in Dasdorf can be explained by something within the physical circumference of Dasdorf, to Dasdorf everything that matters happens in Dasdorf; along brick walks laid in herringbone and basket weave patterns and small winding paths densely bordered with dandelion, dai-sies, speedwell, cock's foot, hound's tongue, yarrow, and smooth meadow grass. Corkscrew Hazel, Cherry Laurel, Pussy Willow, Black Elder, Silver Lime – Dasdorf exhales these names into the atmosphere with the same matter-of-fact affection as the village teacher calls out the names of children in first grade. "It's all the same, all part of the same universe called Dasdorf, such is the spell of Dasdorf," we said, and once under this spell, every human utterance or action is more or less a compliant response to Dasdorf. In Dasdorf, there is nothing, and never has been anything original, or anything special, never has anything more extraordinary happened in Dasdorf than Dasdorf itself.

It's just part of Dasdorf to love furry catkins in early spring, or to be in love with the softness of the flowers of a Pussy Willow, it's part of Dasdorf to have the meaning of one's life depend on the flowering of cherry blossoms, even though everybody obviously knows that the existing love for a plant can't excuse the missing love for another human and that being in a meadow can't make up for being among people. So what? The titmouse does not care if

we chirp. If not faced with competition, nobody shows any signs of ambition. If not surrounded by contradictions, our brains don't demand much stimulation. As a result we are as contented as slugs, sitting in the gardens in Dasdorf nibbling on berries. "There is no urge to change anything in the world while watching a butterfly getting nectar from a flower," we said. That looking at the most efficient seed packing in the universe naturally occurring in the spiral pattern in the head of a sunflower will produce as much or as little wonder as looking at the Empire State Building, the Golden Gate Bridge, and Mount Rushmore combined, is the truth that sits in Dasdorf like a toad inflating and deflating the air sac below its sad looking mouth, we said, and then gestured for the waitress to come.

To people who grew up in a place like Dasdorf, nothing that happens after the age of seven feels substantial, we said, after we had ordered a second coffee and a piece of poppy seed cake in the café in Neubrandenburg. By the age of seven they have witnessed the bloody mess that comes with the births of lambs in the spring and the bloody mess that comes with slaughtering the sheep in October or November, they have seen what happens when a deaf neighbor castrates a bunch of rabbits with a razor blade that he sterilizes in the flame of a candle between each cut, and they know that the consequence of mass castration is a glass jar full of tiny rabbit testicles that get thrown on the compost for the birds to have as a little treat.

By the age of seven the children of Dasdorf have pulled the skin over dead goats that hang upside down from an apple tree and they have stayed awake at night to think about the day they will hang themselves upside down from the oak tree in the driveway to their house, reach up, cut around their ankles and pull down their own skin, in order to see if it will separate itself from the flesh as bloodlessly as it does in the case of the goats.

By the age of seven the children of Dasdorf have had ample opportunity to act upon most of the primal instincts that are ingrained in their little bodies, one of them being the urge to provide milk for a litter of eight naked and blind orphaned rabbits, helplessly squirming in a nest. Their mother had blown up from inner gas, when she – after four months on a winter diet of hay – couldn't properly digest the quantities of fresh dandelion leaves the children of Dasdorf had eagerly stuffed into her tiny cage on the very first warm and sunny day of spring. Yet, life went on. As soon as the dead mother rabbit was discovered and discarded, the children of Dasdorf took to winding and setting their mechanical alarm clocks four times a day, in order to remind their brains what that big, wild thing in their chests urged them to do. They got up at midnight, and again at six am, then at two pm, and eight pm to feed the orphaned litter. And after a month of squeezing lukewarm milk through the plastic parts of syringes into the sucking mouths of rabbit babies, and having felt the fragile creatures gaining weight and becoming bigger and stronger in their hands, and growing fur and frontal teeth and opening their eyes, and starting to jump, and play with each other, one morning at six a.m. when the children walk out into the yard in their dotted pajamas, they find all eight of them strewn over the yard, dead, mutilated and ripped apart. The children of Dasdorf know that if they beat their dog for what he has done, their dog would bite, so instead they trample down the now obsolete basket in which they were to carry the rabbits from the cage into the kitchen. That's nature, the adults say a few minutes later, standing in the yard yawning in their striped pajamas, saddened, to the children's horror, in equal parts

by the sight of the dead rabbits and the destroyed basket, which an aunt had bought for them at a market in Hungary, before they make the children of Dasdorf pick up the rabbit parts, dig a hole, bury them, and take the dog for a walk. By the age of seven the children of Dasdorf know that death is a normal thing, that plain old death is a condition of life, but they also have realized that the normalcy of all of this is sometimes unreliable, especially when it presents itself in unpredictable displays, like that of the macerated body of Mrs. Wehrmann, as she lay motionless and dripping on the marble counter of the butcher's shop after the butcher fished her out of the water on a Sunday morning, which left the children wondering if it was appropriate that already on Monday, only one day later, the butcher stood behind that same counter and used the white marble surface to cut a slice of salami for the children to taste.

By the age of seven it's clear to the children of Dasdorf that the main priority in life is surviving. Motivated by this ever-present urgency, they take cold showers, swallow a spoonful of cod liver oil, and do push-ups every morning. By the age of seven the children of Dasdorf despise the idea of playing, especially the idea of playing with stuffed animals. The children of Dasdorf deal only with real things. There is no pretending. For them the furs of teddy bears and toy giraffes are as artificial as the smiles and gestures of people who live in cities.

By the age of seven the children of Dasdorf have half-way attempted murdering an older cousin using a hammer as their weapon of choice, and they have received an appropriate punishment for that. They know the uncontrollable rage that comes with being the victim of abuse and moral injustice and they know the desperate desire to disappear from the surface of the earth that comes with deep remorse and unbearable regret. The children of Dasdorf have fallen down from a tree and twisted an ankle. They had a rib crushed by a ram and they have crashed through the ice on the shores of a frozen pond. They have strong arms and legs, crooked teeth, and a sense of what it means to fight for one's life, but they also know how they would kill themselves if there were

a need to. They have a plan with pills from their grandmother's medicine cabinet, and a backup plan with a rope that they store in the barn, because they know from their relatives that suicide attempts with pills tend to fail more often than those with ropes.

By the age of seven the children of Dasdorf have never been in an elevator, a ten-story building, a museum, a concert hall, a zoo, a subway, an indoor swimming pool or a playground, but they have one day woken up in a bed on wheels, right next to a closed glass cage in which a premature infant is artificially kept alive by tubes and a red heating lamp that burns through the night. They have responded to the situation by unscrewing the bulb in the reading lamp above their bed and administering themselves electric shocks in regular intervals. They have refused to look at the three cuts in their belly crudely held together with bulky metal clamps, refused to talk, to cry, to weep in a private manner, but officially shown their cooperation with the nurses in charge by compliantly peeing and shitting into a cold metal pan that is pushed underneath their butts three times a day. By the age of seven the children of Dasdorf have already committed to the love of their lives. It's Dasdorf. They love everything about it, every pebble, every smell, every animal, every piece of bark, every crumb of soil. They will never leave this place, they swear, never leave the Weeping Willow, they promise, never cheat on their village by looking at anything else with as much admiration, wonder and thankfulness in their hearts. That Dasdorf can't return the love directly, that the bushes and the grasses and the trees can't do anything else about this love but wave their leaves in the wind, and open their flowers in the spring, that the pond can't speak in any other way to them but by glittering in the sun and sending magical ripples their way, and that the soft, warm wind is unable to whisper the words they so desperately want to hear, is just part of the deal. By the age of seven the children of Dasdorf know that the love that lasts the longest is the one never returned.

By the age of seven the children of Dasdorf have built an igloo big enough to sit inside, on benches covered with sheepskins, and

they have made a fire inside that igloo and roasted potatoes in its ashes, potatoes they have grown and harvested themselves. The sense of accomplishment and joy they have felt about all this, and the sense of confidence they've gained from having provided their own food, and warmth and shelter, having melted their own water for tea above the fire in a small metal bucket, singing songs while doing it, will never be matched again in their lives.

By the age of seven the children of Dasdorf know how to sharpen a knife and peel potatoes, and they have completed the task of drying enough hay to get their animals through the winter. They have shoveled a season's ration of brown coal through a small hole in the basement of their house and felt the calming effect of counting the jars of canned fruits and vegetables stored in the shelves in the cellars. They have brought home buckets of wild blueberries, and rosehips, elderberries, blackberries, and raspberries, and have helped stir them into jams and potent infusions, or dry them for teas. They have collected baskets full of mushrooms that they have identified, cleaned, cut into thin slices, and then laid out on sheets of newspaper to dry and they have been complimented several times by the adults on those accomplishments. Yet, by the age of seven the children of Dasdorf are aware of the fact that they could kill their entire family by accidently or purposely drying a poisonous mushroom, and the possibility frightens and fascinates them every Sunday, when they stare at the cooked parts of sheep or rabbits that lie in a thick, brown mushroom infused sauce on their plates.

By the age of seven the children know how it looks when an animal is in labor and they know how to react when something is not right in the mother's pushing pattern. They know where the veterinarian lives, and they have a way of persuading him to come to the sheep's pen, where they fall on their knees in the straw in order to make him deliver the lamb and save the mother instead of killing them both on the spot, as the veterinarian proposes to do. Early on, the children of Dasdorf sense that there is a price to be paid when humans intervene to save a life that otherwise would

have ended, and they have been given time to reflect on that more deeply while they hold the head of the mother sheep as the veterinarian is inserting a pair of long, metal pliers into her vagina in order to grab the lamb's head. By the age of seven the children of Dasdorf have felt the apathetic heaviness of being stared at by a sheep who has let her baby's head grow much too big to make a natural passage out into the world, and they have internalized the sheep's sour-smelling breath, that comes out her snout the moment her baby's face is being crushed inside her womb. They know what it means to be doing the wrong thing with the right intentions, when the veterinarian makes a second attempt to grab the lamb's head with the pliers therewith ripping apart its lips, rendering it unable to take in milk, and therefore unable to live. By the age of seven the children of Dasdorf have clearly felt what it is like when damage is done beyond repair. They have felt the desperation of not knowing what to do about it. They press their body onto the body of the sheep. They attempt to synchronize the beating of their heart with that of the animal. They insist on going on. "Cut her open!" they say with determination, because by the age of seven the children of Dasdorf are used to acting like adults, who are mostly not around. The veterinarian curses, but complies. He cuts open the mother sheep, takes the damaged lamb out, cuts the umbilical cord, throws the lamb on the straw, and then orders the children to push back the intestines of the mother that are spilling out of her open body, so he can stitch her up. And the children, with the little hands of seven year olds, form a leaky bowl as they try to handle the unruly amounts of flabby intestines, while the veterinarian keeps cursing and sewing the skin of the sheep's stomach back together again. And then, suddenly, he realizes that he has sewn the hand of the children into the stomach. "Pull out," he says, but it is too late.

For a moment the world stops to leave a very deep impression. The veterinarian bends down, puts his hand on the childrens shoulder and whispers into the childrens ears: "Do. Not. Move." Then he walks out of the sheep's pen. The mother sheep closes

82

her eyes. The children stop breathing. They feel the comfort of justice having to leave this earth together with the animals whose death they have inflicted. But the lamb is not ready to die. With its bloody face half-ripped apart it makes a sound and tries to get up, tries to walk, tries to find his mother's teat and nurse, tries against all odds to survive. Again, life goes on. The mother sheep opens her eyes and the child, with his hands stuck inside the still functioning body of the sheep, resumes breathing and starts concentrating on the smell of the cigarette the veterinarian is smoking outside. The veterinarian smells like cold smoke and schnapps when he returns to the sheep's pen. He cuts open the stitches and the children pull their hand out of the warm body of the sheep. They hold the skin of the sheep's belly tight, as the veterinarian stitches again and closes the belly. The veterinarian offers the children a sip from the little flat bottle of emergency medicine in his pocket. The children take a big gulp and immediately feel like throwing up. They lie down next to the lamb and watch it die. A few hours later a neighbor comes and takes the dead lamb home, so his wife can marinate it in a mixture of honey and garlic to be flavorful for lunch on Sunday, and after the mother sheep has, over the next couple of days, kept separating herself from the herd, until she dies alone in a corner of the pen, the children of Dasdorf have been taught another set of practical life lessons: Never get pregnant by someone two heads taller than yourself. Never give birth after your due date. Hence, by the age of seven the children of Dasdorf have acquired some wisdom. The baseline of their judgment is always a herd of sheep. They know that humans have moments when they act smarter than sheep, and moments when they act dumber than sheep. Otherwise, they act exactly like sheep, especially when they are in a group.

By the age of seven the children of Dasdorf have been exposed to all kinds and consistencies of body fluids, fur and flesh, but they have only once been in proximity to another color of human skin, when as a result of East Germany's Treaty with Mozambique, one of the poorest countries of the world at the time, a male agricultural

student was sent to their village for vocational training in the mono-
cultured fields, and then put on a chair in their daycare, so the chil-
dren could meet him. The children of Dasdorf, unfamiliar with any
other method of meeting the unknown, other than first observing
from a distance, then very slowly getting closer, either crawling or
bending over until it is safe enough to stand up, extend a hand and
touch, and feel, smell, pull and push and squeeze, and lick and taste,
do just that. They observe him from a distance and then they get
closer and then they touch him, and then they squeeze his skin and
then they tickle his belly and make him stick out his tongue and pull
on his curly hair in amazement, while their teacher Mrs. Hofmann
fumbles awkwardly around with the curtain on the window. The
man, who does not speak their language, smiles and makes funny
sounds, and a week later he returns with fifteen happy comrades
in a bus. During an official "Welcome to Dasdorf" ceremony, the
exchange students from Mozambique are handed one bunch of red
carnations each, and then they are left to their own devices, while
– for the first time in their lives – the children of Dasdorf are put
under supervision outside of school. They don't understand. Eager
for adventures they keep demanding to be allowed to play with the
new people, who stay in old trailers on the edges of the fields fur-
thest away from the village, but their requests are denied without
logical explanation. Angry, the children start blaming the people
from Mozambique for the lost independence to roam around their
village, until eventually the village's shepherd is put in charge to
practically illustrate a general rule that is impossible for the adults
in the village to explain in words.

Mr. Schneider is a respected man, the only one ever to be
called virtuous. It is a tremendous honor to be taught a lesson by
the shepherd, and the children of Dasdorf are in a dignified and
expectant mood when they sit in the horse carriage that brings
them to the meadow where the shepherd keeps one of his herds
in a temporary enclosure. Mr. Schneider, who always smokes a
pipe, unties the legs of the two baaing white sheep, who have
come with the children in the horse-drawn carriage, and inserts

those into the herd of about forty black sheep. Then he asks the children to observe, over the course of a week, what will happen. The children follow orders, they return to the meadow and witness how the black sheep work together to keep the white sheep separated from the herd, and away from the bucket of water, and the bowl of pellets and the salt ring that hangs from the fence. After a week the white sheep look very exhausted and sick. The shepherd returns and talks about nature's reasons for apples and oranges. One isn't more important than the other, Mr. Schneider says, before he turns the two white sheep's fur black with shoe polish from a metal can. Within a few hours the black, formerly white sheep are part of the herd, they get food, water, and rest. After a week they look healthy and happy and the synapses in the children's brain are snapping together to form yet another Dasdorfian path.

By the age of seven the children of Dasdorf have had their pants pulled down for bare ass spankings often enough to be informed about the fact that knowing certain things can be a burden, and saying them out loud can be a problem, but they also have learned that an ass spanking is just an ass spanking and not the end of the world. By the age of seven the children of Dasdorf are strong, resistant, cocky little bastards who occasionally want to die, but when they get close to acting upon the idea, someone cooks a delicious smelling meal, which makes them change their minds. They diverge from dying, and keep discovering that things are often different from what they appear to be. They practice the headstand and the handstand and they keep reassuring themselves that the pictures the world is made of enter their brains upside down, by spending more time meticulously dissecting the eyes and brains of slaughtered pigs and sheep on a piece of broken window that they keep in the tool shed for that purpose, then combing their own hair and cleaning their fingernails.

In a place like Dasdorf every possible damage is done by the age of seven, we say, before we finish the last bite of poppy seed cake in the café in Neubrandenburg, and from then on the children don't need protection. Life is naked and raw and they are free to

heal themselves with whatever cure suits them best. They leave their bunk beds early in the morning with their brothers and sisters and inbred cousins and inbred great cousins to feed the inbred animals and then they sit in the hay and smell the dried flowers, play with the cats and examine each other's genitals. On the weekends they smoke homemade cigarettes in a moist cave in the forest and during the week they hold hands, sing moody songs about imprisoned people shoveling their own graves in minor keys and dance around a pole in the daycare, where common sense is replaced by Mrs. Hofmann's personal rules and Auntie Erna's legendary pot in which she cooks vanilla pudding every day. And when the daycare is done in the afternoon, the children run home, sometimes alone, sometimes together, sometimes directly, sometimes on detours. On certain days they wade through a little stream and hide underneath the River Valley bridge until an imaginary enemy is out of sight, but most likely the way leads from the kindergarten across the muddy road, up a few old stone steps through a squeaking iron gate into the cemetery, where the dead people live, including the children's relatives who are supposedly there crying and moaning, because they have killed themselves. The children want to hear what their tortured relatives have to say, so they put their ears as close as they can to the engravings of their names, until one day Eugen Bauer's gravestone falls onto Torsten Bachmann and smashes his head. With the innocent strength of children too young to predict the consequences of their efforts, the children of Dasdorf lift Eugen Bauer's gravestone and discover that Torsten Bachmann's head is horribly disfigured, which frightens them so much they let the gravestone drop down on Torsten Bachmann's head a second time and run away.

From then on it is written in blood, shame and smashed brain that the cemetery is a forbidden ground, and that the rule to not disturb the dead is one that should never, ever be broken again. It is clearly understood that the route home through the cemetery is the "absolutely forbidden route," the one that only the bravest attempt when they need to prove their worth, the rest follow the orders of

the adults and run home along the tall stone walls outside the cemetery through the birch forest.

By the age of seven the minds and bodies of the children of Dasdorf are severely addicted to the sensation of being scared to death, and if a life-threatening situation does not present itself at regular intervals, they will have to invent it. They look at a branch of a tree and see a gibbet on which another villager will eventually hang himself. And if not another poor villager, like Tall Thomas on his 16th birthday, then it will be naked strangers with whom the children share the biggest secret of all secrets in Dasdorf, which is that the birch forest in Dasdorf is actually not a birch forest, but a massive killing ground from World War II.

Out of the birch forest the path leads through a meadow, and from the meadow up a little knoll. On top of the little knoll stands the mother of all trees in Dasdorf, the Big Old Weeping Willow and next to her is a wooden bench into which the children of Dasdorf have carved a heart, pierced by an arrow. If one climbs on the bench one can see almost every house in the village, and once every five years when a visitor comes to Dasdorf and is led to the Big Old Weeping Willow, the bench is used in that capacity. Otherwise the bench is more like a monument, there to remind the children of Dasdorf that eventually there will be a visitor again who will use the bench as an observation deck to confirm the existence of Dasdorf.

After the little knoll the path narrows, and is paved with cobblestones. It passes by the cinderblock backside of Blunt Hugo's horse stables and the tiny cottage of Mrs. Stein, directly into the garden of Auntie Lotte, whose parcel connects to the backyards of the children's houses. The children have been running for almost twenty minutes and have seen two hundred naked dead people from World War II hanging from trees, and when they enter the garden they are out of breath, and very relieved to be in such close proximity to the safety of their homes, but also somewhat disappointed that they have not been stopped by the mysterious stranger in the red car, who supposedly comes from a city, the one who has pulled down his pants and peed into Nicole Maier's and Manuela Wehrmann's

faces, which has brought those girls an unreasonable amount of attention and concern from every single adult in the village – just for being peed in the face.

Auntie Lotte, as usual, sits on a bench behind her toolshed, dressed like a rural woman from the sixteenth century, and watches the stork's nest on the pole in the distance. "Sit down," she says and pats the weathered wood of the bench next to her. The children sit down. Close enough to show their compassion, loyalty, and eagerness to hear her story, but also far enough away from Auntie Lotte so they can deal with her intense, old-woman smell which keeps evaporating from layers of skirts, petticoats, and aprons, each one from another decade of her life.

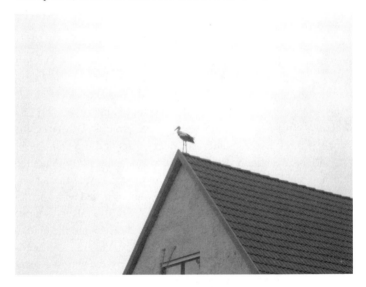

Auntie Lotte starts her routine with the weather forecast for the next day, followed by a moment of silence, and then the story begins. Every day it's the same story, and every day it turns out to be a little different, because every day there is another, sometimes conflicting detail of how the dead have died. Auntie Lotte has lost all her children in the last year of the war, they were

in Saxony while she stayed in Dasdorf, her three sons and her beloved daughter Hannelore, whom she calls "My Löhrchen," as well as her husband Ernst. Her family members were shot in the head, shot in the back, shot in the stomach and pushed into a ditch, done by soldiers from the front and from the back and then left bleeding to death. Each of their deaths, none of which she was able to witness firsthand, haunts Auntie Lotte in the form of excruciating details that are actually unknown to her, but which she has to invent and share every day anew with another human soul in order to maintain the degree of sanity that's left in her. "But the fools survive. I survived, and so will you," Auntie Lotte usually says at the end. "As long as you stay close to where the Greater Plantain grows, you will be fine. The Greater Plantain has the power to heal all wounds. Pick me a leaf from over there, before you go, and put it on my forehead, so it will soften my pain."

And every day the children of Dasdorf pick a leaf from the Greater Plantain. And while they press the leaf against the wrinkled forehead of Auntie Lotte, who has closed her eyes, the children pray that the Greater Plantain will do what it is supposed to do and will help to provide some relief to poor old Auntie Lotte. And once the children feel they have done what is in their power, the children run home through the apple orchard, as fast as they can, away from the fascinations of Auntie Lotte's horrors that fill them with guilt. And hours later, when their mothers get home, the children will be asked what they ate for lunch and if they fed the rabbits, and if they brought fresh water to the sheep, and if they bought the milk, and if the dog was fed and the hay raked into big heaps for the night, and if the sweater was warm enough and by the time the children have answered all the questions their time is up and the children need to go to bed, where they stay awake for hours, thinking about the horrible ways Auntie Lotte's children were murdered by the soldiers of the Red Army, who, as the children keep assuring themselves during the parades on May 1st and May 8th, are actually the children's friends and protectors

against the big evils of the world. By the age of seven the children know that good and evil are always in close proximity, and when twice a year the soldiers of the Red Army roll in their T 34 tanks and tankettes, their jeeps and their trucks and artillery tractors, transporters, motorcycles and buses through Dasdorf in a caravan that lasts sometimes more than an hour from beginning to end, the children of Dasdorf don't just stand silently on the sidewalk. They watch carefully and count, as the vehicles pass by and they assign alternating roles to the Russian soldiers in their green steel helmets – he would kill us, he would protect us, he would shoot us, he would defend us, he would choke us, he would stand up for us, he would rob us, he would save us – so it goes, until the caravan has passed and the children have proven to themselves in numbers that there are more good soldiers than bad ones and that they generally can count on the soldiers of the red Army as their friends and protectors.

The mothers of the children of Dasdorf don't know for certain why their children can't sleep at night and why they sometimes cry longer and louder than they should when they get hurt, but like all mothers, the mothers of Dasdorf too have intuition. And it's probably this intuition that prompts them to run out into the garden and find the leaf of the Greater Plantain when their children – after they have accidently scraped their knees or cut their fingers – scream like wild boars and demand that a leaf of the Greater Plantain has to be put on their wounds instead of a band-aid, otherwise they will die from their never healing wounds.

That is the scary discovery, we say, staring at the remains of the poppy seed cake in front of us. We have not evolved at all. Not a bit. The magic power of the Greater Plantain works upon us in the same mystical way it did when we were seven years old. We are basic, helpless creatures, and the moment we see a Greater Plantain, every rational thought is erased and years of formal education are annihilated. We think we are sophisticated, we go to a museum and look at "The Great Piece of Turf"

by Albrecht Dürer and what happens? When we spot the Great Plantain in the turf, we are powerless to stop the tears running down our cheeks like waterfalls.

What a lazy brood. More than once I had it up to here with these fake Americans. It made me sick watching them from the dormer window. They were as flabby as blooming asparagus. They made me crazy. As soon as the shoots come out of the dirt asparagus needs to be cut. No pain, no gain. No cultivation without trimming. Obviously, no one had ever cut them down, so when they came to Dasdorf they were in full bloom. Useless, indigestible weeds, ready to spread their seeds. I saw it all coming when the wind picked up. They flew from New York City to Dasdorf, and fixed the fence with a string. "Here comes the world's police patrolling Village Road again, taking notes about where we need improvement!" Brauner's Inge said every time they walked down Village Road in their city shoes. But do they

really believe the fence is not fixed because we
could not get any help, or any string for fixing
that fence? Do they really think we need assis-
tance from the United States of America to pull
out the weeds between our raspberry bushes? I
hate these people for making us look like that.
It's not the fence that needs pulling together.
It's the Americans themselves. They are broken
into pieces, have shattered and scattered their
lives all around the world. They don't know who
they are, they don't know where they belong, they
don't know what to do. All they know is how to
take over like weeds.

During the summer of 2007 we spent more time in
Neubrandenburg than in Dasdorf. In the mornings we would
drive from our rented rooms to Dasdorf, park the car in front of
the gardens, get out, assess the property from a landlord's point
of view, and then we would drive back to Neubrandenburg to
buy another tool, drink coffee, eat cake, and tell each other tales
from the past. We usually only returned late in the afternoons to
do the work. Not to do the work, necessarily. Even to us it was
obvious that we only chopped down the weeds that had over-
grown large parts of the gardens, because planning to get rid of
the weeds in the late afternoon had provided us with a reason
in the morning to drive to Neubrandenburg to buy a scythe and
rubber boots. We fastened the two loose boards in the shack an
hour before the sun went down because it had allowed us to
drive to Neubrandenburg to buy a hammer and nails three hours
after the sun came up that day. We only spent an afternoon pull-
ing the fence together because it had taken half a day to drive to
Neubrandenburg to buy the string to do so. The moment we got
there, we wanted to leave; knowing that we would be able to find
a reason to drive away was the main motivation for returning to
Dasdorf in the first place. Nevertheless, things added up.

We got a shovel and filled the holes left by some unknown person who dug up some perennials and bushes. We bought some shears and pruned the apple trees. We got an iron rod, hammered it into the ground and tied the rosebush to it so its branches would not lie on the ground. We bought gloves and pulled out the weeds between the raspberry bushes and the peonies. We collected seed capsules from the poppies, broke them open, and spread the black seeds all over the property in order to increase biodiversity.

None of our improvements ever prompted a comment from anybody or worked as a conversation starter, though. After our very first conversations with Mr. Fuchs, Mr. Kirsche, and the Richters upon our arrival, nobody ever talked to us again. When he came to his garden and we waved a "Hello," Mr. Kirsche raised his hand a few inches and then turned around. The moment we attempted to take a picture of Mr. Fuchs as he was sprinkling his seedlings with water, the watering can was empty and he left. In the evenings, when we walked down Village Road, ready to show

the blisters on our unseasoned skin, the village was deserted. It was not only as if the things we did were invisible, but as if we were as well. And yet we knew that the villagers, including our tenants, were watching us vigilantly: from behind their curtains, from their dormer windows, from behind the garages, from behind the compost heaps, from behind their wheelbarrows, through the fence, through the bushes, through the hedges, through the rhubarb leaves. We felt it on our backs, our necks, our spine. It made our shoulder blades stick out like wings.

We had never walked down a road as awkwardly and insecurely as we walked down Village Road; only because we knew that from the distance at which they watched us, the main criteria for their judgment would be the way we walked.

It was like being in a movie when one late afternoon a few children on bikes obviously fled upon seeing us coming down Village Road, then showed up again, in order to flee a second time, even more dramatically, because obviously it was so exciting to be horrified by our presence.

"If we can't come to them, they have to come to us," we said to each other, after the incidents with the children. We'll wait until they are ready, we said, stopped walking through the village, and confined ourselves to the abandoned parts of the gardens, where we modeled our roaming around upon that of the Tibetan snow leopard in Central Park Zoo, who is often hard to spot from behind the fence, which as we had noticed during several visits to that zoo, made him more appealing to visitors than the depressed polar bear named Gus, who always sat in plain view on his rock, until one day he had enough of it and died. Our strategy worked for a day. Instead of running away, the children came close and peeked through the fence to see if we were still there. And then they started throwing stones at us.

"Call the police!" the Mother yelled. He was lying in the grass, wearing that blue tube on his head, spitting water through the slit. She had been filming how the water came out of the slit like a fountain, but when there was nothing coming out anymore she disappeared into the shack, and then she came out again and went to the car and sat inside, while he was just lying there. Still like a log.

We climbed up an apple tree, thinking we would get an over-view. We found an entrance to some sort of underground drainage system in the wheat field neighboring the gardens, climbed into the chute and pushed open the metal lid on top from the inside, crouched in, waited, and hoped our disappearance would lead to something. We turned ourselves into a fountain. "To rejuvenate the gardens," we said. We took a sip of water, put a plastic tube with a mouth-hole over our head, lay down in the grass and spit the water through the hole. We thought if we repeated the procedure often enough, something would happen. But nothing happened. We brought our suitcases with us to the gardens and used our clothes to make scarecrows. The scarecrows waved in the wind. We waited for a day or two. We took the scarecrows down and built ourselves skirts and hats and shirts out of grass. We put the grass clothes on and hid in the grass. We were thinking of camou-flage, blending in, becoming grass. We ripped more grass, dumped it all on a big pile and jumped up and down on it.

That's when Mr. Kirsche made his way through the bushes and asked for the scythe. "You need to cut the grass around here, let me sharpen the scythe," he said. We handed him the scythe and he

honed it with a stone and some water, mentioning several times
what a waste of time it was to hone a cheap scythe like this.

Strangers like strangers. Erwin and the fake
Americans fit together like the ass on the piss
pot. It's a simple reckoning and I don't mean it
in a bad way, but what am I supposed to say when
Kirsche tells me that Erwin wants to get buried
in Tilsit, not in Dasdorf. Tilsit is two thou-
sand miles away. Almost as far as America. How
does he think his corpse is going to get there?
Tilsit is not even called Tilsit anymore but has
some Russian name now. After sixty-five years in
Dasdorf, he still can't bear the thought of being
buried in Dasdorf, wants to return to these hor-
rible people who killed his sisters and chased
his family out in the first place.

After Mr. Kirsche's visit we stopped everything. We stopped driv-
ing to Neubrandenburg, we stopped drinking coffee, we stopped
lamenting, eating, moving. We simply stayed in the gardens from

morning until dusk. In front of Mrs. Kirchheimer's old shed we sat inert like a stone, and waited. Things were out of our hands. Mr. Kirsche had come and asked for the scythe. He had said that he needed to sharpen it, so we knew that the time was near. This was our very last chance, the Grim Reaper was about to take action. Yet, we did not even lift a finger. We arrived at the gardens in the early mornings, sat down on the cinderblock in front of the shed and stayed until it got dark. Three hundred miles south of Dasdorf our mother was dying. These were her last days on this earth in a human body, and for whatever reason, we had decided to spend those days in Dasdorf, where we numbed our senses by watching the grass grow, the sky being blue. While the sharpened scythe was hanging from a branch dangling in the wind, we poured ourselves into looking at the rusty red of a dead peacock butterfly and its black, blue, and yellow eyespots.

Before we came to Dasdorf a doctor had asked us if it was okay if the nurse increased the doses of morphine until our mother's heart would be unable to handle the load.

"You want to speed up her death? Why don't you ask my mom?" we said.

"I asked her," the doctor said. "She said, I should ask you."

"We can't answer that question. Ask our father," we said.

"He said he doesn't know," the doctor answered.

We went into her bedroom. Her eyes were closed and she breathed evenly. Her bald head was puffy. We put our head as lightly as we could onto her chest from which her breasts had been cut off, closed our eyes and smelled how she smelled. Then we opened our eyes. Her hand was clenching a handkerchief. We lifted our head, carefully opened her fingers and pulled it out. It smelled like her. She opened her eyes and we hid the handkerchief behind our backs.

"Mom," we said. "We have to go to that piece of land we bought in Mecklenburg-Western-Pomerania. Look after these gardens, repair some stuff, you know. It might take a while. Is it okay if we leave?"

"Yes," she said. "Go. Do your thing."

And so we went and sat there. Sometimes the temperature changed suddenly without even a draft, as if the change was internal, as if we had become part of this green construct upon which photosynthesis acted in miraculous ways. There was an ossified rosebush and that thing that we thought was an egg from an ostrich. For a couple of days we didn't care to break it open, until eventually we did, and it turned out to be a mummified squash.

We watched a snail eat a gooseberry. We watched a caterpillar eat a leaf off a rhubarb plant, watched how the little green sausage moved forward bite by bite and stuffed the monstrosity into itself – it was an impossible process. Nevertheless we saw it happen and we let it happen to us. We became part of it. We sat there like stones, and then like cuttings trying to grow roots, until we realized that nature did not judge. She just went on, and on, and on without taking notice of our hopes, our wishes, our shame, helplessness and guilt. Eventually, we got up from the cinderblock and looked

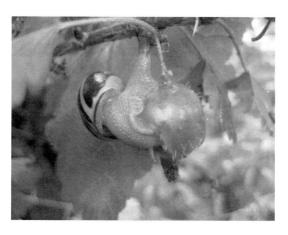

around. The branches of Mrs. Kirsche's cherry tree moved in the wind. Mrs. Kirsche was cutting rhubarb leaves. Mr. Study was carving a path through the grass with a lawnmower. Mrs. Study was dragging a branch of a tree onto a heap. We became aware of

other humans again, noticed how every day our tenants showed up to defend civilization, how they took their shovels, buckets, rakes, and watering cans from their hooks and used them to support the cultivated plants they had singled out. Every plant that was considered a weed was pulled as soon as it had germinated and every task was executed with the experience of a lifetime and the devotion of worker bees serving their queen. No questions asked. There was a reason for the shape of every tool, a duration for every routine, a moon phase for every crop cycle, a method for digging a hole, a chain of causation that explained why the soil needed to be pushed up in little heaps around the potato plants the way they did it. A sense of triumph blew across the fence when Mr. Fuchs pulled out a bunch of long, orange carrots. We stepped closer and looked at them. "Smell them," he said, and we smelled their greens and their body and the dirt and it was the first smell we had smelled after the handkerchief. He pulled another one and chipped off the dirt with his pocketknife. "Eat it," he said.

We chewed the carrot slowly. It was earthy and sweet and nothing could have been more appropriate in this world at that moment than eating that carrot. Everything was in its right place, our lives made some sense again, the carrot possessed all the knowledge and all the well-being there was to have. Our brains were in awe, our bodies marveled in wonder how it had all come together, how the carrot had grown out of a little seed in that soil and how we ended up being there at the right time to eat it.

The Inconsistency of Always the Same

Mr. Fuchs farted. It was a long, loud fart. The squeezing of his lips made it clear, that it was not an accident. "Onions," he said matter of factly, "I ate raw onions this morning." This deliberate release of foul smelling gas worked like a switch. It released a toxic voltage that shocked the most sensitive and fragile part of our bodies, which was at this point, every part of our bodies. We didn't have the capacity to deal with him farting like that. Without another word, we turned around, walked away and disappeared behind the shed. We sat down on the cinder block. With a sense of panic we suddenly realized, how the so called well-being of the universe and Mother Nature's ways of doing things were trespassed upon and vandalized by everything these villagers did and had done all their lives: the way they bent over to hoe, their reddish faces always focused on the ground; their aversion to every plant that couldn't be cooked, baked, dried, canned, or mashed and then shoved down a human digestive tract; their arrangements with the weather; their methods of wiping out unwanted pests; the fact that they spent hours cutting slugs in half with scissors and then talked about how to further increase the efficiency of that very ecological killing method during dinner time, their interactions with each other over the fence, each one accusing the other without pause while the accused nodded mechanically without listening; their refusal to even attempt to recognize that there might be other lives behind their fenced-in garden parcels, that there might be a worthwhile world beyond the outskirts of their village; the blunt examples the men employed in order to prove that women were a different species, while in fact it looked as if there was no difference between the men and women of Dasdorf anymore, as by now they all had evolved into the same body-type. They all employed the same way of walking, and talking, wore the same pants, shoes, and jackets they had all bought in the same store with the same retirement funds and coupons. Their plumpness, the frequency and the ridiculous inappropriateness of their disgusting, sexual jokes, that they appreciated having a cow for the exact same reason they appreciated having a daughter, that

101

the husbands called their wives "mother," and that the wives called their husbands "father" on top of the disturbing fact that everyone was related to everyone else, in addition to the impeccable accuracy of their vegetable rows and the indestructible stoicism with which they pushed their seeds into the ground, their stubbornness and the abundance of their practical knowledge and their harvests, that they glorified and annihilated every crumb of soil with the same stroke of their rusty, rural rakes; their lengthy weather predictions that always sounded like warnings and bad omens, and would always be conveyed with an upright, agitated index finger and then simply shrugged off when they turned out to be wrong, this specifically German way of doing it, of doing everything so deeply invested and emotionally detached at the same time, and finally, the fact that these kind of people kept living on, while our mother was dying just three hundred miles south of here, made it finally unbearable for us to stay. We got up and rushed south, just in time to hold our mother's hands while she took her last breaths.

Open Source

On July 19, 2008, out of the blue, without any warning, they delivered a letter. I marked that day in our kitchen calendar to keep track of their actions. To have a record, at least. They walked from parcel to parcel and tied the letters on the fence with a string, each one wrapped in clear plastic. That, I liked; one never knows when it's going to rain these days. The Mother watched as they did it from behind the dormer window. "They've hung something on our fence," she shouted. "Go get it!"

I let her keep shouting from upstairs and waited for Erwin to come check on his cat.

They had tied his letter to the door of his shack. He took it, put it in his pocket, and went home with it. Half an hour later Brauner's Inge called and said that Fuchs had told her that on

Thursday he and the Americans would have coffee and cake. That's when Fuchs is first in line. Fuchs the fast fart. Fuchs the smart dart. That's when he suddenly had time to do something other than spray weed-killing poison.

The invitation said: "Come for coffee and cake and bring your own chair." They know that you catch more flies with honey. But not with us! We don't play these games. We are honest people, who don't immediately start running because someone offers us a pittance. We stayed home, the mother and me, when these patronizing Americans did their coffee and cake thing. We don't sit at the same table with the liar Fuchs, who spreads rumors like weed killer, just because these strangers show up and pull out a floppy coffee table. The Richters didn't come either, obviously.

We had written the invitations by hand and wrapped them in clear plastic wrap and then we had written a speech for the coffee-and-cake party and had rehearsed it several times in the overgrown part of the gardens. We had also dressed up for the occasion – in a beige suit with brown Western boots and a Stetson hat, and in a synthetic yellow shirt with a scarf, dark blue shorts, and black rubber boots.

Like clockwork. We had a perfect view from the dormer window. At three o'clock they all sat down. Kirsches, the Sister, Fuchs, and the Boss. Miss America stood at the end of the table in a yellow uniform with a paper in her hand and explained something to them. "They are going to raise the rent," the Mother said. "I told you, these penny pinchers are full of American greed. They can't think of anything but money."

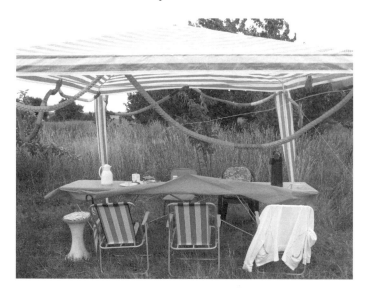

Our guests sat around a piece of particleboard we had covered
with a red paper tablecloth. "Thank you for making time to join
us for our coffee-and-cake party," we said, with a trembling
voice, trying to concentrate our weight on the left foot, as if
we were giving a speech on the downward-sloping ramp of the
Guggenheim Museum on Fifth Avenue in Manhattan. "To us this
place and this occasion are very special, and we feel lucky that it
is not raining yet. We believe that the gardens have great poten-
tial for the future and we are committed to making this potential
accessible so we can share it among all of us. We've started by
taking seriously the complaints that some of you have voiced.
We have repaired the fence, pulled out most of the weeds on the
abandoned parcels, and filled two bags with trash. But, as you
have probably noticed while you were watching us from behind
your curtains, we have not yet tackled the main problem. Water!
You've told us that it's hard to garden without access to water,
that you are tired of carrying watering cans from your kitchen
sink or the pond to your garden beds. Mr. Kirsche explained to

us last year: "A garden without water is like a house without a roof!" We will change that. We brought eight sets of divining rods from America. We made them ourselves from the metal hangers people put their clothes on in America." We paused. "Since nobody knows this place as well as you do, we hope you will point us in the right direction and we can go divining together, find a source of water, dig a well, and open up a fountain of youth, so to speak, that will bring new life to the gardens and rejuvenate our spirits."

Here Mr. Kirsche interrupted, saying that he wouldn't dig deeper than six feet, that all he needed to rejuvenate himself was six feet. Everybody laughed. And then Mr. Fuchs asked if we would increase the rent. We said: "No." The Kirsches and the Sister started clapping their hands, which ended the speech before we even had presented our research in regards to dowsing, witching, and DIY well-digging; before we had explained that we thought of the gardens as a big computer hard drive – that the land was the hardware and that what was missing was the software to run it, that is – water.

Mr. Kirsche began to pour the coffee. "In former times the water cost next to nothing, but we could not afford the coffee, and now we have as much coffee as we want but we can't afford the water anymore," he said. And then they drank the coffee and ate the cake and talked among themselves about things that had happened in the seventy years they had all known one another, but rarely sat together around a table and talked, at least in the last years. It didn't matter that it started raining, it didn't matter that the cheap paper garlands we had decorated the tent with were dripping their dye onto their beige jackets, it didn't matter that the paper tablecloth and the paper plates and the plastic cups were flying off into the air. At seven p.m., when the rain had stopped and the sun had almost set behind the endless cornfields, they got up, said "thank you," took their chairs, and disappeared behind the bushes for another year. We flew back to New York City where we discovered that the videotape in our camera was

corrupted. It had either been affected by the electromagnetic fields of the divining rods or by the pouring rain.

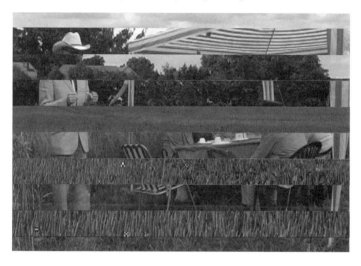

Landcruise

Their next letter came a year later, at the end
of June in 2009. It was addressed to all of us —
Fuchs, the two Kirsches, Richter, the Sister, the
Mother, and me — from America, in an envelope with
three postage stamps. This time we had learned our
lesson. "Our turn!" the Mother said, and immedi-
ately called Brauner's Inge to tell her that we
would go on the cruise with the Americans. After
he heard, Fuchs, of course, told Brauner's Inge
that he did not have time to do a cruise, that
he had work to do, had to put his beans in so he
could feed the unfortunate TV- watching fat sacks
who never leave his couch. "I don't think that's
what Fuch's daughter would have wanted for her
brood," the Mother kept saying. "To have them sit
in front of the tube like brain dead potatoes."

His lettuce heads weren't even fully grown
yet. Nevertheless, two days before the Americans
arrived, he started ripping them out and feeding
them to his pigeons. He didn't even cut the lettuce
heads, he just ripped them out like a barbarian.

Pigeons don't even like lettuce. It makes them
sick. It makes me sick. "Ah," the Mother said,
"that Fuchs drives me crazy. Will it ever be
possible to look out the dormer window in the
morning and not see that Fuchs getting ready to
plow through his garden like a kidney-eyed pig
sniffing for nuts? Could we ever look out the
dormer window in the morning and see anything
but that blue boiler suit of his? Is it raining,
is the sun shining? I cannot tell, because that
Fuchs with his eager business is always block-
ing my view. Instead of the sun, I have to look
at another mountain of produce that madman has
harvested. He is like a machine, that Fuchs.
'Who rests, rusts,' he whistles, like a bell on
a steam engine. No human shows up every day at
the same time at the same spot. No human is never
late. That Fuchs is a pre-programmed machine. A
heartless machine."

But we made it this time. That's the point.
Fuchs was out. He, who comes late, gets pun-
ished by life. Richter didn't join, either. The
Americans tried to talk to her when they got
here, Brauner's Inge said, but it ended only in
another of her breakdowns. That forlorn woman. If
at least she still had a parcel to console her,
a little piece of dirt to keep her busy growing
flowers for her mother's grave. But Horst died
as stubbornly as he lived. An ox until the end.
"Not beyond my grave," he said to Brauner's Inge.
"For forty-six years that parcel has not seen a
weed growing larger than a thumb! I always told
people: if you see a weed on my parcel that is
larger than your dick, you come over with an ax
and chop off mine!

"There has never been a more properly kept parcel than mine! This piece of land is truly something a plowing ox like me can be proud of. I am an honest man. I've always spoken the truth, rammed it in with my forehead if necessary, while you cowards were hiding behind the bushes in fear like rabbits. I am not afraid!" That boozer never knew where to draw the line. "My wife is old and weak. She won't be able to maintain my standards. If I am going down, the parcel is too. I never left the table without finishing what was on my plate. If I could afford it, I would pour concrete over it," he ranted, Brauner's Inge said. That carouser didn't even ask if anybody wanted his gooseberry bushes. One morning Jawsmith's Kurt just showed up with his son and his plow. They ripped everything out, plowed through, and in the afternoon burnt what was left. "No more extra compost for the cemetery," Jawsmith's Kurt said, when he was done. Dementia left and right, one case worse than the other.

For twenty years that babbler had been threatening to charge the Richters a fee at the cemetery for her overuse of the communal compost bin. "It is as if she wants to have more vases on her mother's grave than Vladimir Iljitsch Lenin has tourists around his glass coffin," he used to point out. "Every day she adds more bouquets, one in the morning, one in the afternoon. My mommy used to love peonies, my mommy used to love irises, used to love asters, my mommy used to love bleeding hearts, my mommy used to love violets, daisies, sunflowers, nasturtiums, calendulas, my mommy, my mommy, my mommy," he mimicked Richter. "If she wants to open a flower shop, she should open one

at the Autobahn and sell her posies there. But
not in our cemetery," the Mother would say. "Her
flowers make everybody else look bad, as if we
hadn't loved our mothers. Nobody can keep up with
Richter's flower madness." And now this forlorn
woman has nothing left. No mother, no children,
and no husband, though that might be a blessing.
For months after Horst passed away, she kept run-
ning down Village Road empty-handed, back and
forth, higgledy-piggledy, like a chicken with its
head cut off. "A car is going to run her over even-
tually and that will be the end of that story,"
the Mother kept saying. She is right. Life is
nothing but a pointless tragedy.

In Dasdorf "work" was understood to be a physical activity with
a tangible outcome. Water was carried. Manure was shoveled.
Weeds were pulled, hay turned over, fruits picked, soil pronged,
floors scrubbed, dirt scooped up, carrots peeled, plums pitted,
water boiled, sausages cooked, toilets sprayed, mice caught,
garage doors painted, tires fixed, septic tanks emptied, firewood
split, sidewalks swept, holes dug, fences expanded, stairs pol-
ished, gravestones rubbed, puddings chilled, pants fixed, pillows
stuffed, animals fed, beds made, boulders rolled, trees planted,
scythes sharpened, grass mowed, fertilizer spread, strawberries
propagated, blackberries frozen, goats milked, milk strained, light
bulbs screwed in, branches cut, coops ventilated, pigs treated,
groceries carried, cabbage shredded, sauerkraut pounded, nuts
cracked, pockets stitched, intestines stuffed, napkins embroidered,
tractors driven, curtains bleached, tablecloths soaked, newspapers
burned, horse tails combed, cherries preserved, ashtrays emptied,
carpets vacuumed, shrubs trimmed, juices bottled, lamp shades
dusted, pots scraped, fuel injections checked, motors idled, lad-
ders repaired, carrots fermented, pigeons plucked, pipes drained,
ploughs pulled, foundations laid, apples cored, jars labeled, wood

reclaimed, sawdust collected, honey extracted, tables set, cucumbers pickled, kittens drowned, mushrooms dried, tools organized, roosters selected, filters unclogged, potholders knitted, dough kneaded, potatoes smashed, chocolate melted, dogs buried, jam stirred, cellars winterized, cookies sprinkled, pebbles sorted, bicycles oiled, wheelbarrows pushed, wasp nests destroyed, puppies separated, leaves composted, holes spaced, chickens kept warm, beams connected, cement mixed, bricks laid, sticks measured, strings fastened, straw loaded, poles anchored, elderberries squeezed, herbs distilled, cheeses sliced, baskets decorated, graves adorned, rye milled, meadows raked, engines stripped down, roots trimmed, geraniums potted, seeds moistened, cutting boards waxed, beetles identified, mulch laid, bins punched, stakes bundled, hoses coiled, pumps galvanized, vines sprayed, ashes disposed, conveyers timed, peppermint hung, gooseberries transplanted, sheep herded, ducks locked up, latches stacked, gears greased, trees uprooted, sidings sanded, grapes gathered, beds harrowed, kitchen counters wiped, garlic bulbs covered, snow shoveled, and lunches packed.

Reading a book for example was not work. Positioning a video camera or taking photographs was, at most, a hobby. If people in Dasdorf believed in the moral of any fable, it was the one of "The Grasshopper and the Ant," where the grasshopper, who had spent the whole summer singing and enjoying itself, has to deal with the consequences of such a lifestyle once winter arrives. Hungry and freezing the grasshopper knocks on the ant's door to beg for food. Having filled every minute of the summer with collecting, preserving, and storing food the ant opens the door and says to the grasshopper: "You spent the summer singing? Then now, my neighbor, it's time to dance," before it shuts its door to the grasshopper again.

They were the ants; we, the grasshoppers. We would die dancing; they would survive eating potatoes. They had warned us numerous times. Since our first visit three years before, they had repeatedly told us that it was unnecessary to record or photograph

anything. Not because they had anything to hide, but because it was a waste of energy. It would make much more sense to plant a few potatoes instead. Yet three years later we were still around, still taking pictures – and that was something they could not have predicted.

Mr. Kirsche was the first to speak to us when we returned to take the gardeners on a cruise. He approached us slowly, stepping deliberately, wearing the same brown ventilated shoes and the same light blue cotton jacket he had worn in previous years. In greeting, he raised his right arm, pointed toward the fields, and spoke of how in the fall, when he was mowing the wheat fields, the path of his combine harvester used to be followed by a parade of red foxes and storks. "The foxes were waiting for the rabbits that would be chased out or killed by the harvester and the storks were waiting for the mice," he said. We asked if he knew about the Aesopian fable of "The Fox and the Stork." He shrugged his shoulders, took a big white cotton handkerchief out of the pocket of his beige corduroy pants, shook it open, blew his nose two times and looked matter-of-factly at the discharge before he folded the handkerchief into a small rectangle, put it back into his pocket, and asked if we wanted him to sharpen the scythe again. We said "yes." He sat down on the bench and we did nothing else but listen to the sound of a stone stroking a metal blade.

If Fuchs had not sprayed that new weed killer for the past fifteen years, Horst might still be alive. That's my opinion. The Mother, of course, thinks otherwise. "Nobody is blaming Horst for getting what he got," the Mother said, "it's just where he got it. That it started in his testicles of all places and spread from there like wildfire, that is a sign that everybody knows how to read." This is the crux of the matter. To a woman, everything is a sign. If the weather vane rotates twice, it is indicating wind and rain. And if it rotates four

times, a woman counts it as double proof. Nothing but random misery comes with this kind of fishwife wisdom. When Long Karl won the lotto, it was because he was born on a Sunday. He had played the lotto for forty years, and after forty years of losing every single week, in May he wins twenty thousand euros and every woman immediately knows he won the twenty thousand euros because he was born sixty-eight years ago on a Sunday, that he always had all the luck of the world in his pants because he was born on a Sunday. "You should stop playing the lotto," the Mother said to Achim at his birthday party. "Monday men never win the lotto." What misery. The odds against a woman saying something smart even exceed the randomness of playing lotto. In the end it took a whole bottle for Horst to make it through the night. "If hard liquor doesn't cure, the disease is fatal," he said. He was in a lot of pain by then. His general brainsickness made matters worse, didn't let him depart like a man who bows and simply leaves the stage when his act is over, like I will hopefully do, if good luck stands by my side. Horst didn't leave — he stuck around till the end. He had to show us what it's like. "If you saw a cow being in so much pain, you would hit her with an ax on the head and make sure she doesn't have to go on suffering a second longer," he yelled down Ringstrasse while that poor Pole driving the taxi tried to drag him into the back seat to take him to Neubrandenburg. "Be somebody, get an ax and finish me off, you wussy washrags!" What were we supposed to do? Hit him on the head with a hammer and pay that Pole fifty euros so he would dump him in the forest? "There is nothing we can do. It's illegal to kill a man," the Mother said.

We started the cruise on Friday, June 2. We were wearing rubber boots and yellow rain jackets. It was drizzling when we approached the yellow rope. One end was knotted to a metal link in the fence surrounding the gardens and the other attached to the ground via an iron rod, right by the side of Village Road. According to the embedded time code of the picture we took, it was 10:34 a.m. in Northern Europe when we pulled out the rod and threw it over the fence.

The moment it hit the ground inside the enclosure, the garden began to rise, like a tide, and reconfigure as a vessel. The material link to Dasdorf was broken. The gardens floated, as if the allotments had taken their rightful form, they became what they had been for more than half a century already: a ghost ship, stuck in resistant self-sufficiency with no authorities to care about it or even really know of its existence. But as soon as that vision emerged it started to blur again. Not because the life preservers we had hung on the fence weren't sufficient to mark the transformation, or because the cardboard seagull cutouts we

had propped up on the fence posts were cheap and crappy. All that matter didn't matter. What mattered wasn't actually the simulacra-of-a-ship part of the undertaking. What mattered was that the garden had suddenly found its connection to the fluid state of the 106,400,000-square-kilometer area between Europe and America that covered about twenty percent of the earth's surface, that it had detached itself from its solid state in Mecklenburg-Western

Pomerania to become part of the liberating vagueness of the Atlantic Ocean. It had found water.

We'll call the vessel *Unpredictability*, we said. *International Waters,* we said, *Possibility, Chaotica, Unlikeliness*, let's call her something that doesn't confine her again, something that will always remind us that she can only exist in the perpetual genera-tion of questions about her own form and purpose. Let her never be anything else but an extra permanent moment in time. Let's not call her anything, we said.

In the end it was just the two Kirsches, the Sister, the Mother and me. In their invitations the Americans had written that we should be there at three p.m. on the 2nd of June, 2009, but when we arrived at two-thirty p.m., nothing was fin-ished yet. The Sister was of course already on board. They had put out a couple of folding chairs and a sun umbrella and were sitting around with their feet up. It was clear by then that his wife was pretty pregnant. "At least seven months," the Mother said. The young girl they had brought along was supposed to be their daughter. It was hard to believe. She was already sixteen years old and had long blond hair, like my sister when she signed up with the Hitler Youth. "What kind of family is that?" the Sister whispered. "Having a child every sixteen years? What did they do in between?"

When we got there, they were still waiting for more things to arrive. A truck was supposed to come from Berlin but they hadn't heard from the driver since ten a.m. They said they wanted to put up a tent and that they had planned for more bun-ting and white cotton tablecloths, because this was supposed to be a luxury cruise. "The trip of a lifetime," they said. We waited for an hour

and a half for the tent but nothing happened. Eventually Erwin put on the captain's uniform, which they had hung on a branch of one of Trude's old apple trees, and grabbed the steering wheel. Their daughter blew the whistle and commenced a life vest drill. We all put the life vests on and blew the whistles on those, except Erwin.

"A captain dies with his ship," he said. "What do I care? The world is going down the drain anyway. Life vest on, life vest off. It does not matter. Rain doesn't concern a man who's drowning."

After the drill the Americans served champagne for the captain's reception. It was non-alcoholic, because of the pregnancy. It tasted like sugar water and it was lukewarm like baby piss. "Champagne has to be cold! Warm champagne is the coronation of tastelessness," the Mother hissed in my ear. We drank it anyway and kept a straight face through the whole ceremony, like in old

times, when the party gave out medals. And then
we went to the railing and waved goodbye.

People like them are lost. They drift wher-
ever the wind blows them. And even if they act
normal once in a while and attempt to settle
down, buy a piece of land, what happens? They
call it a ship and sail away. It's no good. They
go against nature, not just nature in general,
but also their own inner nature — and soon they
will feel the results. Having been everywhere
else will never make up for the lack of a place
one calls home. Good people stay and stick it
out. It's the criminals who are always on the
run. Last year the Americans asked Kirsche if she
could pick the apples in the fall from that tree
on Trude's old parcel and send them to America.
That kind of logic is simply repugnant. Why would
anybody do such a stupid thing? They have super-
markets in America. And what did they say? "We eat
apples from Chile, apples from Italy, apples from
California, why not eat apples from Dasdorf?"

During the second night I could not sleep at
all. I rolled around in my bed like a hamster in
a wheel. I am sure the coffee wasn't decaffeinated.
They had told us that one pot was decaffeinated
and one wasn't. But when I looked up, my cup was
full and I didn't even know who had poured it.
The Sister said, as weak as the Americans had
cooked that coffee, it wouldn't make a difference
at all. But she was wrong. I didn't close an eye
until one-thirty in the morning. The Mother on
the other hand snored like a big brown bear and
kept pulling the covers over to her side.

That they got the entertainment program going
by putting that foreigner on stage was not a good

idea. She looked like a half-skinned rabbit. I understand, other countries, other customs, and nobody wants to paint the devil on the wall, but what if the right people find out she is here with us? What a nightmare this could have turned into. They had sent her all the way from Marterhof on a bike in a short dress. Two miles on a bike through the forest all by herself. "If the right people would have spotted her, I don't want to know what would have happened," the Mother said.

Don't these smartasses read the newspaper? Just last week the shaved heads marched through Neubrandenburg burning torches and shouting slogans, with the police standing by calmly, as if Goebbels himself had paid them overtime. "And this is just the infantry," the Sister said. "The true ones know better than to shave their heads. They'd rather let their hair grow long into golden locks and walk behind an Aryan horse and an iron plow with their brood," the Sister said. Everybody knows why the Artamanen moved to Mecklenburg-Western

Pomerania. Not to grow red beets, that's for sure. Blood and soil. Those Bio Nazis are getting Back to the Land, twenty sacks of potatoes and one dead foreigner at a time. But it's not my business to enlighten the Americans about that. Behind an able man there are always other able men, and if the Sister thinks it would be wise to tell them, she should go ahead. Otherwise they will find out about Brauner's gang anyway. Nobody is as blind as those who don't want to see and all I am saying is that the Americans were just lucky that nothing happened to that foreign woman. On the fourth day the poor creature jumped overboard anyway. A sailor from Berlin fished her out and brought her back to Berlin. What a relief for all of us. We did not like to see that creature suffering, but what were we supposed to do with her? She spoke six words in German. That was all. The elbow is always close, yet you can't bite it.

CC had replied to an ad we posted on Craigslist for crewmembers, dancers, musicians, comedians, clowns, scientists, and magicians to perform on the cruise ship. She was from New York City and had been preparing for a trip to Germany when she saw our ad. Two days before her departure, the friend she was supposed to stay with had stopped communicating and could not be reached. She therefore welcomed the alternative of performing on a cruise ship in exchange for board and food.

After her arrival in Berlin she waited in a coffee shop to be picked up and transported to Dasdorf. That's when her bag containing her passport, laptop, credit card, cash, and cell phone was stolen. She didn't speak any German and she hadn't brought any warm clothes. Yet, at the end of a long day and an even longer night that had stretched itself through several continents and time zones, she mounted the small wooden platform in front of the

dining room tent where the passengers from Dasdorf had assembled for coffee and cake. Tired but committed, CC played her pink, battery-operated Hello Kitty guitar.

Her voice was strong and her costume pretty spectacular. Nevertheless, physically only twelve feet away from her, the passengers sipped coffee and discussed the prices of bananas and bread in the supermarket without looking at her once. It was as if CC was see-through, inaudible and weightless, as if she were still in New York City, as if the stage and the tent with the passengers were still four thousand miles apart from each other, while we were right in the middle between here and there, surrounded by nothing but the deep incomprehensibility of the ocean that kept us all apart.

At some point they told us that the folderol would run for six days. They said that's how long it would take to cruise from Germany to New York. "That's also how long it took God to create the world," the Sister said, "cause he rested on day seven," but the Boss said that was just a coincidence. It's six days because the boat goes steadily at about thirty miles per hour and it's roughly four thousand miles between Dasdorf and New York

City, which would bring us to around one hundred and thirty hours at sea, a little bit more than five days. One hundred and thirty hours with this brood.

Every morning they hung a sheet of paper on the fence listing the activities for the day. I never read it. Nobody read it, except Brauner's Inge and she said there were more program points in a day than things happening in Dasdorf in a year. I just wish it were warmer. The year before we had picked the last strawberries by the beginning of June. On the cruise, they had not even started to turn red. The strawberries were at least two weeks behind, that's how cold it was, especially at night. The whole thing wasn't good for my arthritis. I had to take an extra pill for every four hours we spent in Albert's former parcel, which they called "the outside deck." They hadn't even bothered to cut all the grass. Kirsche said she had to take four extra pills a day. Her son had to come all the way from Neubrandenburg and bring her a new package of pills so she would make it. That's how severe the weather was at times. When the sun was shining, it was warm, but too much sun is not good for me anymore. I get a headache from the ozone. Clouds are better; I need some cloud-cover to feel normal, but not as badly as it was when we did the workshop with the sailor from Berlin on how to tie sailor's knots. I forget what day we did that, forgot everything about those knots. The double half hitch, or the figure eight, sling that end of the rope around the other end and make a loop, who but a sailor would care? He was a nice man, a very patient man, but it almost made me angry to see how he wasted his time. As if he hadn't anything better to do than

do these stupid knots with us. It's all mixed up
now, but I remember that I sat so close to the
edqe of the tent that I got completely soaked by
all the water that flushed down from the roof.
My whole left side was soaked. The jacket, the
sweater, the pants. In retrospect it was a fool-
ish thing. I should have asked the Mother and the
Sister to get up from their chairs and move a lit-
tle bit closer in. But once an old ass has made
itself a warm nest, it's hard to get it up` again.
I am lucky I didn't catch my death that day. When
one is young these things don't matter. But once
you get old, everything goes directly through the
skin and penetrates the bones.

At first we imagined this as a luxury transatlantic crossing on
one of the most magnificent ocean liners ever built. We envisioned
exquisite dining with white tablecloths, we mentioned formal eve-
ning dress, talked about silverware, porcelain, glasses, and deco-
rative syrup splashes over mango sorbet. We had hoped that every
day there would be a new, exuberant bouquet of flowers on the por-
ter's desk, a full program of daytime and evening entertainment,
that there would be lectures, workshops and enrichment programs,
that there would be a captain and a crew, that the service would be
impeccable and the experience synonymous with unforgettable ele-
gance. We wanted the passengers' nightgowns to be sculpted into
the shape of a peacock after the comforters on their beds had been
folded back for the night, a new piece of soap placed on the basin
every time they washed their hands, and the end of the toilet paper
would be folded into a triangle each time they took a dump. We
wanted the passengers to be stunned by the whiteness of the ship,
baffled by the smoothness of the operation, perplexed by the grand-
ness of the endeavor, and emancipated by the expanse of the ocean.

In preparation for this we had hired a single assistant over
the Internet who had no references. Instead she had kind of an

emergency, a fourteen-year-old daughter who was suicidal and who, her mother said, would greatly benefit from accompanying her into the countryside for a week.

Agnes, a middle-aged woman from Berlin wearing black, pin-striped office pants with an oversized woolen sweater, was down to earth – and thereby the opposite of a person who would enjoy a week of sailing on imaginary water.

She kept complaining about the things that were missing, the things that were invisible, the things that from our point of view naturally actualized themselves through "stepping onboard" and were never meant to be tangible in the first place. The only thing Agnes could see was the cooking tent. She demanded to be the chef and then, for the rest of the journey she told everyone how much she regretted this decision. Her world depended on evidence, if she reached out she expected an immediate return, everything that mattered to her depended on outer circumstances. Her daughter on the other hand lived inside her head. She rarely came close, simply seated herself at the very far edge of the garden, made a grim face, chain-smoked cigarettes and listened to music that, according to her mother, encouraged young adults to slash their wrists. It made her the ideal candidate for our ship's figurehead, we thought, a female force on the bow, who would inspire fear and angst in the hearts of eventual enemies approaching from the open sea, and thereby protect us.

"What's wrong with my daughter that your daughter doesn't hang out with my daughter?" Agnes asked. "Nothing," we replied. "She is doing an excellent job warding off evil spirits." That her daughter's unsociability had been accepted, that her daughter was collectively seen as a cherished naval figurehead on the bow of the ship, while Agnes herself had ended up in the rather ordinary position of cook-and-dishwasher, undermined her ambition to turn things around in the countryside. Her frustration grew with each serving of mashed potatoes she slammed down on the passengers' dinner plates, and as if these dinner plate presentations wouldn't speak for themselves, she also had to be vocal about it: The charcoal

grill took forever to get started. It was always cold and raining. The
conditions in the kitchen tent were worse than in the Third World.
There was no electricity. There was no running water. There was no
proper storage for the food. We were such a disappointment. Her
daughter had only come to Dasdorf because she, Agnes, had told her
that we were from New York City. And now, nothing about us was
like New York City, or even American, except our superficiality.
We were a cheap fake, and everything about us and about this cruise
was fake. There was no cutting board. There was no corkscrew. We
folded paper towels into napkins. It was unsanitary, even poten-
tially harmful to drag in the drinking water in old milk containers
from Marterhof to the kitchen tent. It made her uncomfortable to
have a foreign woman onboard, who was freezing most of the time.
It was disrespectful that CC had flown in from NYC to perform for
these village idiots who would never ever be able to appreciate an
experimental rock concert. Mr. Krater kept creeping up behind her
telling her disgusting sex jokes. We put our unborn child in danger
when we lifted heavy things. On every blade of grass sat a tick that
carried an infectious disease that would lead to chronic illnesses.
Most of the time it was freezing cold. The passengers were rude
and greedy. If they didn't like the food she cooked, they wrinkled
up their potato noses. After every meal the tablecloth looked dirtier.
It was infuriating to be called "our private cook" by these indigent
farmers. We were unbearably naïve and arrogant. It was impossible
to talk with us. The cruise was just about sitting around and eating.
It was boring, ugly, wasteful, and totally meaningless. There was no
concept, no utopia, and no relation to anything close to the reality of
a cruise. And, nobody in the whole world cared about what we were
doing in this forgotten piece-of-shit boat.

Thinking like normal humans do, we obviously
assumed the Americans would know the people they
brought onboard, but they didn't know any of them
besides their own daughter. They didn't even know
their family names. They were all strangers among

strangers. All this we found out through the
clown. The Sister was outraged when she heard, and
kept pestering the little guy in disbelief. Where
the Americans were from, what the foreigner was
saying about us in English, if Miranda really was
their daughter, and so on. "I don't know anything
about them, except what is on the Internet," the
clown said. The Sister was furious. "Who is going
to show up next to entertain us," she cried. "A
naked man with a tiger tail?"

During the cruise we spent our nights in Marterhof, where we
had rented a ground floor apartment in a two-family house. The
furniture in the apartment was basic and mostly beige, the floors
were tiled in gray. The heaters were turned off for the season
and at night it was damp and cold. There was no Internet con-
nection, no cell phone reception, not even a fire detector with a
red-blinking light. There were windows in the house but by the
time we got there, the pre-programmed, automated blinds had
already lowered themselves to hermetically seal the apartment
off from its surroundings.

Every night we descended into "the hull of the ship," as we called this apartment in Marterhof, and there was nothing to do but to sit around on the oversized couch and drown our isolation below the waterline in bags of pretzels, potato chips, and the never-ending tales of Jens. Jens was twenty-four years old and wanted to become a professional comedian. Like CC he had responded to our ad on Craigslist at the last minute in exchange for adventure, pretzels, and a place on the couch in Marterhof. On our first day at sea, after we had sent Agnes to Neubrandenburg to message Jens the coordinates of our boat, he hitchhiked from Berlin to Dasdorf. A truck driver dropped him off where L33, Village Road, and Ringstrasse all meet. As in every small village, the intersection is the place with the highest probability of action, and when Jens jumped out of the truck there, he was greeted by three teenagers on home-tuned dirt bikes who had been loitering at this spot since they were two years old and allowed to roam the village without parental supervision. Jens asked them the way to the gardens, which they called "the ship of fools," and they sent him and his suitcase-on-wheels into the fields. After a while they caught up with him on their bikes, said they had made a mistake, directed him back to the intersection and sent him toward the cow-stables, then toward the soccer field, and then toward a little pond, where Jens finally broke down and started to beg them to have mercy.

The menacing interaction with the village youth had an effect and probably conditioned Jens, upon arrival, to embrace the cruise ship unconditionally, like a long lost mothership. But who knows. Maybe it was just the first time he had run away from home, and it wasn't as bad as he had always feared, or maybe it was just an exciting time in his life. We never asked.

Comedy Night was Jens's first big appearance. We set up two rows of chairs between the dining room tent and the stage, and Jens put on a red-and-white striped shirt and black pants with suspenders that ended where the green socks started. The passengers had just finished a big sausage dinner with sauerkraut and seemed

to be in the right mood to enjoy watching a clown try to keep his imaginary poodle Poopoo from peeing on the expensive carpet in the middle of the dining room. Soon the passengers were crying tears of laughter, which Jens took as an endorsement.

Over the course of the next five days he transformed himself unceasingly into one unstoppable character after another. In the afternoons he was a retired widow wearing a silky scarf and watching the ocean, his right hand shadowing his eyes. For dinner he put on a bowtie and took on the role of an entertaining gentleman from London who had recently traveled to Zimbabwe in a hot air balloon, and when dinner was over he helped out as a dishwasher from the Bronx who cursed a lot. In the mornings he was a running coach with a Swiss accent, then our yoga teacher who communicated simply through heavy breathing, and then Wolfram Wiederfrack from the Black Forest, who could not be prevented from sharing his political views about the food crisis and the instability in North Africa with us at the breakfast table. Whenever there was a fraction of an unused second available, Jens jumped forward and filled it. He documented life onboard with an imaginary large format camera from the 18th century and a piece of real black cloth that he kept throwing over his head every time he pulled the trigger, and he videotaped hours of the passengers eating their meals. Jens was an energetic poet, who seemed to have adopted "Sturm and Drang", the late eighteenth century movement whose goal was to overthrow the cult of Rationalism, as his lifestyle. He freely experimented with ways to express every possible emotion experienced by humankind in the past two thousand years, and his favorite ballad, which he loved to recite during his walks on the starboard side at twilight in the voice of a medieval crooner, was the one about the glove, written by Friedrich Schiller in 1797. Besides that, Jens tap-danced, played ball, served food, dealt cards, fixed nets, caught fish, and was the only one ever seen talking to Agnes's daughter. He even, on occasion, made her smile. Once Jens became extremely seasick. He rolled back and forth on the ground moaning groans, and

then got better again. He told "Yo Mama" jokes while we packed the van to go to Marterhof, and "Blonde jokes" when we drove from Marterhof to Dasdorf early in the morning to get the breakfast brunch buffet ready on time. Jens sipped lemonade with CC and Miranda in the legendary Admirals Lounge through a twisted straw and cooked waffles in the kitchen tent with Mr. Krater, a neighbor who one day showed up with a waffle maker and a bowl of homemade batter, an unrequested service for which he charged us seven-and-a-half euros per bowl. This made Jens, at times, to us what we – at times – must have been to the passengers: a mix of everything that in the end amounted to nothing in particular. Once or twice we articulated our concerns that he might be going overboard, being too numerous and overdoing it in order to compensate for something that was forever lost. Jens understood immediately, gave us a hug, and said he couldn't help it. Since his arrival on the ocean liner, "this magnificent ocean liner," as he put it, he consistently felt that it was his job to make up for the three thousand passengers and two thousand crew members that were unaccounted for on board.

Jens's counterparts were Miranda and CC. While Jens was helpful in his capacity to impersonate a vast variety of hard-working crew and eccentric passengers, these two skillfully enveloped the ship in a much-needed aura of style and elegance, adding hints of beauty and grandeur (unless they were needed for other emergency jobs). They wore high heels for breakfast and miniskirts for dinner. They did their hair in the morning and their nails after lunch. They lounged in the deckchairs that faced Village Road, put earplugs in their ears, lowered their long lashes over their eyeballs, and let the village people, who passed by on their barges, watch them with their mouths open.

They were beautiful. They were calm. They were reassuring. They seldom talked. Their presence simply embodied the ambience we had tried to construct by loading the breakfast table with strawberries stacked into pyramids, deviled egg-halves filled with fake caviar, cucumbers carved into dragons, cheese

platters layered in yellow sliced flower blossoms, and watermelons into which we had carved the face of a mermaid or the outline of a swan.

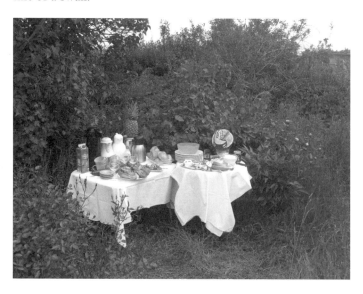

Generally it was not the worst idea to sit outside for a while and get a little bit of fresh air. The doctor always says it's good for you to spend more time outside, because we don't spend as much time outdoors as we used to. The weather has become so unpredictable. It's too difficult to figure out these new weather patterns now. I look at the temperature and it does not match the calendar. I look at the colors of the leaves and they don't match the season. I look at the sky and it looks exactly like it used to look thirty years ago when a sunny afternoon was in store. I get the sun umbrella out and set everything up for coffee, and then it starts raining. Out of the blue. It doesn't even need a cloud anymore to rain — or hail. It's

all that radioactivity in the air, all these reac-
tors, all the ozone in the sunbeams. Every bug and
butterfly is infected with some kind of disease, and
every fruit tree with some kind of fungus. It's
even dangerous to sit in the grass, that's what
it's come to. It's life-threatening to sit in one's
own garden. Every day of the cruise we found ticks
on ourselves. I pulled two off my left leg, and the
Mother had one on her neck already on the first day.
When we were young we would let them suck until
they became big and full of blood before we pulled
them out. Just for fun, just to be disgusting. And
nothing ever happened. Now you have to pull the
suckers out immediately and still, it turns red
and blue around the bite and then you've got the
disease. "The ship is infested with ticks, the
Americans don't even know the risk we are taking by
being on this cruise!" the Sister lamented daily.
"Pregnant women should be banned!" she said, sev-
eral times, when the Americans came near enough to
hear her. "The tick disease will harm the fetus."
But the Americans pretended not to hear her.

Each of the six days of the cruise was packed with events, which we
hoped would appeal enough to the gardeners that they would stay
on-board. Maintaining the presence of voyagers was like swinging
a bucket filled with water in a vertical circle fast enough to keep the

water inside even while the bucket was upside down, a continuous effort to invert the laws of gravity and therewith the existing value system. The moment we slowed down, the water would fall out of the bucket. Accordingly, we provided one cruise activity after the next to keep the passengers on board like the water in the bucket.

On the day of our departure, a few hours after we had left Dasdorf harbor, Mr. Kirsche, who had volunteered to be the captain during the life vest drill, abandoned ship because, he said, his hearing aid couldn't handle the sound the plastic covering produced when the wind started blowing against the walls of the dining tent. Nobody else was interested in commanding the vessel, so we replaced the captain with "The Weather" – a moody mate who kept turning the barometer up and down, and steered the ship toward a sporadic chain of unpredictable meteorological events. At the time of our departure the air was warm, the sun was orange, the sea was calm, and the grass was green. Exactly as it was supposed to be.

The shores of Dasdorf still in sight, we glided through areas of blue sky, occasionally interspersed with long layers of lens-like

cloud shapes that tapered as if they had been painted with one long stroke of a bristle brush that dried out at the end, until in the morning of the second day we reached an area of densely patched grayness that lacked structural detail. Then the course suddenly changed and we headed toward the rain shaft at the base of a thunderstorm. Accompanied by lightning our vessel maneuvered itself into the epicenter of a torrential rain that, judging from the impact the drops had on the skin, might have actually been classified as a hail storm.

We had been certain that this storm would be the end of our journey, that the passengers would disappear and not return; but to our surprise, heavy rain, thunderstorms, graupel – whatever happened over the course of the next days, the passengers endured it all, rather unimpressed. If the sun came out, they wore their summer cotton jackets, the women's beige and the men's light blue. If it rained or hailed, they put on rubber boots and plastic ponchos, pulled their shoulders up, pushed their hands between their meaty inner thighs, rested their blank stares on the tablecloth, and remained in stillness.

Landcruise

It seemed as if the experiences of a lifetime had trained them to endure temperature changes, pressure changes, and fast moving air in the same stoic and submissive way as they had endured every other authority that over the years had appeared and affected their lives without taking into consideration that they even existed. There was nothing to be done about it but to let it pass. Freezing is simply an activity one does when it gets cold. Hence, they froze until the noise of raindrops subsided and then they warmed up again and continued their conversations where they had stopped.

They always said the clouds from Chernobyl never reached us, but everybody knows that is a lie. Look at Ernst's son and the Bechers' twins. When were they born? All at the end of 1986. November, December 1986. You don't have to be a scientist to figure out that this is not a coincidence. The radioactive cloud rained down on us and the pregnant ones produced the proof. Every idiot can recognize the pattern if he chooses to. The next disaster of that sort, I am sure, will happen soon. We'll probably get it from the Poles. Their nuclear plants were never updated like ours — all sloppy regulations, rust, and corruption.

Every day something burnt. Those clumsy fellows never learned how a charcoal grill works. In the beginning the woman they hired did most of the cooking. But when she didn't show up, the Boss put on the chef's hat, and once in a while, when she was not lying in a deckchair, the foreigner helped him. Then they both wore big chef's hats.

But that was the only thing gourmet about the whole operation. Every night, when the soup was served cold again, the Sister asked me, "What's so good about a private cook, if the soup is

141

cold by the time they serve it? How can one not keep soup hot in a pot?" As if I were the manager. Eventually I had enough. "Mother," I said, "I am going to run a power cable from the garage and give them the emergency hot-plate from the basement. The Sister is driving me nuts with her complaints." Of course once I ran the power cable, the Americans immediately produced a multiple outlet power strip. You offer these people a small finger and they grab the whole hand. They connected stage lights and let them burn all night. Four lights, two hundred watts each, for the clown and his imaginary dog. The women thought he was funny. They laughed and laughed. I thought the Kirsche would suffocate herself with all the laughter and I am sure the Mother wetted her pants. The next morning the fun was over. I could tell the Mother was mad that I had run the power cable. "Now we are paying for all the electricity. Now it's us paying for the whole show," she said. "In the end we are going to pay for everything then it doesn't really matter if that soup is cold or hot. One can't make a silk purse out of a sow's ear. Our hot-plate is never going to change that."

The dog barks, but the caravan passes on. Has there been a minute of silence since we boarded the ship? For hours and hours they squeezed me under that tent between these four old gossipmongers, who kept grinding and grinding the same old stories and could never, even for a few minutes, keep their mouths shut, while the beautiful young ladies lounged on Richter's old parcel facing the street, where every village idiot that trudged by could take advantage of the sight.

On the second evening, Mrs. Trautmann, who seemed to dislike the cruise for the same reasons as Agnes, left the table under the tent. "I am going to look at that ocean of yours," she said in a voice a mother uses when she threatens to abandon her five-year-old child. She positioned herself next to the life preserver at the railing, took a couple of pictures with her 35mm point-and-shoot photo camera, and then remained there looking out.

We had met her two days earlier, on the day of the detachment for the first time. She had stepped on board almost an hour before anyone else, walked up to us and shook our hands stiffly and said: "My name is Trautmann, I hate being late, that's why I am early. And, just to let you know, I am still the official leaseholder, even though my name is not on the list. I haven't paid my rent, because I don't live in Dasdorf anymore. I have been forced out against my will, but I am determined to come back. Continue with your preparations and don't pay any attention to me," she added and then turned her back to us. Since then we had gotten to know her as a know-it-all, eye-rolling, throat-clearing woman, who had

criticized almost everything we had done so far – never by talking to us directly, but by addressing her fellow passengers: "If I had invited people for coffee and cake on my boat, I would not have bought some cheap, pre-packaged cake from the supermarket. I would have baked my own and I would have served it on a nice day, not during weather like this."

Who was this woman, why was she so angry and why did she keep joining the cruise, even though she did not live in Dasdorf and sincerely disapproved of the improvised character of our undertaking, we wondered, as we listened to the almost whispered conversation between Mrs. Study, Mrs. Kirsche, and another elderly woman in a beige jacket who had stepped on board and had sat down at the table earlier that afternoon without introducing herself, while we were setting up a tripod and a video camera to film Mrs. Trautmann standing in front of one of the life preservers that hung on several fence posts, looking out into the fields.

According to Mrs. Study, Mrs. Trautmann was not only a merciless stickler for punctuality but apparently also a respected traveling nurse, who for forty years had ridden her bike with a black leather bag full of syringes, vaccines, cotton balls, and bandages to every village in a fifteen-mile radius around Burg Stargard in order to administer to the children of the region the mandatory shots for polio, measles, mumps, diphtheria, and hepatitis A and B. Everyone called her the Sister, because the word for nurse in German is sister. We framed the shot and pressed the record button.

"The children just feared her like the plague," Mrs. Kirsche said with her voice low, her body bent forward toward the other woman at the table, who were also bent forward. "Shock-shots, that's what Walter called her method. Not one child ever cried. Naturally she was enraged after what happened with her husband and her sons. Could never get over it. It was everyone's fault. Everyone was to blame for it, even the children. Remember how she would line them up in a row in their undershirts, take out the syringes, place them on the tray, put the tray on a table in front of the row of children and leave the room for five minutes? Nobody was allowed to

144

talk. When she came back, everyone froze, and kept frozen as she went down the row. 'Why bother with ice packs?' the Sister used to say," Mrs. Kirsche kept on in her low voice.

We looked at the preview screen on our video camera and zoomed in as far as we could on Mrs. Trautmann's face and then we kept zooming out again and then in again. "The Boat Dragon," as we had started to call her secretly, looked small and vulnerable, a lone figure facing the vastness before her. And while the sun started to fade and the darkening, laden sky kept narrowing the bright block of light above the horizon until it was just a thin sliver, we kept switching back and forth between looking at her on the preview screen of our video camera and looking at her directly. Mrs. Trautmann stands there facing something much bigger than herself, we thought. And then, while we kept adjusting the aperture of the lens, Mrs. Trautmann turned into what art historians call a "Rückenfigur," a figure seen from behind contemplating the landscape before them, and we, almost against our own will, started to see – through her – the metaphysical notions we had been taught to address when looking at paintings by Caspar David Friedrich. It is brave of her to step forward and face the overwhelming tragedy that is probably to some degree inherent in every landscape, but definitely fully present in the fields around Dasdorf, we thought.

The "Rückenfigur" is such a genius device, especially if the proportions are right, we thought and Mrs. Trautmann is such a natural allegory for the Dasdorfian pain. Since she was the one to administer the agents that would fortify the children's bodies against foreign elements and unwanted invasions, as we had just learned by overhearing Mrs. Kirsche talking to the women who had stepped onboard that afternoon without introducing herself, it was she who was in charge, we thought, to prepare the children in a fifteen-mile radius around Burg Stargard to fight off encounters with the non-self by injecting them with antibodies. She had been a stinger all her life, a pain in the ass, it was her duty to poke around, we thought, and then we asked ourselves: What if we kept stepping back, further and further into Dasdorf, while the people of Dasdorf

kept stepping further and further out into the fields, out of Dasdorf, out into the open, so they could see us and we could see them with the distance necessary to contemplate the bigger picture? What if our inwardness and our outwardness would find a middle ground, what if we could uphold the laboratory condition of an ideal balance, what if we could endure Dasdorf as a museum and our human encounters as parts of large format landscape paintings? It never could last, we thought, not longer than five minutes. Dasdorf isn't a museum. It's neither curated nor climate controlled. There are no labels on the walls of Dasdorf that help us understand what is going on, there is no wall text that explains the inexorable persistence with which Dasdorf presents itself, or what has led Mrs. Trautmann to participate in the cruise. She is not part of a painting, she is not there to be contemplated, she is not a Rückenfigur, she is alive and unpredictable and annoying, we thought. She is confrontational and confusing. And that's why we fundamentally like her and can't wait for her to turn around and start yapping in order to question us and everything we are doing, we thought and pressed the stop button on our video camera, while Mrs. Trautmann came back walking towards us with a stern expression on her face.

Count on a good weather day if it starts out foggy
and gray. I did not even have to wear my jacket
when we got in the tent for coffee and cake on day
three. Already in the morning, when I fed the
chickens and the rest of the geese, it was three
degrees warmer than the day before, and by the
time I cut the grass for the rabbits I had to take
my vest off, that's how warm it was. The weather
was demented. As long as I can remember, we have
never had such extreme weather up and downturns
in such a short period of time. It was as if the
Americans, on top of everything else, now also
controlled the weather and played around with
it, as if it was just another one of their toys.
They brought the cake from the supermarket, the
Weinheimer Coffee Roll we usually get too, and
heavy cream in a spray can. A young man dressed up
as a cowboy was singing songs and playing his gui-
tar while we ate. The young fellow actually had
a nice voice, but as usual the Sister ruined the
concert by talking about the reunification. The
Kirsche and the Americans moved their chairs out
of the tent toward the stage, but I was trapped
between the Sister and the Mother. The Sister
still gets agitated about it, as if the GDR had
dissolved only to play a dirty trick on her. To
her, everything in the world happens only to play
a dirty trick on her, so she has another reason
to act like a viper who was just stepped upon. I
don't understand why. She still owns her house,
and that she would have to pay rent to her daugh-
ter if she wanted to move back in has nothing to
do with the reunification. "All that we ended up
with from that glorious scheme of reunification
is what's up for sale in the supermarket," she

147

keeps saying. "Last week again the Brie was on sale. But who likes Brie? We didn't give up our country to eat French cheese. We like Harzer, everyone here likes Harzer, but Harzer is never on sale," she said, "only the Brie." That's when the Mother turned around and told her that it only looked like the Harzer was never on sale because if it's going to be on sale, Else calls us the night before, and then I take the school bus to Burg Stargard in the morning and buy all of it at once. And then, naturally, they take the sign down. "The time of rations is over," the Mother said. "Every fool can take the school bus and buy as many Harzers as they want and no one can make me feel bad about it. No one! One euro ninety-nine instead of two euros fifty-nine. The expiration date said April 31, 2012, so who is to blame for stocking up? We don't have a car to drive to Poland like the Brauners clan to buy our cheese and sausage there for half the price. All we can do is sit at home and keep on counting pennies."

Mrs. Trautmann had been exposed to a greater variety of places on earth than Mrs. Kirsche and Mrs. Study, who had spent most of their professional careers somewhat sheltered underneath the

warm swollen udders of cows at the government-operated farm-ing collective in Dasdorf, and later behind big, oversized mobs in the youth hostel in Burg Stargard. Mrs. Trautmann, as we learned from bits of conversation between the passengers, had once been on a two-engine propeller airplane, and had eaten frog's legs in Russia. She had been on a ship in the Black Sea and had seen the Charles Bridge in Prague. She'd even once been to Norway, after the Wall came down, while Mrs. Study and Mrs. Kirsche had never left Mecklenburg Western-Pomerania in which they were born, married, had multiplied, and would most likely die.

Yet, despite her expanded worldview, Mrs. Trautmann took almost childish pride in claiming herself to be the only true Dasdorfian among the female passengers, the only one who per-sonified the essence of Dasdorf. She had been born in her par-ents' house in Dasdorf and had been living there her whole life, as she mentioned numerous times, while the other women had only moved to Dasdorf from surrounding villages. The others had contracted Dasdorf like a disease, she said. Dasdorf to them was like an infection they had adapted to, while she herself was sim-ply a "natural secretion." Three years ago though, her daughter had staunched the flow of that secretion and "robbed her of every-thing," when one night, in an inexplicable chain of events, she threw her out of her own house with bag and baggage. Since then Mrs. Trautmann had been living in Burg Stargard in a studio apart-ment, a situation she found unbearably unjustified and alienating. As the days passed, we slowly understood that for Mrs. Trautmann the cruise was a sort of homecoming, an opportunity to prove to her daughter that she was still capable of maintaining a presence in Dasdorf and wouldn't go away that easily. Every morning she rode the six miles from Burg Stargard to Dasdorf on her old fixed gear bike, always sat on a chair from which she could see her daughter's house, which like Mr. and Mrs. Study's bordered the gardens, and was the last one at night to leave, most likely when it was already dark, cold, and sometimes raining.

I am too tired now. I started too early, when I
was twelve, and I quit too late, when I was sev-
enty-two. How many days of work did I miss in all
these years? Four days with pneumonia and then
one for my mother's funeral and then one more when
I got the license plate for the new car. I could
have made my entire career with only five sick
days, but the car registration did me in. And who
is impressed by it? I have nothing to say to them.
Nowadays, people have more sick days on their
record than working hours. What kind of use is
such a life? That's what these sick people should
ask themselves. It's not that they cannot walk
anymore. It's not that they cannot pull a cart
anymore, or lift a shovel and make themselves
useful this way. My daughter-in-law stays home
for weeks at a time because she has a headache.
My daughter has allergic reactions. I tell her:
"If it's not good for you, don't eat it. Leave it

alone. Every animal knows that. The plant king-
dom isn't supposed to be benign, and neither is
the supermarket. People pay to get poisoned, just
because the product comes in a colorful box."
Dumber than dumb. That's what I keep telling my
daughter. Just because some greedy moneybag is
selling it to you doesn't mean it's good for you.
But these fools keep shoveling it in. I keep tell-
ing my children what the war taught me, but the
quarrel of the sheep doesn't concern the goats.
It's impossible to tell anyone, anyway. What the
Russians did with Aunt Lieselott, if Amelie would
have witnessed that, she wouldn't dare to stay
in bed the whole day because she got a rash from
peanut butter. Aunt Lieselott. That woman was an
example. One of the old generation. She still
knew how to pull herself together. She used to
say: "I keep going on, otherwise I might as well
kill myself," and she just kept moving on like a
cold blooded horse and pulled her heavy load with
strength and dignity. On the day she died, she
baked four loaves of bread and made a big potato
salad, so we wouldn't have to worry about food for
the funeral. There are no women like her around
anymore. That breed has died out. Just look at
the rosebush on her grave. Look how it blooms,
year in, year out. One look at that rosebush and
you know what kind of woman Aunt Lieselott was.
But the Mother thinks otherwise. "The roses bloom
for her children, not for Aunt Lieselott." She
doesn't understand. But that's all right. Nobody
will ever understand what it was like.

Being captive on a ship with a bunch of strangers has the potential
to turn into a claustrophobic situation. One way big ocean liners

address this problem is by installing running tracks, which loop around the outside decks like horizontal hamster wheels. Every morning we ran a loop and circled our ship several times as if to stake out the parameters for the day within which we had to operate. None of the older travelers ever joined us during these early morning activities, but we knew that they watched us from their cabin windows. At least we hoped they did.

Every so often the Americans led us to the fence and said, "Look behind that railing, can you see the ocean out there? Isn't it immense?" The Sister even took a couple of pictures with that camera of hers.

But what do they expect? That I will start seeing things that are not there? A man may well drag a pig to the water but he cannot make it drink. Why would I want to see an ocean when there is a field? Why don't they acknowledge the facts before they invent some fairy tale? Sixty years ago there were

two hundred parcels with hedges in between. "Junker land in farmer's hand." The Russians kicked out Mr. Bülow, the land was divided, everyone got a parcel, and then we started digging, no machines, no tractor, no support from anyone. Only when it was time to get the harvest in, then the comrades showed up with big trucks to load it all up. Remember the starving children in the bombed out cities, they said. First we had to give up a quarter of every harvest and then a third and then they said, "It's not going to work," give up the land, we'll merge all the little parcels into one big field and buy a tractor together. Uncle Hubert almost lost his mind about it. He had a wife strong like an ox, his son had survived the war, he had a little plow, and with them strapped on in the front and him in the back, they managed to produce enough to keep the family from starving. And when the comrades came and said, "Hubert, it's time to join the collective, he refused. And three months later he was part of the collective anyway. Officially. All his potatoes disappeared one night. All dug out. All his wheat was trampled down. Later, they said that he was building an airplane in a barn in Tschechow and was planning to escape to the West, but easier said than done. I never believed it anyway. Now he has calmed down and lies peacefully in the cemetery. Time heals all wounds. Isn't that what they say?

The Americans called it the Concert Night. The Kirsche had brought two extra cushions for the Sister and the Mother. "Plastic chairs and bladders — that's the crux of the matter," she said. She was absolutely right. The Americans have no idea. No idea what it means to grow old, no idea

what it means to live with a leaking bladder, no idea what it means to live with a brain that starts to malfunction, and no idea in general. They don't even know how to grow a potato. "We are not interested in growing potatoes," they said, when Kirsche asked them why they would not want to put a few potatoes in the ground while they were around. These spoiled city slickers! Aren't they eating French fries in their oh-so-great America? It has not always been easy here. Where there is sunshine, there is also shade, but that doesn't mean I have to run away. I don't understand how two young German people like them could leave Germany without being forced. To me that is betrayal — what else would you call it if someone abandons the Motherland? Where did they learn to walk? On German roads. Who fed them? German pigs. Who taught them to read and write? German teachers. And what is their thank-you? A pack of chewing gum. They do "the Cruise." They should get punished for such a goof, so their conscience might return. A man needs to know his boundaries, just like an animal. They need to know their boundaries, too. It's a safety measure, it's for their own security otherwise their minds go insane. They need to know that once they cross a line, consequences will follow. Look what happens to the people who leave their village even for a week to go for a vacation. It's always the same result. They go out for wool and come home shorn. Every year Amelie tells us another horror story when she comes back from vacation. They treat her like a dumb sheep in the world. Her wallet got stolen, in Greece she crashed her car and the insurance never paid, and then the room is always noisy so she

can't sleep and her stomach gets upset from the
garbage they serve the tourists in foreign coun-
tries. Every year she pays one thousand euros for
another drama. What's the use? As soon as I open
my back door and I step out, I am confronted with
the world. East or west, home is best.

The musicians had been recommended by a friend and were sent
to Dasdorf by someone we didn't know, a friend of a friend of a
friend. We never found out what they had been told, or what they
had expected their performance on the cruise ship to be, and
who knows what had happened during their journey from Berlin
to Dasdorf and why it took five hours instead of two. The only
thing we knew for certain was that when we walked toward them
on the narrow path during the second evening at sea to say hello,
the ponytailed trumpet player, who wore a black suit, a white
shirt, a tie, and polished dress shoes, dismissed us with such
unconcealed, heartfelt contempt that any eventual reconciliation
with him moved toward the end of the list of things the universe
would help to negotiate in the next twenty-five years. Luckily
the trumpet player was a soloist and the other two musicians,
a polite duo in their fifties, also dressed in evening attire, were
part of another band, prepared to perform. Despite the unusually
cold weather, the two of them set up under the stage tent and
delivered a combination of Spanish classical guitar and melliflu-
ously tragic vocals for almost an hour. There was a strong wind
blowing when they started but during the performance the gusts
calmed down, the sky began to fill with orange light, and the air
smelled good. The music was sad and beautiful. Mrs. Kirsche
let tears linger in her eyes and so did Mrs. Study, and Mrs.
Trautmann and Mr. Study and CC and Agnes and her daugh-
ter and our daughter. What one day we hoped would become
our independently breathing, eating, walking, thinking baby boy
gently kicked in our belly and Jens dangled his feet from his
chair. Even the trumpet player seemed moved, or at least led

astray enough to not pursue further mental degradations against us. For the first time since we had departed from Dasdorf, it seemed as if our flimsy, barely floating cruise ship revealed to us that it actually had something like a big, deep, aching soul, which could appreciate the uplift that came with music; that we were collectively able to surrender to the music's ability to strip us, layer by layer, of our heavy, innate hardheartedness, so we could soften up and fall in love with the dark German cumulus clouds, as they kept rising up into spheres, filled with little puffs of glowing cotton candy.

After the concert, the Americans squeezed every-one around the dinner table in the tent, and then they disappeared to prepare the food. Nobody said a word and it started raining. I would have told these people that I liked their music, but I was waiting for the Sister to say it. Or at least Kirsche, but neither the Sister nor the Kirsche opened their mouth and said a word. Never count on these female pantywaists. All day long they wear their mustaches proud like a man, from morning until night they bark their opinions like a band of Prussian generals, but the moment their words would make a difference, they can't even stammer out one piece of chicken fart. We sat there in silence as if we all had just killed a foreigner.

After half an hour the Americans returned and said they were having a hard time getting the charcoal grill going because of the rain. The for-eign woman wanted to get up and help them, but she didn't have a raincoat, and since she was shivering already, they did not want her to get wet on top of that, and catch her death. I asked the Mother if I should get the wool blanket so the woman would stop her teeth chattering, but the Mother gave me

a hateful look, as if I had just asked the foreign
women to sleep with us in our bed tonight.

It took another half hour until the Americans
brought the food. Their daughter served it. The
poor girl was drenched from top to bottom, and the
stuffed peppers swam in rainwater from the short
walk between the kitchen tent and the dining room
tent. What misery. We all ate in cold silence and
then the musicians finally left. They had not even

got into their car when the sister erupted like
a volcano. "I can already hear the stories this
pretender is going to tell his highbrow friends
about us dumb peasants when he's back in Berlin,"
she said. "How they came here all dressed up in
fine black suits and sang Italian operas while we
just cowered in the dirt with rubber boots and
didn't know what to say. It's a shame. It's such
a shame, because that pale hag of a woman truly
poured out her soul with that singing, and her
poor little husband, or temporary living partner,
or whatever they call their spouses these days,
kept playing his guitar until his fingers started
jerking like the legs of a dying spider from
the cold. The least I wanted to do was to thank

them, but that repellent ponytail who couldn't
stop behaving like a big time boss, was just too
snooty! Did you see that uptight smile on his
lips? As if dining among a bunch of village cows
like us was dishonoring him as a human being. This
afternoon, when the car pulled in, the Americans
said to me: 'These are the musicians from Berlin
who will play two concerts for you. First there
will be an opera singer together with a man on the
guitar and then there will be a trumpet concert.'
Did anybody hear one single squeak of a trumpet?"

"Pride comes before the fall," the Kirsche said.
"Don't worry. That man paid his price! His bile is
going to hurt him badly all night, while we will be
lying in bed, dreaming of that beautiful music."

No on-board entertainment rivaled the popularity of playing Chinese
checkers, also known as Halma. The rules are simple and easy to
remember and the equipment consists of a checkered board and a
number of little pawns that the player has to move from the home
camp on one side of the board into the opposing camp on the other
side, while negotiating passages with the opponent. For three days
in a row Mrs. Trautmann, Mrs. Study, Mrs. Kirsche, and the woman
the other passengers called Brauner's Inge met around a picnic table
covered in dark green velvet among three apple trees, where they
played for hours while we prepared lunch in the kitchen tent.

Every now and then one of us took a break and sat down on a
chair next to Mr. Study, and observed the ways the women antici-
pated, calculated, and mapped out their strategies; how that made
them gnaw their nails, scratch their foreheads, squint their eyes,
and press their lips together.

If the preceding player had made an unexpected move, the fol-
lowing player's disappointment took over her whole body immedi-
ately. Mrs. Kirsche, for example, groaned. Mrs. Trautmann cursed
before she let the corners of her mouth sag down in tandem with

her spine, while the hope for revenge spurred her right hand up into the air, where it hovered above the game board for long periods of time like a remote-controlled hawk. The nervously-moving fingers occupied the air-space above the board and signaled preparedness to attack swiftly and with precision, while Mrs. Trautmann's piercing eyes searched the ground for a passage, until suddenly, when her turn had come, her hand darted down, grabbed a figure, and moved it forward another step or two. Her upper body then sank back into the chair exhausted, her face relaxed, and for a split second she looked satisfied – until Brauner's Inge's hand started hovering and Mrs. Trautmann's just-relaxed body stiffened and darted forward again, eyes squinted fiercely at the next move.

When the "adult's game room" had successfully established itself as a freestanding table in the open, Miranda set up a kid's playroom on the floor of the performance tent, where she patiently engaged a group of three young girls in playing Uno and the German board game "Do not get angry, man." We suspected that the girls were part of the group who had thrown stones at us the year before, when we had felt the need to emulate a depressed tiger in a zoo, but we weren't sure. The first time they came onboard, they politely introduced themselves as pirates from the "Blackbird," they said please and thank you before and after eating cake and were gener-ally an adorable and thankful audience for Anneliese's nephew, who

started to come by in the afternoons with his girlfriend to play the guitar and sing Western cowboy songs with a heavy German accent.

Mr Study on the other hand never played, nor did he show interest in any sort of game. He used the time to sit motionless in a chair in the tent, where he stared straight ahead expressionless, as if a tilt of his head or the movement of his eyes would further complicate his mortality.

In general, we couldn't make up our minds about their real intentions. That's why we stayed. Just to see what they would come up with next. "In the end we'll be able to nail them down," the Sister said. "It's one of those things that takes time to figure out." On Thursday Brauner's Inge showed up. She walked casually on board in that typical way of hers. As if she had come all by herself. "You cannot just pop up like that," the Mother said to her. "We are in the middle of the Atlantic. We have not seen land for two days. How are you supposed to get here?" Brauner's Inge said that Mike had sent her to tell the Americans that if they wanted to take a cruise, they should go to the Tollense Lake and stop using a bunch of old people to turn the gardens into a dumb circus. Boat tours were offered for reasonable rates on the Tollense Lake throughout the whole summer. The Boss was unimpressed and offered her a seat and a piece of cheesecake. "Tell Mike we are just having a little bit of fun," the Kirsche said. "It's nothing but a humble party between a few neighbors."

"Why not?" she said, drooling like a border dog. "A penny saved is a penny earned. Since my sons are not paying me for my service, why shouldn't I have at least a piece of cheesecake for free?"

After that, she stayed on for two more days. The
Americans don't even know how lucky they are that
Brauner's Inge likes cheesecake. Otherwise, that
could have been the end of it all.

During the cruise a digital camera was strapped around our
necks, a portable audio recorder lay on the table, and weath-
er-permitting, sometimes one, sometimes two video cameras
were mounted on tripods out in the open. The cruise ship, its
crew, and its passengers were "in a constant state of surveil-
lance, worse than in old times," Mrs. Trautmann remarked, as
we tried to document and record the transformation the land was
undergoing from being a place with fixed coordinates to becom-
ing a location-independent platform. The more we recorded,
though, the less clear we were about what exactly we were try-
ing to capture; and at times it looked as if the recording devices
pointed toward nothing but the unattainability of our concept.
Nevertheless we continued and saved hundreds of images and
hours of video and sound on digital chips. Eventually we will
sort through the data and analyze it and then we will get a
better picture of what is happening right now, we encouraged

each other. In hindsight we will understand the details, we
can't connect the dots of the future, only those of the past,"
we said, yet once back in New York City, we never looked at
the footage. Instead we copied the data unseen from the chips
onto hard drives, and then we copied those originals onto several

external hard drives, renamed them, and put them into new folders in order to avoid confusing the copies with the originals. We then sent the external backup hard drives to different physical locations in Europe and America, so in case there was a flood or a fire, there would always be a safe copy somewhere.

On June 4, 2009, a group of about twenty people came down the narrow path, which despite its heavy use was still only as wide as a standard push mower. We met them midway between Village Road and the dining tent, where a tall man in his fifties squeezed by with a firm, eager handshake and a friendly "Good Afternoon." The second man followed his example, as did the next woman and everybody after that.

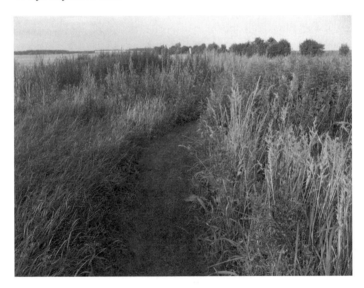

Each person in the group was dressed in some sort of Western outfit. The women wore long, brown, patterned skirts, earthy colored t-shirts, cowboy hats of leather, straw, bamboo or plastic, and all kinds of shoes with Cuban heels and pointed toes. Most of the men wore blue jeans with white shirts tucked in and some of them sported shiny belt buckles or shoestring

neckties and matching Stetsons. Once they had all arrived in what – during the greetings at the bend in the path – we referred to as "the grand ballroom of the cruise ship," a silent awkwardness started to build. "The stage is a little small," we said, as we pointed toward the two Euro pallets in the trampled down grass. Nobody said a word, so we got busy repositioning our small video camera and readjusted the legs of its tripod. Life is always embarrassing when it is naked and unrehearsed and the roles are not assigned yet, we thought, while we extended the legs of the second tripod, mounted the second, much bigger camera, took off the lens cap, pointed the lens toward the dining room tent and then watched through the viewfinder how Mrs. Trautmann, Mr. and Mrs. Study, and Mrs. Kirsche, who sat in their plastic chairs like a bunch of statues just shrugged their shoulders when one of the cowboys stepped forward and asked them how they handled the inevitable seasickness.

When the cowboys marched in I was impressed that they had come by. I am old, I live two minutes away, I sat through the whole thing because of the free food. But these people . . . even Amelie's coworker came out. I didn't recognize her right away, but the Mother did, despite the hat. "I can't believe Mrs. Schneider sees us being part of this," she whispered into Kirsche's ear. "Who is she to judge?" Kirsche hissed back. "Has a husband and three children at home waiting for dinner. And what does she do? Honkey Tonkey with a bunch of guys in cowboy hats."

We had met Anneliese two years before, when instead of taking the shortest route back from Neubrandenburg to Dasdorf, where we had gone to buy string to fix the fence on Village Road, we took a detour on a whim and saw a sign for a horse farm called "Fohrs." We drove past it, but there was something about the sign

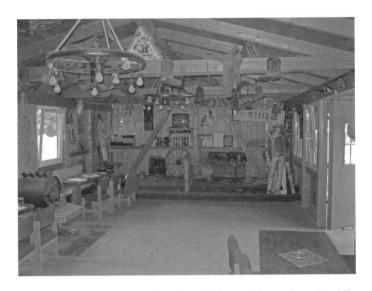

– most likely the fact that the slogan "Rent a Horse from Freddie Fohrs" rhymed and was branded into a weathered wooden board that dangled on two iron rings in the wind above the entrance gate next to the flag of the Confederate States of America on a pole – that made us turn around, park the car on the side of the street, and walk through the gate toward a Western Saloon. A small blonde woman, who seemed to have come in on a steam train from Dollywood in Tennessee, was inside and gestured to us to enter. We followed the friendly invitation and walked through the batwing doors when her cell phone started ringing. She took it out of a brown leather purse with fringes, told the person on the phone that she would come outside, and while she was walking toward the batwing doors, she covered the speaker with her left hand and said to us that she would be right back.

We stayed behind and looked around. Everything in the saloon was made of wood. The floor was made of weathered hardwood planks, the walls were covered with soft, rustic pine, and the ceiling was a patchwork of materials that ranged from cherry to particle board and featured an immense wagon wheel

with milky light bulbs as a rustic chandelier. The edges of the
room were hemmed-in by exhausted looking chairs and benches
that were still recovering, we felt, from a long, distressing jour-
ney that had brought them from a decommissioned waiting room
further east in Europe to this Western Saloon at the Fohrs estate
in Germany. Most of them didn't look as if they wanted to be sat
on. Their reluctance was somewhat matched by a row of neatly
lined-up oak tables that carried the weight of massive blown-
glass ashtrays with the attitude of weight-lifters who had just
tested positive for performance-enhancing drugs and therefore
had been disqualified to participate in the upcoming game. The
wall across the entrance was decorated with one of the most
successful American campaigns for self-destruction, featuring
several rugged Marlboro Men smoking lung cancer-causing cig-
arettes in mind-blowing nature; and in a corner stood a life-size
cardboard cut-out of John Wayne with his hands on his gun hol-
sters ready to shoot, next to a life-size Native American figure
carved out of orange wood, who crossed his muscular arms over
his naked, polished chest. Rows of engraved cigar boxes hung
next to two slot machines that stood close to a mirrored bar with
glass shelves, which featured a full bottle of whiskey, an almost
empty bottle of clear schnapps, and a toothbrush cup holder with
red lollipops. The setup reminded us of the displays in fruit and
vegetable shops in former East Germany, where the customer's
attention wasn't drawn to the product on the shelf, but to the
empty space between the products. Isn't that how the Cubists
saw the world? -- we suddenly wondered. Hadn't the Cubists
established the idea that the negative space between objects was
as essential, or even more essential than the objects themselves,
hadn't they considered the absence around a painted object as
valuable as that object?

After the blond women had finished her phone call and sailed
back through the bat wing doors into the Western Salon, we intro-
duced each other. "You are the first German couple I ever met,"
Anneliese said, "who have made my dream come true. You are

living in America!" she exclaimed and repeated the sentence several times, without letting us explain that there might be a difference between her dream and our reality of living in a one bedroom apartment in Queens, until it became clear to us that "Living In America!" was a sacred object not to be disturbed. When an artificially tanned, chemically curled, boot-cut Levi's jeans-wearing man and a bleached-blonde, torpedo-breasted woman entered the saloon, Anneliese advanced on them with open arms, warmly embraced both of their hands with both of her hands, introduced them as Wolfgang and Heidemarie, then looked at the time on her golden wrist watch, went over to the wall, pressed play on a portable boom box that stood on a windowsill near the entrance, positioned herself in the middle of the room, and clapped her hands four times, upon which the three of them started synchronously marching a few steps forwards and then a few steps backwards, and then to the side, and so on, in what looked like a line dance practice. That was in 2007.

Then, almost two years later, in May of 2009 when we were sitting in our apartment in Queens wondering what kind of entertainment could turn our upcoming land cruise from Dasdorf to New York City into an unforgettable first class experience for passengers, performers, possible bystanders and ourselves, we suddenly remembered that Anneliese, after the line dance practice with Heidemarie and Wolfgang had written down her email address. We found the little paper in the blue folder into which we had stuffed all paper documents related to Dasdorf, and sent Anneliese an email asking if she wanted to do some line dancing on a cruise ship the following week. She instantly sent an email back: "My pleasure! Wednesday five p.m. would work for me if it does for you. I will come with my group. Send address."

And so it happened, that two years after we had watched her line dance practice with Wolfgang and Heidemarie in the Western Saloon, Anneliese entered the grand ballroom on the cruise ship as the last one of her group on the narrow path that led through the overgrown parts of the abandoned parcels.

Once she had fully materialized in the middle of the floating ballroom, that not only lacked the male dance hosts waiting to serve unaccompanied older ladies, but also the parquet flooring and its hardwood inlays, the larger-than-life persona that so beautifully dwelled in Anneliese's rather small body swiftly absorbed the confusion that had rendered the people of her dance group unable to move, talk, or smile. Without any sort of question or hesitation she placed her battery-operated boom box on top of an ant hill, pressed the black "play" button, turned up the volume, clapped her hands above her head and cried "Yeehaw," when the song "I ride a horse" by Raymond Fraggot started to play.

The members of her dance group who just a moment before hadn't known how to act or who they were supposed to be in this place, that bore the name "Grand Ballroom," but no resemblance to that name, followed the call of their leader and assembled into dancing pairs, woman and man, or woman and woman. Anneliese pressed the "stop" button on the boom box again, counted up to four, pressed "play" again, and then they all moved back and forth holding hands, left and right, step by step, synchronized like a mechanical loom, as if controlled by punch cards with punched holes, each row corresponding to one choreographic pattern of the dance. "One forward, two back, three left, four right. And again. One forward, two back, three left, four right."

167

step forward, one two
step to the left
step forward
step to the right
step to the back, turn right
step to the left
step forward
step forward, turn left
step back
step forward
step forward, turn right

It could have been as simple as that, but it wasn't.

step forward, one two
step to the left
step forward
step to the right
step to the back, turn right
step to the left

Eventually a few of the dancers realized that the unevenness of the terrain made it impossible to move perfectly in straight lines back and forth and the tall man who earlier had asked Mrs. Kirsche for advice on handling seasickness cried out: "This is impossible!"

"Absolutely ridiculous," another one cried, and with that the stiff spell was broken. First they giggled when they stumbled out of line, then they laughed out loud, then they purposely stepped into the holes, stroked one another's breasts, grabbed one another's hips and hung onto one another's necks to stabilize themselves again. There are basically only two modes in which the German body knows how to operate when in a group, we thought, watching the dancers tumble back and forth, either stiff and formal like soldiers in an army, or primitive and horny like the members of Germanic tribes in the Teutoburg Forest around nine A.D.

Mr. and Mrs. Study got up, moved their chairs into a single row in front of the tent, and clapped their hands under the open sky, and while we recorded the development of the situation with our video cameras, CC, Jens, and Miranda, who had been in charge of the kitchen, let the thirty small pig intestines stuffed with ground meat, we had bought for the dancers, burn black on the grill. But it did not seem to matter. After an hour, when the dancing was over, the three of them placed the charcoal sticks in whole-wheat buns, drew a thick red line of ketchup on top and, to our utter amazement, distributed them among the line dancers with the unquestionable assertiveness of three mystical apprentices who offer ceremonial implements in a ritual. The line dancers accepted the gifts with friendly earnestness, bowed their heads, and with charcoal stick-filled buns in hand they left the ship, giggling and laughing the same way they had entered, in single file through the mown path, never to be seen or heard from again. Anneliese, however, we would see again.

When the dancers were gone, Mrs. Kirsche crossed the line into the kitchen tent for the first time. "I have a pot of solyanka at home we can eat for dinner," she said. "I can bring it over, but none of the others must know that I brought the solyanka. In fifteen minutes you'll meet me behind the fence. Take the back

path through the field." We wondered about the secrecy but did what we were told. We found the entrance of the path into the field behind the last plot of the gardens, and followed it until we met her at a spot that seemed far out, surrounded by millions of eight foot high corn plants, which had started to grow ears with pink flowers in their midsections. "Pour the soup into one of your pots and return my pot." We followed the path back to the edge of the field, crawled under the fence into the gardens, followed the next path through the grass to the kitchen tent, poured the solyanka from her pot into one of ours, and then dove back into the underwater world of the cornfield. "Thank you," we said. "For what?" she asked. "For letting us know about the path," we said. She smiled.

Twenty minutes later Mrs. Kirsche entered the ship from the front and sat down in the dining room. Mrs. Trautmann planted that special steady gaze of hers onto Mrs. Kirsche's forehead and then raised her eyebrows, which prompted Mrs. Kirsche to look at the white tablecloth, on which Mrs. Study kept tapping the fingers of her right hand. They remained like that for a while and then Mrs. Kirsche cleared her throat.

"You know why Washer's Irmgard gave all the boxes of children's books to Horst's daughter?" she asked, still looking down at the tablecloth.

"No," Mrs. Trautmann said.

"Why?" Mrs. Study asked.

Mrs. Kirsche raised her head, and with the earnestness of a choirboy delivered the explanation, not to the question that Mrs. Trautmann and Mrs. Study were obviously asking with their facial expressions, but to the question of why Washer's Irmgard gave all the boxes of children's books to Horst's daughter.

"This is how Washer's Irmgard told me the story," Mrs. Kirsche said. "My daughter has turned forty-two, and now she is pregnant, which means, excuse my bluntness, the chances of my grandchild being eventually able to read are so low, it's not worth keeping one's basement cluttered with old children's books." Mrs.

Trautmann kept her eyebrows up. "What do you expect from an egg that has been cooking in my daughter's ovaries for forty-two years? It's overcooked. I gave birth when I was eighteen, my mother gave birth to me at seventeen, but my daughter lets me wait twenty-four years? Naturally I gave the books away. I kept the baby bathtub and the baby chair though, I told her, because even if that child turns out to be an idiot, it still will be my flesh and blood and I will bathe and feed it anyway."

Half an hour later, when it was already dark, we served the soup. As we poured a ladleful onto Mrs. Kirsche's plate we were about to give her a friendly wink, but before we could, she snarled at us, "What is that supposed to be? Solyanka? What kind of Americans serve Russian soup?"

Thursday was nice. I had slept so well I almost didn't hear my cock getting everybody out of bed. At eight o'clock, after I finished my coffee and my bread with strawberry jam, I looked out the window as usual and counted the rounds the Americans made during their daily hamster run. He did five rounds again, his wife and his daughter walked one, exactly as they had done the day before; and then they did their gymnastics with the clown, which agitated the Mother, because as a woman she was afraid his wife would have a miscarriage from that snake-bending she did. Around ten a.m., the Americans went to Burg Stargard to buy coffee rolls and another spray can of heavy cream. The Mother, the Kirsche, and the Sister immediately went over and played Halma for more than three hours. Finally I had some peace and quiet to just sit there. As a child I liked to look up and watch the clouds pass by, but now my neck hurts and I can only look straight ahead and see who is walking by on the street. My grandfather used to

say that every cloud has a silver lining, but all
that's left from that piece of wisdom is the sil-
ver handle on the coffin I see waiting for everyone
at the end of Village Road.

I am a dying old fool, I am long overdue, but
I haven't yet had the opportunity to share my two
cents. My grandfather taught me lessons in life,
but what have I passed on? My own grandchildren
never gave me a chance. Whenever there is a vaca-
tion they fly to Mallorca and lie in the sun on the
beach with their eyes closed all day. Everything
about that is wrong, not just the skin cancer.
Don't call me when you get it. But they wouldn't
call anyway. They don't even make a phone call to
thank us for the money the Mother always sends
them for their birthdays. Not even the fifty euros
for Christmas. To them that's nothing. They've
always had too much. They never starved, they
don't know what suffering is; they never did not
get what they wanted. They lie in the same yellow
sun that also shines in Dasdorf, and let it cost
them money. Every penny we save, they spend.

We troubled ourselves through day and night,
the Mother and me, never counting the hours we did
not get to live like humans. We worked for them,
crawled around on all fours, prayed without a God
in sight, just to make sure they were all right.
And what's the gratitude? My own grandchildren
can't wait to run out of the door when I talk to
them. All they want is the twenty euro bill in my
pocket. It feels as if I am paying them by the
minute for their gracious presence. It torments
them to be around us. They cringe when I open my
mouth, and I see the disgust in their faces when
they look at the Mother's ugly throat.

It's not that I cannot think of a way to spend
my money. I could buy myself a new shirt. There
are hundreds of shirts in that mail order catalog
we get. Green ones, blue ones, brown ones. But I
don't do it, because the Mother and me, we want
to do something good for them. It's all a disas-
ter. It's how their parents brought them up. No
manners. No discipline. A spoiled, bored brood,
and dumb on top of that. "There is no need to lec-
ture me," Robert said to me last time I talked to
him. But what does an eighteen year old know? Or
twenty or twenty-five or however old he is now. Of
course there is a need to lecture him. I've been
through things I can't even imagine myself any-
more. Things one would never talk about, because
if one did, one would be locked up for saying such
things. They will never find out what the war did
to us. That goddamn war. That horrible piece of
pride we kept shoving up our asses, until we fig-
ured out what that ass-shoving led to. But then
it was too late. Anyway. I've paid my dues. I am
done. I did what I was expected to do at the time,
I did what I was expected to do for more than
seventy years, until my legal retirement. While
everybody else was fired after the Wall came down,
they kept me on in the stable. Why was I one of
the few they kept despite my age? That's what my
grandson should ask himself. In my entire life of
work I only missed six days. After a life like
that, who is out there to prevent me from sitting
on the sofa? I can fart into the cushions as long
and loud as I want to. I can blow up every sin-
gle one of these cross-stitched cathead pillows
the Mother keeps producing like a factory, as if
there was nothing better to do than stitching.

173

Maybe I should have gotten that hearing aid,
so Robert cannot use that as an excuse for not
calling anymore. That I don't hear what he says
when he calls me on the phone, "that's why he
stopped calling," he says. As if it was important
what he says. Nobody cares what he says, but it
is important that he calls. Is that so difficult to
understand? Erwin got his hearing aid right after
the Wall came down. He got used to it over the
years, he says. He turns it off, when the Kirsche
gets on his nerves. "The most useful part of the
hearing aid is not that I can turn it on and hear,
but that I can turn it off and get some peace from
my wife," he said to me. But now it's too late
anyway. It's not worth it anymore. The sheep lie
in the meadow and nod while they're chewing their
cud, and I am sure they couldn't care less whether
I have a hearing aid or not.

Every day the Americans set up the Halma table
in the same spot where Trude once planted her
two-headed cherry tree. That Trude woman. She
was a special lady, that's for sure. She grafted
the tree herself. The first two or three attempts
failed, and everyone told her it was a waste of
time. "Haste makes waste," she said, and tried
again, and after a couple of years, she actu-
ally managed to graft a shoot of Dietmar's sour
cherry tree onto the rootstock of a sweet cherry
tree. "Come and look at my little wonder tree,"
she would call out when I went to feed the ducks.
That Trude woman. After five years the tree had
a few sweet cherries and then later a few sour
cherries. The tree is like me, Trude used to say.
"A little bit sweet and a little bit sour." The
Mother never liked it. "Neither fish nor flesh,"

she said. "There will never be enough cherries on that tree to make some jam, or even to bake a pie. What's the use?"

In the beginning the garden parcels were much sought after. First come, first served. Fuchs threatened to kill the mayor if he did not get one. What an idiot. The Mother did the right thing. She stood in line in front of the municipal office ready to get on the waiting list, when there wasn't even a waiting list out yet. That was the way to go. And now, nobody cares. Everybody goes to the supermarket. They drive across the border because it's cheaper there. The Mother keeps saying we should go too, Amelie could drive us, but where does she park in Poland? You park your car and when you get out of the supermarket, they have smashed the windows, swiped the tires, and emptied the gas tank. That's what you get when you pay

fifty cents for a pound of carrots. I keep telling
the Mother, that's what those carrots will taste
like in the end. Like empty gas tanks. Nothing in
this world is for free and I would not even eat
these Polish carrots if they cost a cent a piece.

What brilliant logic, these masterminds of ours.
When the collectives couldn't produce enough and
people started to get angry, the government said,
why don't you produce some extra food on your own
after work. We'll subsidize it.

In Dasdorf the program started in 1971. First
only with rabbits, and then they added eggs, veg-
etables, fruits, even carp from the ponds. The
grocery store was required to buy it. Otherwise
there wouldn't be any fresh produce in the gro-
cery store. The produce shelf would have been
empty! But who goes to the grocery store other
than the people who are supposed to grow and sell
their food there? It was hilarious. The Mother
would collect a dozen eggs in the morning and sell
them at the back door of the grocery store before
she went to work, for two marks. They would subsi-
dize it, and during lunch break, the Mother would
return and buy them back for one mark. Most likely
the same eggs. In the same box. Even the biggest
fool could see that this was going nowhere. It was
just a matter of time. The few smart rats who left
the sinking ship got shot at the border. So what
else was there to do but try to make the best of
it? I specialized in rabbits. At one point I had
more than one hundred rabbits.

Ahhhhh, how it hurts. My knee, my heart, my
chest. I should not have eaten the leftovers from
last week. But what am I supposed to do, feed it
to the ducks? I hate that word. Leftover. I keep

telling the Mother, cook the portions right, we eat what's on the plate, end of story. I eat three potatoes for lunch. Medium-sized. So, if they are really big, I'll eat two of those, and if they are really small, I will have four. What is difficult to understand about this? Why can't the woman get it right? I know she means well, but all I end up with from her cooking is that burn, this elephant sitting on my chest, ahhh! The doctor said I am going to have a heart attack if I don't lose weight. "Is that how you want to lose weight?" the Mother asked me the night before, after we had finished the solyanka. I was sure the Americans had served the soup as an appetizer. We sat there and wondered what would be for the main course and why it took so long, and then the daughter came and brought a plate with broken up pieces of dark chocolate and apologized. "This is all we have for tonight, something went wrong in the kitchen," she said. They always send their daughter to deliver the bad news. No one could be mad at her. Gentle as a lamb. And she was smart too — she rarely talked to anybody. She simply kept away from all that misery that builds up like a cancer once people start exchanging their opinions.

Thursday night was the Talent Show. Mrs. Trautmann had brought her accordion on the back of her bike from Burg Stargard for the occasion. She was the only contestant. On stage she looked like CC just three days before. A small woman surrounded by nature's abundance of overwhelmingly green leaves on branches. Mrs. Trautmann had not touched her instrument in more than twenty years. During that time, she had either shrunk or the accordion had grown bigger, either way it was almost impossible for her even to reach around the front and press the different buttons there. The

whole thing was simply too bulky to have its bellows squeezed by a woman her size. Nevertheless, she tried, and eventually she produced bits and pieces of sound that had some resemblance to *Little Rose on the Field*, a poem by Johann Wolfgang von Goethe set to music by Franz Schubert. The song is about a boy who falls in love with a red rose that rejects him. Angry, the little boy goes ahead and breaks the flower. The red rose fights and pricks, "yet she sighed and cried in vain, and had to let it happen."

People slept at work and worked when they got home. No difference in the paycheck. Some years I made more than nine hundred East German marks with selling rabbits on the side and the Mother three hundred marks with her eggs. And then we had that big cherry tree and lots of rhubarb we sold. Now it's the opposite. These low prices at the store make us look like fools, who work a whole summer for a bunch of carrots that are worth fifty cents. That's what makes me angry.

Such piggish hardship for nothing, fifty cents per pound. The seeds are almost as expensive as the produce when you buy them. It's all bullshit. Of course I collect my own seeds from my own plants. But then I got the problem with the fertilizer. Before the Wall came down I just asked whoever was in the stable to load some manure on a truck and dump it in front of my garden for a beer and a schnapps. One hand washes the other, that's how it always worked, and now they tell me I should pay them. Are they out of their minds? I am not paying for manure. These bandits. They squeeze over one thousand cows into that stable and can't afford to part with one load of dung? It's like a high security prison.

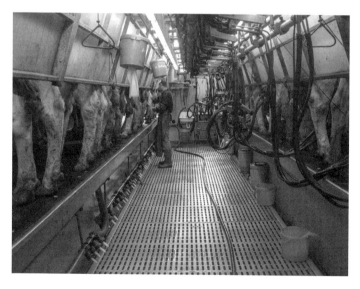

One can't even go there with a wheelbarrow and carry some shit away. And everybody knows why. Their shitty dung is poisoned with the hormones

they feed the livestock, and they are afraid it will produce evidence if we use it in the gardens. But who needs evidence? Those exploding udders speak for themselves. What they feed those cows didn't grow on the meadow behind the barn. Disgusting. That's what it is. No wonder the milk tastes bad. It's actually a blessing that they don't give me their dung. If I would use it on my plants, I could probably milk the Mother next year.

Nevertheless, what a drag, Fuchs's brother-in-law did this stupid thing. If he wasn't good for anything else, he was good for free manure. And then that idiot burned down his stable. What a lunatic. Put his three cows in his brother's stable and the next day everything is on fire and he thinks the insurance guy is as dumb as he is and is going to pay him. Wherever he goes, disaster follows. He is just one of those poor bastards who can't even help it. Cursed. That's what he is. Fate is inescapable when it runs in the family. Lucky me, my father didn't line up two refugees behind the barn and shoot them because he thought that was obligatory to win the war. Who wants to pay for something like that? Just thinking of that Fuchs's brother-in-law makes me sick. How rotten his brain must look from the inside. Full of maggots I bet. Eventually they'll need to cut it out and lock him up. They should have done it after he burned down the stable. Who knows what he will do next? For years he's been running around, mumbling the same sentence. "Some things you can't explain. Some things you can't explain."

I still see him in the bus station with a bottle of corn schnapps. That was twenty-five years ago. I sat down next to him and I said, "What is wrong

with you, Old House?" And he tells me that ridicu-
lous story about milking his cow. After the bucket
is almost filled up, the cow pushes it over with
her left leg. He gets angry and takes a rope and
ties her left leg to the stable wall. Continues
milking and when the bucket is almost full again,
she kicks it over with her right leg. Only a guy
like Fuchs's brother-in-law could own such a stu-
pid cow in the first place. He takes another rope
and ties her right leg to the other wall, and con-
tinues milking her. And right then, when he was
almost finished, that bitch of a cow pushes the
bucket over with her tail. He's furious, but since
there is no more rope, he takes the belt out of
his pants to tie her tail to the ceiling. Without
the belt his pants are loose and they fall down
while he is trying to tie up her tail and that's
the moment his wife comes in the stable and sees
him like this. She runs out of the barn and locks
herself into the bedroom.

 So the next day I go to her house and I say,
Margarete, I need to talk to you. Margarete, I
say, that whole story is just a bad joke. If it
wasn't your husband you would laugh about it,
like everybody else laughs about it. She is in
the kitchen cooking potato soup. I tell her how
one thing led to another and after I am finished
she just lifts the lid and spits in the pot. And
a month later she hangs herself. In the little
birch patch near the pond. That she used the oak
tree was the worst part of it. That she did it
where the children play, used their swing to get
up there. How can you let the children find you?
"If that is who she was, then it's better she is
dead," the Mother said. Fuchs's brother-in-law

was nowhere to be found. Her own father had to
cut her down. What a dreadful sight that was. Old
Fuchs collapsed on the ground, his dead daughter
on top of him and the children behind the bushes
saw it all.

Give and take. A day went by. What did we give? A day that
went by. What did they take? A day went by. Wasn't everything
a given, anyway? A priori knowledge, a lifetime sentence? What
a thought, we thought. Back then. A day went by. We weren't
giving up; they weren't giving in. A day attached itself to a date
and . . . went by. What in the world had we gotten into? Give or
take, a day went by. We took their time, we took our time, a day
went by, they gave their presence. We gave them food. They gave
us time. We cooked; they ate. We ate what we would have never
cooked except for them. We gave them entertainment, they gave
us more than that, but what that was, give or take, how could we
know, unless another day went by?

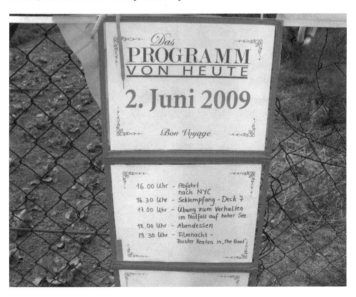

We sat next to Mrs. Kirsche on the blue-and-white lounge chair, feet up, and looked out at the ocean.

"Your father still alive?" Mrs. Kirsche asked out of the blue.

"Yes."

"He has a job?"

"Kind of."

She nodded.

"Is your mother still alive?" she asked.

Alive? What does alive mean in Dasdorf, we thought and looked at her from the side. Mrs. Kirsche had put on lipstick. She had been to the hairdresser in the morning. Her blow-dried hair went well with the breeze on the outer deck. We looked at the field in front of us, the dark green of the healthy looking leaves of corn. The wind. The swaying. We looked at the clouds. Our feet could touch them. There was a faint smell of hairspray. It brought the scattered particles of happiness that stick on the soul. She had gone to the hairdresser in the morning. We felt relief, that there still was a hairdresser in Burg Stargard, that there was a woman behind a sink who squeezed shampoo into her hands and then rubbed it into hair that had grown long in Dasdorf. That someone washed their hair. And combed it. That there was a woman who held their heads as she ran her fingers through their strands and cut them... And that Mrs. Kirsche had put on lipstick. And that it looked nice. And that she smiled. And that we could smell the hairspray.

Mrs. Kirsche nodded.

"Brothers, sisters?"

We answered. She nodded.

"How old?"

We told her, she nodded.

"Grandparents?"

We answered, she nodded.

"Where do they live?"

We told her, she nodded.

"Uncles, aunts, cousins?"

We answered, she nodded.

"Where do they live?"

We told her, she nodded. Point by point we obliged, filled out her survey and supplied Mrs. Kirsche with the numbers, names, and zip codes of our German relatives, as if we were applying for a passport and had to prove the German blood in us. Then the conversation was finished. We fell silent and stared at the life preserver.

After what seemed to be an hour, but probably was no longer than a couple of minutes, Mrs. Kirsche spoke again. It was unclear if she was addressing us or if it was her habit to speak out loud when her mind worked through certain topics.

"Old age is the worst kind of poverty," she said. "They say, getting older is an advancement, and being old is just the awful price one pays for it. I always took pride in my work. Working was all I did all my life. Why should I be around if I am not useful anymore? Last fall in early October, when I dug out my potatoes, I put them in the basket, like I've always done. I have used the same basket for forty years. My aunt had given it to me. I put the potatoes in, but then I could not lift it anymore. It was impossible to strap it on my back and carry the potatoes home. I knew it wasn't just that I couldn't lift up the basket because I was sick, or because I had a bad day. I knew it right away. This was how it would be from now on. I would never be able to lift that basket again. What disgrace! I wanted to die on the spot. I said: 'Death! Come and catch me,' and then I sat down on the bench and waited. I thought of all kinds of things while I was waiting, this and that, my cats, my daughters, and when he finally appeared with his scythe in his hand and said, 'Are you ready,' I was already worrying about not getting the cabbage soup ready in time for lunch. I looked up at him and without even thinking I said, 'Help me lift up my basket so I can strap it on my back. I need to get home in time for lunch.'"

The ocean looked calm. The ship advanced at a steady thirty miles per hour. Not fast, not slow, but steady. The sky was ever so slightly blue. No clouds.

There was a white line of past turbulences attached to the ship's path, getting thinner and thinner in the distance. "Cows are

184

as hungry on a Sunday as on every other day of the week. I never took a vacation. I never went to the ocean. But now I see how big it is. I guess it's endless," she said.

The head of state, Erich Honecker, arrives in the morning at his office in the Palace of the Republic. He opens the window and says: "Good morning, dear sun!" "Good morning, dear Erich," the sun says. And at noon, after he has lunch, he opens the window again and says, "Good day, dear sun!" And the sun says: "Good day, dear Erich." And in the evening, when Erich is ready to go home, he opens the window again and says, "Good evening, dear sun," but the sun doesn't answer. "What's the matter?" Erich asks, and the sun snorts, "Kiss my ass, fucker! I am in the West, now!"

Every time I think of that famous joke, I have to laugh, that's all I need. But people nowadays need more than one good joke. They want to be

"happy" all the time. As if that's something to
kill an ox for. What about surviving first? No hap-
piness when you are dead, no matter east or west.
They haven't seen enough heaps of human bones
to understand that it's this that counts in the
end. Dead or alive. Nothing else. They don't know
how to kill a pig, but they know how to carve a
watermelon. "We watched a tutorial on the com-
puter," the Americans said when they put it on the
breakfast table. "It's a tradition in Thailand."
But why should I care about a carved watermelon
from Thailand? "The Americans adorn themselves
with borrowed plumes because they have nothing
of their own to bring to the table," the Mother
said. Why not make a decent potato salad and get
us some beer? We don't need to be cultivated with
traditions from Thailand. It just makes me angry
when food is used as decoration.

Landcruise

```
Every day of that year in Russia I was hungry.
Every minute of a whole year I thought of food.
People killed themselves because they couldn't
take it anymore. And now? At the end of the day, I
took the whole watermelon and fed it to the chick-
ens. What a waste. And the next day, they just
went ahead and carved a new one. It looked like a
crown with a carrot on top. Like an exposed dick.
Is that what they laugh about in Thailand? A dick
at the breakfast table?
```

On the last day of the cruise it poured down without the mercy of the tiny spaces that usually occur between raindrops. A seamless wall of waterfalls that poured down from the roof surrounded the tent; nevertheless at half past eight a.m. the passengers broke through to attend the "Hello America" brunch. In anticipation of her paycheck, Agnes had shown up at seven a.m. and loaded the table with an arrangement of coffee and orange juice, hardboiled eggs, a variety of cheeses, bread and rolls, butter and rose hip jelly, cut fruits, yogurt, and stacks of soggy croissants as nicely as she had never done it before and without one word of complaint. Her daughter had brought a cheerful friend along. They both helped Agnes setting up the table. Mr. and Mrs. Study, Mrs. Trautmann, Mrs. Kirsche, and Mr. Krater, who had brought another bowl of batter for which he charged us seven euros fifty despite us being unable to bake the waffles because of the rain, ate as if it was their last day on earth. When nothing but a few crumpled lettuce leaves was left on the platters, the floods around the tent returned to regular rain and everyone turned their chairs toward the stage, where an art auction was scheduled to begin.

Marina, a late responder to our online call for entertainers, was from Berlin. She had spent the morning running along the path, back and forth between her car parked on Village Road and the stage tent in the back of the gardens, stacking up about fifty of her paintings under a plastic tarp. We thought it wasn't worth it; we tried to save her from letting the rain ruin her work, but she insisted

and soon we realized that talking to Marina was like talking to a
stranger who had climbed up on the guardrail of the Golden Gate
Bridge and was about to jump off. She was extremely anxious,
mad with an unstoppable and exponentially growing anticipa-
tion of the opportunity to let go. Every time she ran with another
painting through the rain, it was as if she was experiencing the
liberation that is said to come with the final jump, and every time
she survived only because Jens, patiently waiting for her under
the stage tent, dressed as an angel in white pants and a white vest,
caught her before she hit bottom.

The official auction began at eleven a.m., when Marina pulled
her first painting from under the black tarp and put it on an easel
under the tent. When it was leveled perfectly, she nodded toward
Jens and took a step back. Jens read through the bullet points
Marina had prepared in a binder for each of her paintings – mea-
surements, materials, date of creation, her inspiration, and a gen-
eral interpretation. Painting by painting, Jens blurted Marina's
innermost personal and professional details out into the open air,

while she stood right behind the easel, motionless and ceremonial, like a guard at Buckingham Palace. When Jens skipped a part or read too fast, she corrected him matter-of-factly, without turning her head; when he mispronounced or skipped a word, her fists tightened. Once the formal introduction of each work for auction was accomplished, Jens stepped forward and switched into sales mode, appealing to his audience with the enthusiasm and charisma of a candidate for the American presidency. The more he did it, the better at it he got. Eventually it sounded like the start of a revolution. "Despite being the poorest people in Germany, you should buy a work of art and put it up in your living room, high above the sofa, so you will have to look up to see it. Once your chin is up your attitude and self-perception will change as well."

Not one bid was placed, and nothing happened. Jens stepped from under the tent out into the open, expanded his arms and exposed the palms of his hands toward the heavens from where he seemed to expect practical advice. We suggested he skip the presentation of the remaining thirty paintings, but Marina, determined to prevent any intervention on her behalf, firmly shook her head and exchanged the twentieth painting on the easel with the twenty-first. There was no way to stop her now. Jens complied. They proceeded calmly and with sincerity. And then, after the display of a few more paintings, Marina's husband, who sat in the third row under the dining tent with two digital photo cameras around his neck, suddenly started bidding, against himself, almost frantically. Behind him, in the last row, sat Marina's mother, who had come with them on that early trip from Berlin. While her son-in-law staged an irrational frenzy of hyperinflation last experienced in the Weimar Republic, yelling two thousand euros, three thousand euros, three thousand three hundred, four thousand eight hundred euros, four thousand nine hundred euros, twenty thousand euros – bids Jens repeated frantically, for the first, second and . . . almost third time, until he was interrupted by the next bid again, Marina's mother pulled a medium-sized bottle of a high percentage grain liquor out of her brown leather handbag

and passed it around. Everyone took a sip. The effect was almost immediate. The passengers' faces turned red, and then they started bidding, first against Marina's husband, then against one another. The numbers skyrocketed in irrational increments, and their voices grew louder. They clapped, they cheered, the auction lasted almost three hours, and by the time it was finally over, Marina's lips were as blue as her fingernails. She had virtually sold everything, even the paintings that had been rejected first, and wanted to smoke a cigarette. And while we stood there, holding the cigarette in front of Marina's trembling lips so she could keep her hands in her pockets and suck in the smoke that gave her comfort, our ship approached New York Harbor. Everyone staggered to the railing, and when she saw the Statue of Liberty floating by, Mrs. Trautmann said she knew it all along, "New York was built on nothing else but water."

The Boss had dressed up as the American freedom statue with a torch. First I didn't even realize what it was supposed to be. I just thought why is he in the middle of the field and what is he holding

up? It was pouring. Ice cold. Almost hailing. "I didn't come all the way to America for rainy days like these," the Sister complained while she was taking photographs. "That's no rain, that's smog," the Mother said. "That's how polluted the air is over a big city."

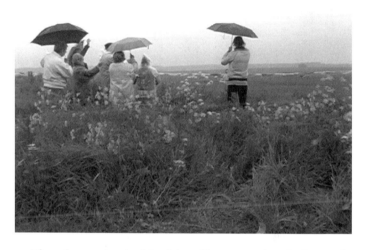

The clown started to kiss the ground and shouted: "Bless America, bless America." Miss America gave us sparklers, and after we had burnt up all three packages and waved at the Boss as he was hopping through the field, she said we had arrived, and Miranda shook everyone's hand and said: "Welcome to the United States of America." And then Krater jumped forward and asked how much they would sell it for. They said they had bought it for two thousand euros and they couldn't sell it for less. Krater said he would pay twenty-five hundred but the Boss said it was waterfront property, it was

prone to flooding, so two thousand was enough, and then I understood. They were talking about the gardens. Krater said they had a deal.

Krater? That cheap, messy crook. In which one of his five hundred piles of useless garbage did that loggerheaded hoarder find two thousand euros to buy our land right off the bat? They shook hands. "It's a relief," the Americans said, "to get rid of the property." They didn't even ask us what we thought about Krater as a new landlord. We stood there like idiots. "We pressured them too much," the Kirsche said. "We should not have told them about the street. How much it will cost them when the village is going to tar the left side of the street." Should have, should have, should have. Too late. If the devil can't come himself, he sends an old woman. "With the length of the property facing the street, it's going to

cost you at least twenty thousand euros when they come and fix the street next year," the Mother and the Sister kept telling the Americans over and over. They just can't control their vocal discharge anymore. Everybody knows the village won't tar the other half of the street. It hasn't been done for the last twenty years, why should it be done now? All we got out of their talking is Krater, who is either going to triple the rent or throw us out.

The sparklers had not even sparkled all the way to the end when Mrs. Trautmann asked: "What are you going to do with the dining room tent?"

"You can have it," we said.

"What about the garden chairs?" Mrs. Kirsche asked. "What about the lounge chairs, the table, the sun umbrella, the grill, the Halma game, the pallets, the tablecloth?"

"You can have it all," we said.

Without another word they turned and ran. They grabbed and they dragged and they carried and they pulled and they yelled. Their passion for passiveness was gone. We stood there like Achilles after losing the race against the tortoise in the parking lot of a super mall on Black Friday and watched – confused, exhausted, freezing, and completely wet. All we wanted was to go home, crawl into bed, and give birth to our son.

```
"You grab the tent, I grab the chairs," the Mother
yelled. Krater was there first. "They sold me the
land," he said. "They sold you shit," the Sister
said to him. In the end we did well, the Mother
and me. We got the dining room tent, two lounge
chairs, one of the big pots, and the pallets.
```

Nobody stood on Village Road and waved when we got into the van and left Dasdorf on that gray afternoon. We were certain we would never return.

Three months later our phone rang. The leaves on the maple tree in front of our window were waving slightly in a hot breeze and we were barefoot when Mrs. Kirsche made her long distance call from Dasdorf to New York to update her survey.

While she was talking to us from far away we were looking out the window, and realized for the first time that the foliage of the maple tree in front of our window had grown so thick and green that it was impossible to see the brick houses across the backyards that seemed so close during the winter time. Mrs. Kirsche insisted on writing the information we gave her down on a piece of paper, so she could share it with the others, and while we spelled out our baby's name, and kept repeating the letters that made up his first, his middle, and his last name, as well as the numbers that described the weight and the lengths of his body on the day of his birth, our amazement at nature's outpouring of so many green leaves on a single tree alone sank in with some strange heaviness.

"When will we see the boy?" she asked.

We did not know what to say. We got up from the sofa and rushed into the bedroom to see if he was still there. "I have a special edition coin for him. I want him to have it," Mrs. Kirsche said. "Once a year our bank in Burg Stargard gives out special editions of ten euro coins for eleven euros each. I usually buy one for each of my grandchildren, but this year I bought one extra."

He was there, sleeping in his small wooden basket on the floor, breathing evenly, his little chest out in the open, his hands beside his head.

"You have to come and pick it up," Mrs. Kirsche continued. "I would send it, but I never put money into the mail. Especially not overseas. This is a special coin, so it has extra weight. They probably would charge me five euros to send it. That does not make sense – it halves the value of the coin. You understand?"

We said yes, and after that Mrs. Kirsche hung up, and we thought of winter being here in less than three months. All the leaves would be gone and the two-story brick houses across the backyard would be visible again, and behind them, the six-story brick buildings and a patch of sky in which we would see airplanes for a second or two, in five-minute intervals, on their final descent into New York City. Dasdorf wouldn't be our son's first trip out into the world, we thought. Anywhere else, but not Dasdorf.

The Kirsche and the Sister had been right. It was a boy and she had squeezed him out on his due date without any medication. America should feel lucky for receiving such a gift from our gene pool, the Mother said.

Every year on October 20th, no matter what day of the week, the people of Oasis held a UFO preparedness training. Oasis was one of the closest settlements to our ten-acre lot in Nevada, and for the last three years we had attended. We had parked a rental car on the side of the road that led into the settlement, walked into the settlement like aliens, stood around like aliens for a while, and a little later left and drove away, always with the nagging feeling of having missed something important.

Oasis was a town, that had been built on one man's privately-owned property, and therefore wasn't actually a town at all, but rather a semi-private cult furnished with trailers. On a satellite image the layout of the settlement looked like a child's abstracted drawing of a daisy. A long, straight dirt road, a driveway really, branched off from NV-233. This stem connected, half a mile

down, to a big circle, a sort of central disk from which four other short roads spread out like rays of the sun, each one leading to another, smaller circle. Between five and seven trailers or small houses were placed around each smaller circle and about half of them seemed inhabited. The outer ring of the big central circle was planted with trees; the inside was perfectly flat and empty in order to ensure the safe landing of the alien ship that the community had been eagerly awaiting since the late seventies.

On October 20th of 2009, when we entered the town, the self-proclaimed mayor of Oasis introduced himself and spoke about the town's history with alien – as well as US military aircraft – encounters. He explained that the people of Oasis had decided to extend the durational margins for a possible UFO landing, and that we should come back the next day and bring a homemade German potato salad. He said he would throw a couple of burgers on the grill and we would have a good time. Now that we had brought not only our daughter but also our newborn son, it was time to loosen up and embrace some family values, the mayor said. The request was a nice gesture, but somewhat challenging on a practical level. We didn't have a bowl. We didn't have a pot. We didn't have a hot plate. We were staying in a hotel room in one of the casinos in Wendover. We did not know what to say. Our inability to decide whether to say "yes, we will bring a potato salad," or "no, we cannot bring a potato salad," prompted an elderly man who had been living in Oasis for fifteen years to step forward and take action. "Potato Salad," he said, and gestured for us to jump into his military jeep, in which we then drove into the mountains, higher and higher up, until the sage brush that dominated the valley around Pilot Peak was replaced with small, crippled cedar trees. Halfway to the summit of Pilot Peak we stopped at an abandoned-looking apple orchard, possibly the actual oasis that had inspired the people down in the valley with a name for their rather dry patch. There was a little pond, fed by a spring, surrounded by green weeping willows; an abandoned sheep pen with a sleeping copperhead snake on the doorstep; and

lots of green grass, which we had not seen since leaving Salt Lake City a couple of days earlier.

On the apple trees, which were mostly dead, grew potatoes. Potatoes. Normal-looking potatoes. "This is Nevada," our guide said, as he seated himself on the ice cooler filled with bottles of drinking water intended to keep us hydrated in the burning sun, and smiled. "Go. Get them!"

Miranda returned his smile with one of her deeply mysterious looks that always made us realize that she had understood everything, while we could not even begin to comprehend. She took a bowl, stepped forward, and started scraping the potatoes off the trees with a stick. We followed her example, and collected enough potatoes to feed not only the people of Oasis, the expected aliens from outer space, but also the Airmen and women from the nearest US Air Force Base, should they decide to drop in. After we had loaded the potatoes into the back of the old man's jeep, we seated ourselves next to him on the ground, and tried, like him, to contemplate the big, beautiful valley in front of us, which was hard, because we could not stop thinking about the potatoes,

what kinds of weapons the US military was testing in the Nevada deserts and what the sun at this altitude could do to our baby boy if we let it shine much longer on his little head. Eventually the old man got up, we hopped back into his jeep, the old man released the handbrake and we rolled all the way back down into the valley pulled by nothing else but gravity. We transferred into our rental car furnished with airbags, airconditioning and seatbelts, drove to Wendover, crossed the crowded gambling floor of the Montego Bay casino (not without dropping a quarter into a slot machine), got into our mirrored hotel room, put on bikinis, shorts, and sun lotion, went back to the casino restaurant, borrowed some knives, went to the pool, and sat down at a table under an artificial palm tree to peel thirty pounds of tree-potatoes. Now, the question of cooking them arose. We needed time to find a solution without worrying about the peeled potatoes going bad, so we filled the bathtub in our hotel room with all the ice cubes the self-serve machines on floors eight, nine, ten, and eleven at Montego Bay were capable of spitting out within a fifteen-minute period, and gave the potatoes a cold bath in the bathtub. By the next morning

we had befriended a beautiful young woman with long hair, cut-off jeans, a hot plate and a big pot, whose mother, she said, had made her a contestant in beauty pageants from the age of five. She was temporarily living at the edge of town near the Salt Flats,

in a trailer near a runway whose lights could be turned on by pilots who were arriving at night, remotely from the dark sky. There was also a big, old, patched-up airplane hangar, which had once housed the "Enola Gay," named for Enola Gay Tibbets, the mother of the pilot, Colonel Paul W. Tibbets, who flew the Boeing B-29 Superfortress bomber over Hiroshima and dropped "Little Boy," the first atomic bomb on August 6, 1945, which killed about 66,000 people and injured about 69,000 to varying degrees.

"Did you know that Tibbets's mother herself had been named for the heroine of a novel?" the hot-plate lady asked as we dumped our second batch of peeled potatoes into the boiling water.

"Yes," we said.

"And, have you spelled 'Enola' backwards?"

"Yes," we said.

"The novel was written in 1886 by a woman called Mary Young Ridenbaugh," she went on, "do you know what it is called?"

"*Enola; or, Her Fatal Mistake.*"

"Do you know the poem that introduces the book?"

"No."

"Do you want to hear it?"

"We have four more batches of potatoes to boil, we probably can read the whole novel," we said.

Oh, fatal day – oh, day of sorrow,
It was no trouble she could borrow;
But in the future she could see
The clouds of infelicity.

It took four hours to boil and cut all the potatoes, pickles, onions and the parsley that go into a German potato salad and mix them together with sour cream, salt and pepper, enough time for our new hot-plate friend to relay to us in chronological order her research about the serial killer incidents that had happened at the rest stops along I-80 since the fifties. Later that afternoon, when we drove along I-80 back to Oasis, with the hot-plate lady squeezed between Miranda and the baby boy in the back seat, we could not really see concrete evidence of this deadly dimension of the American interstate system, yet we sensed, along the straight road something frightening that haunted us for a while.

The people of Oasis, Nevada not only grew potatoes on trees, they also harvested frozen water cubes from the abandoned mines that a century earlier had been tunneled into the mountains by thousands of men and women who had come to the West in search of silver and gold. The man who had shown us the potatoes was eager to show us the ice cube mines – the ones some locals called the "i-cube mines." We put the potato salad on a folding table near the BBQ grill, jumped into his old jeep again and drove up the mountain on a different path. We stopped in front of several big heaps of red earth scattered around a few

abandoned trailers and log structures. Narrow tracks led to the entrance of the old mine; a door-like hole stabilized by wooden planks led into a narrow tunnel. There was a heavy draft in the entrance area, and just a few minutes' walk inside the dark tunnel the temperature, which had been baking hot outside, was almost freezing. We kept walking down the pitch-black tunnel, our eyes slowly adjusting to the light from the flashlights on our foreheads, until we came to a carved-out area with a wooden signboard that said, "Keep Out!!!!"

"Typography is what language looks like," the hot-plate lady said matter of factly. She was right. Whoever had written the warning would surely have screamed it into our faces. "It's filled with old dynamite that hasn't exploded yet," our guide said, pointing at a stack of rusty sticks bundled with a rope. We held our little baby boy very tightly and followed our guide deeper into the mountain, until we heard noises of tools and then voices. The underground tunnel opened up into a big cavern and it got lighter.

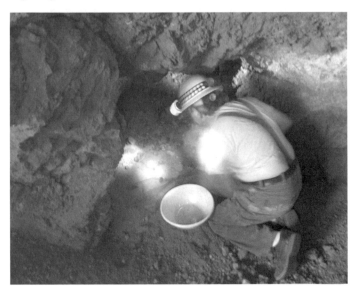

There were people working in hardhats with flashlights and the lights of little lamps expanded the hollowness of the space. An unshaved man hammered a pickax against the rocks in front of him; another lay on the ground and used some kind of metal hook, like a dentist scratching out a cavity.

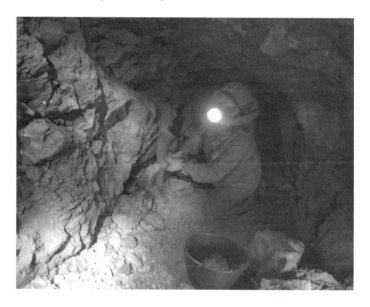

There was a woman we had seen the day before in Oasis, pushing a wheelbarrow filled with what looked like little light brown rocks. "These are the i-cubes," our guide explained. "They bring them outside to the washing station and then they put them into special coolers that look like insulated egg cartons. We sell them, either directly to people from Wendover, or over the Internet. UPS comes almost every day and picks up an order of artisan-crafted, mineral-rich ice cubes to ship to upscale hotel bars all over Asia, where they use them to chill this Taiwanese whisky called "Kavalan."

"Lucky us that a couple of years ago this famous Chinese guy figured out that our ice cubes go so well with 'Kavalan.'"

Grabeland

We didn't know what to say. We didn't know what to think. The only thing we knew was that in the belly of this mountain, surrounded by ice cubes and dynamite, we felt, as we occasionally do, somewhat at home.

In November they sent us a bunch of doctored photographs. Us sightseeing in New York City. Erwin with a big cowboy hat in front of big buildings. The Mother and me in a horse-drawn carriage. That was an outrage at first. The Sister was furious. "Who gave them the right to internationalize us? Putting us in a red velvet-lined horse-drawn carriage when we've never been in a carriage like that? As if we were landlords and had made our money exploiting other people. It is illegal to forge this kind of evidence. If we wanted to be real capitalists, we would bring them to trial and at least get some money out of these deformations."

At her birthday party in Burg Stargard, the photos were the main attraction. Everybody had to look at them, while the Sister kept shouting that she would go after the Americans for forgery. But when that drunken fool of a nephew started yelling that she didn't even know *where* the photos had been taken, she snapped and did a one-eighty. Like women do. "Prove to me that we weren't at Central Park," she snarled at him.

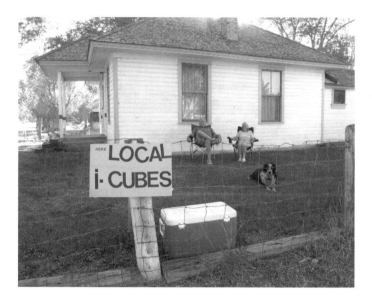

"Take any of these pictures and prove to me that we weren't there!"

After the birthday party she went to the drug store in Burg Stargard, bought one of the black photo albums they have there, and glued all the pictures in. And then she wrote her own captions. She said that it took three weeks to arrange the photos in the right order and think of the captions. "Now

there is real evidence," she said, when she came over and showed us the photo album. "We authorized it." And then she sent it to New York.

She paid twenty-eight euros for the postage. Out of her own pocket. And what was the result? We did not hear from them. Fall, winter, spring — out of sight, out of mind. The Sister was huffy about the whole thing. Every time we saw her and asked if she had heard something from the Americans she blew some angry steam into the air. By late spring we avoided mentioning the Americans at all. By the end of April the Sister couldn't stand it any longer. She called them on the telephone.

"This is Mrs. Trautmann!"

"Oh. . . . Hello, how are you?"

"Did you get the photo album?"

"Yes, we did."

"So . . . ?"

"We like it."

"Here is why I am so upset. I sent you a photo album, you don't even call to say if you got it or not. You want to get rid of us?"

"We don't want to get rid of you."

"What do you want to do, then?"

"What do you mean?"

"You know exactly what I mean!"

Gemerica

On June 1st, International Children's Day, they
called the Kirsche on the phone and told her that
we all should meet on June 5th in an apartment
in Burg Stargard behind the Penguin Ice Cream
Parlor. Marktstraße 20. "Ring the bottom bell
at three p.m.," they told her. These lame ducks.
After we had not heard from them for a whole year.
"What if we had died meanwhile? What kind of plan-
ning is that?" the Kirsche asked. The Sister said
she would only go to tell them to their faces how
rude and selfish it was that they never responded
to the photo album.

The apartment used to be Ursula Schön's. Her
daughter opened the door when we got there. She
looked exactly like her mother. "I left every-
thing as it was," she said. "I did not throw out
a thing. It's all still good. My mother used to
complain about cold feet, so I got her sheep's
wool slippers. But then she never wore them. 'I
am not going to ruin the sheep's wool slippers
by walking around in them,' she said, and kept
walking around in her old leather slippers. Only
in the evenings after she had put her feet up
on the footrest did she put on the sheep's wool
slippers. That's why they are in such good shape.
These slippers never touched the floor." It took
that woman almost an hour to let us in. She was
relentless like a windmill in a storm telling us
beaten-up slipper stories. If I had ended up with
a talking machine like her instead of the Mother,
I would have cut off my ears, I thought. No wonder
she never found a husband. By the time she was
done and went upstairs, I had already forgotten
what we were doing in Mrs. Schön's apartment, and
when the Americans came out of the kitchen, my

heart almost stopped, that's how confused I was. What in the world are the Americans doing in Mrs. Schön's kitchen? I thought. Their daughter was with them and the new baby boy.

"For twenty years she has been dead, but doesn't it feel like Mrs. Schön just went out and would be right back?" the Kirsche asked them, before the Sister could even get started. The Americans said it was all very strange. And they hadn't even known Mrs. Schön like we did, in blood and flesh! They said they had rented the apartment from America over the computer. They had planned to stay there overnight, but after they got there in the morning and looked around, they realized that they wouldn't be able to sleep in Mrs. Schön's bed so they went out to the tourist information board on market square and looked for another vacation rental. They found one a fifteen minute drive away. When she heard that story, the Sister exploded with a red face. "They buy a plane ticket from NYC, rent a car, rent an entire apartment and then they rent another apartment on top of that apartment. Why don't they just go ahead and buy the whole village?" The Mother grabbed her by the arm and took her to the living room. The Kirsche followed, so I followed as well. "It angers me," the Mother said, "because it's our money they are wasting. We've paid them rent for three years and then they sold our gardens for two thousand euros and now they are wasting that money in the same way they've wasted our gardens by selling them to Krater."

"Eventually they are going to run out of money," the Kirsche said. "Then we'll see who has the last laugh."

The year before, we had spent six days together on a cruise ship and crossed an imaginary ocean, and even if the ship had been at most a placeholder for proximity, it had also been a vehicle for forward motion. We had come together to do something together, left something familiar behind to face something unknown. The ocean and the weather had been our lowest common denominators, but they had also been the biggest. There was no other way of crossing an ocean but by being in the same boat, worrying about the same waves, marveling at the same clouds and sunsets.

Now, inside Mrs. Schön's apartment there was no ocean, there were no waves, no wind, no fluidity, no unknowns. It didn't take long to realize that our reunion in an apartment was ill-conceived. Indoors was no space to move or change perspective. Everything was in place, properly situated, and securely fastened. Indoors we could not be anything to one another but stereotypes stuck in clichés. That we wore a star-spangled t-shirt from Goodwill and a Mets baseball hat, and that we had brought a suitcase full of neatly folded Crowley pasteurized, homogenized, Vitamin D enriched milk packages, as well as

Tropicana orange juice tetra-packs, American Eagle napkins, a pack of Sweet'n Low, two copies of the evening edition of the *USA Today*, *New York Times*, *The Washington Post*, and a bunch of empty Poland Spring water bottles, two boxes of Oreo cookies, a jar of Marshmallow Fluff, a bag of squashed Wonder Bread, a package of equally distorted Kraft's American Cheese singles, the original Nestlé Coffeemate powdered creamer, Cheez-It Twisterz, Doritos Cool American, and a can of Campbell's Tomato Soup in order to strategically place these objects around the kitchen and living room and therewith suggest that our meeting took place in an apartment in America had no transformative effect on anybody.

"Erwin has the same blue thermos," Kirsche said when we had coffee and cake in the kitchen. I looked up, and there it was on Mrs. Schön's kitchen shelf. Same one, I thought, and felt a stab in my heart. How many times have I replayed in my mind how the Mother filled this blue thermos

with coffee that morning, and how Kurt added the milk? He was so particular about the amount of milk. I still see him screwing on the cap. And that's what I still can't understand, when I see Erwin sitting on his bench in the garden. Why is that overdue fart sitting there, sipping coffee out of his blue thermos, while our Kurt, who had his whole life ahead of him, is dead? It doesn't make sense. They gave me the thermos, after they found him, and when I opened it, the coffee was still warm, while Kurt was already a cold corpse.

We had found the apartment in Burg Stargard online as a vacation rental and got in touch with Mrs. Schön's neighbor Mrs. Engel, who managed Mrs. Schön's Internet presence and online communication. When we arrived there, Wednesday morning at nine a.m., Mrs. Schön told us that her mother had passed away twenty years ago, one year after the reunification, and that since then nothing had changed.

"I even left my mother's old slippers in the shoe cabinet in the hallway, in case you are wondering why these old slippers are there. Please feel free to use them when you get cold feet," she said, as we stood barefoot in the hallway. And then Mrs. Schön went on to explain how the temperature of the warm water boiler could be regulated and that the yellow glass window in the toilet could be fully opened but also just tilted a tiny bit, in case we weren't interested in having Mr. Tommer, her neighbor watch us sitting on the toilet. The armchair in the living room had a little metal hook that could be lifted in order to recline the back so we could be in a more relaxed position when we would cuddle up under the blanket her mother had gotten from a Russian women, Olga Ivanovich, in Moscow in November 1983 as a friendship present when we possibly, like her, would watch *The Mountain Doctor* which would be playing at eight fifteen p.m. that night on ZDF, button #2 on the TV. In case we needed something, she continued, we should go into the broom closet, get the kitchen broom and use the upper part of the stick, sheathed with a bright yellow rubber, to knock three times on the cloth of red velvet on the hallway ceiling, installed there by a formerly trusted, now diseased gentleman friend to save the artificial, yet relatively expensive oak wood paneling from damage, when transmitting the message. There were a few more things Mrs. Schön explained to us about the apartment and its interior, yet eventually she looked at her wrist watch, encouraged us to feel like we'd come home after a long journey, and cautioned us, before she finally left for her appointment with Doctor Schmidt-Neubauer, the dentist on Lange Straße who would get her a new ceramic filling for the molar in the lower jaw of her left side, to refrain from unpacking our suitcases, mostly because she was afraid our stuff would mix up too much with her mother's. After ten days living in the apartment we would have a hard time sorting stuff out.

Mrs. Schön has a peculiar sense of privacy, we thought as we opened and closed the drawers in the bedroom dresser looking at her mother's personal belongings, which in one of the drawers

smelled like a potpourri of brittle packaging paper and old herbs that had been imported on a sailing ship under the auspices of the Catholic Monarchs of Spain by a contemporary of Christopher Columbus. The drawers in the dresser were filled with white cotton socks, thick gray woolen hand-knitted socks, flannel nightgowns, brown hairnets, belts and a stack of black tights, all of them unopened, in their original packaging that featured the natural looking legs and breasts of a female model without a head. Maybe she took this to the theater, or to a concert, maybe that was her "culture bag," the one she put her concert tickets in, we thought, while opening a small brown hand-made leather bag, that held a pack of disposable tissues with a faint feminine scent.

On top of the dresser stood an empty perfume bottle in front of an old mirror with rusty freckles. A pig-bristle hairbrush lay in a creamy celluloid tray next to the mirror and looked lonely and longing, as if it missed its matching companion comb. This is not a collection of stuff, we thought, but a recollection, we are being reminded; this is a reminder that things we touch will touch us back, that being touched this way is a reanimation of something buried deep in ourselves, we thought, shook open one of the blue towels covered with red peonies and marveled at the hand-drawn green line accentuating its edges. One day, someone had the idea to mass-produce red peonies on towels in watercolors. Why was it so easy to imagine that person, we wondered, why was it comforting to feel how they held the brush for the first sketches, how the tip of the brush touched down and how the water color paper soaked up the liquid? Why could we clearly see the collar of the factory painter's white cotton coat and the yellowish buttons, smell the Rondo coffee in the room, imagine the spider plants, the mother-in-law-tongues and the rubber figs on the windowsill? Why did red Chinese peonies on East German kitchen towels make so much sense? What was so cogent about the hand-drawn green outline marking the edges of this little towel's blooming garden? We sat down on the bed, folded the towel, flattened the seams and put it back in the drawer.

Right next to the bed was a small stack of three cardboard shoe-boxes containing pairs of glossy high heel shoes in black, red and white. How did Mrs. Schön move forward? we wondered, how did she walk, how did she stagnate in a country, where women and men were publicly treated as equal partners in the socialist workforce, but privately retreated back into their traditional roles as wives and husbands? On the top shelf in the closet was a card-board box of a medical red-light lamp, most likely used to exter-nally relieve the stinging pain of ear infections, next to a box for an inflatable air mattress and a pump, whose valve had hardened into a stiff, yellow piece of tube. The rest of the shelves in the bed-room cabinets were filled with lifetime supplies of linens, towels, table cloths, kitchen towels and wash clothes, neatly stacked like public records, which in retrospect explained the shortage of such things in other parts of the country. We knew we were getting lost in there. Was this the right time, the right place? The apartment was big, the walls were covered with pictures in wooden frames, cross-stitched embroideries, floral oil paintings, a series of local birds prints in beige oval plastic frames, a wood panel with inlaid straw pieces that depicted a mother and her daughters from a Russian book right after Mischa the bear had told them that all the mushrooms in their baskets were poisoned. There was a small tap-estry suspended from a cherry branch, decorative ceramic plates with garlands of corn caressing tractors, red poppies in front of a blue sky, sunflowers in a collective field, a black-and-white pho-tograph of a freezing town in a puddle of mud, and a slice from the trunk of a birch tree on which sat a dead butterfly.

The wall of shelving in the living room was massive, made from dark, thick wood. It held a color TV and a cabinet that turned itself into an electrically-illuminated minibar the moment one opened the door. Clear liquor in white glass, brown liquor in green glass, bottles half-full and half-empty, pear-liqueur, homemade blackthorn schnapps from "After the first frost - November 1980" as it was marked on a handwritten label, two bottles of egg liqueur (never opened, never enjoyed), silver shot glasses and brownish

smoked ones, wine glasses in tangerine orange with floral etch-
ings. A rustic looking wooden napkin holder. A stack of mint green
folded cotton napkins. This is not a museum nor an archive, defi-
nitely not an ordinary vacation rental, this is something else, we
thought. Maybe it is what they call a Wunderkammer, a memory
theater that imbues the dull with a strange joy, we kept thinking, as
we held one of the ruby colored wine glasses with a clear tapered
base stem against the light that came in through the windows in
the living room. "Better red than dead," they used to say. Who
were "they," we wondered? The factory workers? The party? The
newspaper? The radio? What comes to light in red, and blue and
green? we wondered. What happens when the sun shines through
the stained glass windows in a church and transforms itself into a
power? Or a statement. A statement like a stack of coasters in Mrs.
Schön's liquor drawer. Retained in remembrances, how absurd,
the randomness of it all. A bunch of strangers from the Internet
discovering seed beads, felt doily and rope coiled coasters, next
to a stack of square ones made of polished hardwood. Crystal cut
champagne glasses with thick gold lines on the top, "Herzlichen

Glückwunsch meine Liebe," we hear them say, kling, kling, kling, a stack of white ceramic ashtrays, a cork screw, an open cardboard box with three compartments holding the skewers for the cocktail cherries, the skewers for the cheese cubes and the skewers for the sour gherkins. And then another box with skewers. Red, blue, green, yellow and orange plastic ones with fish heads, wooden ones with hand-carved deer heads, the ones that look like toothpicks with foldable paper umbrellas on top, the colors of those umbrellas slightly faded. Bowls for peanuts, bowls for pretzels, bowls for salted sunflower seeds. Macadamia nuts. Macadamia nuts? From where would Mrs. Schön have gotten the Macadamia nuts? West German currency? Relatives in West Berlin? Intershop?

We opened the compartment next to the illuminated liquor bar. It had served as an entertainment center and was filled with board games, gambling cards, dice in felt-covered leather cups, colored cubes and plastic chips, notepads and small yellow pencils. There was a plastic roulette wheel with a silver ball, a green felt roulette rollout tabletop, a plastic rake and a traditional Russian lacquer box with a hand-painted scene from a colorful fairy tale that featured about thirty seemingly interrelated characters on its lid. The box was stuffed with fake money for gambling and folded papers containing rows of handwritten numbers that added up into sums. Miranda called out. She had discovered another room behind the kitchen with walls covered top-to-bottom in red velvet. The centerpiece, a manual sewing machine, looked as natural as a fox in a hotel elevator, and when we got to the bottom of Mrs. Schön's sewing basket and found a year's supply of Mondos Gold, Silver, and Luxus, the only available brand of condoms produced by an East German publicly-owned cooperative called Plastina, we reasoned that this room, rather than only being a sewing chamber, had also been a screwing chamber, in which Mrs. Schön had organized professional intercourse either with party officials, or with specialized handymen in exchange for furniture that wasn't, like the rest of the country's, made of particleboard and thin plastic.

"But why jump to such conclusions?" we said to Miranda, who carefully leafed though a jewel case of handwritten notes on paper, mostly addresses and phone numbers in Berlin, Oranienburg, Neuruppin, Potsdam, Dresden, Neubrandenburg, Bernau, Eisenhüttenstadt, Prötzel, Stechlin, Templin.

We kept going. With every compartment we opened, the fear of invading a dead woman's privacy dwindled more and more, and when we opened the drawer in the hallway closet we almost felt that it was our duty to know what it contained, that it was our responsibility to be a witness rather than a tourist, that Mrs. Schön's intention wasn't simply to rent her mother's interior to people, but to bequeath it to the them, and through them to the world, and that we had not ended up here casually to be around her mother's belongings, but by destiny in order to inherit them. A slim phonebook lay next to a pair of leather gloves; a few pens, brittle rubber bands, and a single ten-cent GDR stamp featuring a tiny portrait of Adam Scharrer lay next to an image of his book, *Vaterlandslose Gesellen.* Like a flash from another universe it came back to us, standing in front of the open cabinet within Mrs.

Schön's time capsule: *Thugs without Fatherland*, published in 1930 describing a revolution of a working class, the first book on war by a German worker. Our eighth-grade German-literature-and-civics teacher had put it on the list of mandatory literature, but then the Wall came down and a few months later he hanged himself by jumping off a tall stack of Bruno Apitz's *Naked Among Wolves* in the attic of the school. We, his former pupils, had found it utterly revolting at the time that our German-literature-and-civics teacher had used the stack of *Naked Among Wolves* to hang himself. We had loved that book. It had been our only early child-hood education about concentration camps that went beyond pure shock and shame, we reflected, now in Mrs. Schön's apartment.

We tried to remember. The mandatory eighth grade trip to Buchenwald was scheduled for the eighth graders, but the teacher of the eighth grade class, Mrs. Friedland had called in sick that day. Since there was no substitute, the first grade teacher, Mrs. Habermann, had decided to send the eighth grade students to practical education in the thermometer factory so they could continue to practice drilling holes into metal plates. She did this without consulting Mr. Chickenmountain, the director of the school. There was tension in the air. We were in sixth grade. Or fifth? The bus, we remembered now while putting on Mrs. Schön's black leather gloves (which fit perfectly), had been wait-ing next to the empty flagpole for quite some time. There was the clinking of glass. The school's janitor came out of the basement with two green, elongated wooden baskets, each containing two rows of milk bottles and loaded them in the back of the bus.

Our lunch, bread with butter and an apple, was packed in parchment paper. The bus was gray and it had been booked a year in advance, we heard someone say. The tour could not be resched-uled and the bus driver had promised to deliver five baskets of freshly picked apples to his relatives in Weimar. He was supposed to meet them at the gate. "That gate?" – "Yes, that gate." There was pressure on Mr. Chickenmountain's shoulders. Someone had to go! Our math teacher, Mr. Stautmann, obliged and dutifully

took with him the excited and completely unprepared children of the sixth grade. It smelled like gasoline and freshly picked apples inside the bus. Seven hours later, back at school, the world had turned itself inside out. We disembarked the vehicle not as people, but "as the offspring of a race," as the descendants of –... – we could not find a fitting word. We had looked at lampshades constructed out of human skin, and watched a short movie that showed a tractor bulldozing piles of dead, starved, naked bodies into ...piles? ... mountains??? -- --- any ... any ---? --- all so we, the children of the sixth grade, could sit in the bus and be "among ourselves?" Was that what this trip was meant to teach us?

Without any kind of debriefing from Mr. Stautmann we were left hanging in a dark, disturbing, speechless vacuum – until, two years later, when *Naked Among Wolves* appeared on the curriculum and the topic was officially approached again in school. The book was about a three-year-old Jewish boy who was smuggled into Buchenwald in a suitcase. Despite the German thoroughness we had been shown in the concentration camp, the boy survived, hidden by the inmates. There had been humans in Buchenwald after all. People did not just mass murder or get mass murdered. We were relieved that people in Buchenwald also ate, talked, slept and scratched their noses — it made us cry. We were relieved that there had been resistance among the prisoners and solidarity, relieved that despite the SS searching the camp for the little boy, torturing inmates and killing them, the boy's survival instilled a sense of hope and pride. The sense of hope we intuited would always partially be irrational, and the sense of pride would always feel shameful and misplaced, as long as Buchenwald would remain connected with Weimar. The townspeople, we had read on a label underneath a big black and white photograph of the town, had smelled "a strange smell on the days the wind blew down from the Ettersberg into the market square" where they probably had broomed the cobbled sidewalk in front of Goethe's house in order to keep the famous entry way into the genius parts of German culture nice and clean.

Grabeland

And then the Wall came down and our German-literature-and-civics teacher used our school's stack of *Naked Among Wolves* as a scaffold from which to jump off and hang himself in the attic of our school "in an act of revenge against the invasion of fascist forces from the West," as some adults interpreted the gesture at the time.

His name had been Hasse, Mr. Hate with a wistful "e" at the end. He had been a small, soft, shortsighted communist and an impossible role model, though he probably meant well when he attempted to relay to us that we needed to believe in the political system as a whole, instead of wasting our energy analyzing and questioning its particulars. "We don't want to be fake communists," we told him. "We don't want to please the officials of the party, we want to blow their heads off . . . in a good way." We were not ready yet to play the game, or, maybe, we were already tired of having naturally played the game since we were born, simply imitating what the adults around us were doing, and we were ready for a change. We wanted the world to be an honest place. We wanted to believe in something for real. But our teacher shook his head and shrugged his shoulders: "Impossible," he said, and he made a sad face.

We called him a liar, shoved him into a corner of the classroom and then pushed the piano in front of him at a forty-five-degree angle so he could experience how it felt to be cornered. We called him a weak whiner. We told him that if he had to lie, we expected a certain standard in the delivery, a certain creativity in the construction of the lie, otherwise he may as well skip the hocus-pocus and tell us the truth. "It had come to this," we told Miranda as she adjusted the feather on Mrs. Schön's brown felt hat in front of the mirror, because at the beginning of the class our German-literature-and-civics teacher had tried to prevent us from singing the national anthem of the German Democratic Republic, which – as only one of the many great paradoxes this perpetually self-denying country had to offer – was illegal to sing. Nevertheless, a few weeks before things changed something was in the air. A

book was being circulated in school, we told her, and each of us had secretly memorized the once official, now illegal lyrics of our national anthem. And on that day, not long before the wall would come down, we locked the door of our classroom, stood up and sang it! Miranda smiled at her reflection in the mirror as if it were a camera and combed a strand of her blond hair with her fingers. "We need to legalize the lyrics," we yelled at our German-literature-and-civics teacher, while he threatened us with juvenile detention. And that's how it happened. Once he started to talk about incarceration, we started to push him into the corner, and once he was behind the piano and we had yelled at him, he started to cry. We felt bad and we apologized and told him that we just wanted him to be reasonable, that we simply wanted our athletes – like every other athlete in the world – to sing the lyrics along with the music of our national anthem, as they stood on pedestals with medals around their necks during the Olympic Games. This was our country making a rare appearance on the world stage, we told our German-literature-and-civics teacher, and it was not only extremely annoying, but simply wrong, to see our athletes, who were beautiful and strong and fast, on TV – next to the proudly singing Americans and Russians and French and Brazilians – humming along like brain-dead idiots who had forgotten the words, as our national anthem was played through the loudspeakers.

"Why was it forbidden to sing the lyrics?" Miranda asked. "Because it contained the words 'unity', 'Germany' and 'father-land,'" we said. "Risen from ruins and facing the future, let us serve You for the good, Germany united fatherland . . ." We sang, to our own surprise, the whole anthem without having to search for the words even once, while Miranda tried on one of Mrs. Schön's black felt hats. "Doesn't the tune sound a bit like 'Goodbye Johnny'?" we asked. Miranda's pale skin reflected back from the mirror. She smiled. The lyrics were written in 1949, we told her, after the war, when everybody thought the occupied zones would be reunited eventually. But after 1961, after the Wall was built, Germany as a whole was unthinkable. In East Germany

one could not even use the word "Germany" anymore. The term "Germany" was removed from the GDR constitution. Hence, we didn't call ourselves "Germans." We could probably have called ourselves "German Democratic Republicans," but nobody did that. We might have simply called ourselves "Zonies", the ones living in the Russian zone, but since we rarely traveled outside the country, there was actually no need to call ourselves anything.

The Kirsche was right when she said that it felt like Mrs. Schön had just gone out and would be back any minute. That's why I didn't like sitting at her kitchen table like that. I wanted to go home, but as usual, one thing led to another, and the Sister started making coffee, and the Boss gave me an American newspaper to read, and I was so tired I must have dozed off while looking at it. I shivered when they put the Bismarcks on the table and the Mother kicked me in the side. The Americans had brought a whole cardboard box full of them.

In the middle, where one usually bites into the
plum butter, there was nothing. Not even dough.
They tasted stale. The American said they were
two days old already, because they had had to buy
them in Berlin, because in Berlin was the closest
American bakery they could find. But what kind of
logic is that? Why do they have to bring two-day-
old American biscuits with holes from Berlin, when
we are meeting in Burg Stargard and the bakery is
right around the corner? They should have gotten
the crumb cake from there. In my opinion, Wisdom's
bakery still bakes the best crumb cake. We don't
need American biscuits. It's just hard to make a
U-turn there. That's why we never have the crumb
cake anymore. As Amelie says, with all the traffic
these days, one sometimes has to wait up to five
minutes until it's possible to pull out of that
parking spot and do a U-turn. And it's dangerous
to make the U-turn there. It's not worth it.

After we drank the coffee and ate the donuts, Mrs. Kirsche, Mrs.
Study, and Mrs. Trautmann went through the apartment in the
same manner we had just a couple of hours earlier. They started
slightly hesitantly in the bedroom, then became more confident
and determined. They recognized and remembered, giggled and
laughed and slowly the unproductive tension that had suffo-
cated the stiff and stilted beginning of our reunion dissolved. We
relaxed our eyebrows, sat on the sofa in the living room and began
to breath normally. Mr. Study did not actively join the trip down
memory lane. Silently he rested in front of the TV in an armchair,
his feet up on the footrest and looked even more tired than he had
earlier when sitting on the kitchen chair.

"Mrs. Schön had the same pink towels in the bath-
room as we do. She too must have gotten a whole

bunch of them at the liquidation sale of the department store in Burg Stargard, even though I don't recall seeing her in line," the Mother said. Women and their urge to stockpile. Every year I have to climb up into the attic and push another package in there. We've still got five boxes of that GDR toilet paper from the VEB in Heiligenstadt we will never use, I am sure. Nothing else, but my old asshole got used to the comforts of the West. I told the Mother, as long as we can afford it, there is no way I will return to sand-papering the debris from the disaster zone. The East German toilet paper was rough and thin – the worst combination. We've got two boxes of white bathroom tiles and three cartons full of can-ning jars from her cousin in Templin for twenty cents apiece. Two years ago the Mother actually thought she would use some of them to make jam, but then the Americans turned up and picked all the black currants. Three years ago, she stood in line for an hour to buy three cartons full of fabric softener when it was on sale in Burg Stargard, but then she discovered that in order to use it, she would have to switch the program on the washing machine from Number One to Number Three, and this we can't afford anymore, with the price of water and electricity these days. First it concerned me how the Sister, the Mother and Kirsche went through Mrs. Schön's personal stuff, but then I realized that they probably had not been the first ones who had done that. Mrs. Schön was smarter than anyone else in this god-forsaken cow-village. One had been able to hear it in her voice and now, even twenty years after her death, I could see that she had always been

a step ahead of those know-it-alls who thought they could use her. She must have known that the Stasi had come here regularly to conduct their people-control-operations, so she probably had it all very clearly laid out for those boys.

"Do you remember that fur coat?" the Sister asked. Even I remembered it. Mrs. Schön wore it every winter after she got it from the Soviet Union friendship trip when they went with the chief to Kaluga. It was such a scandal back in those days. The party had sent her as one of the most devoted of the young brigade, and instead of returning in her uniform with another medal pinned to those pretty boobs of hers, she comes back with a mink coat some Russian official gave her. Obviously not for my work on the tractor, she said. To her defense, she wore it publicly, not like others, who only dared to put their mink coats on when they danced around the kitchen table in their datschas. Mrs. Schön knew how to play the game. It was an open secret that she had coffee and cake with the secret service. "Watch what you say, my dear, I will report every word I hear," she used to sing, like a lark. Every Friday, she got off from work three hours early, switched into a blouse and a skirt, and took the one fifteen p.m. bus to Neubrandenburg to file her report. "I go to Neubrandenburg and report that we are very close to one hundred percent in ful-filling the plan, and then I get my hair done," she used to say. "I tell them that we currently have a ninety-five percent fulfillment rate of the five year plan, but are working hard and harder striving for one hundred percent. And I let them know who the naughty boys are around here." We

never knew how serious she was. Everyone knew
she played along but nobody knew her hand of
cards. But with a sweet caboose like hers, who
cared. One would have to get up and look at the
dust between the towel stacks to find out the
truth. Read between the lines, as they used to
say. But it's already too late. The next show has
already started. The Americans are here acting
out who knows what story. They use the same back-
drop playing games with us that Ursula Schön used
for her informant games with the Stasi. Oh, if I
had the energy, I would loathe this world with all
my might. Horst Schiefer once asked me if I knew
that Schön was a double agent, that she worked for
the Stasi and the West Germans. That slimy bas-
tard. Three days after his son read his Stasi files
in the Stasi Record Agency in Berlin Schiefer
disappears, never to be seen and heard of again.
As if the son had chased his father away by find-
ing out the truth. What can I say? It's a mess.
Such different times. And now? What can smoke do
to iron? I don't even recall if Mrs. Schön was
cremated or not. On the morning of her funeral I
stepped on a rusty nail in front of the garage,
and it went through the sole of my shoe into my
foot. It was raining that day. I limped to the
cemetery, my socks got wet, and when the Sister
saw me in my bloody shoe, she insisted she ride
her bike all the way to the doctor's office in
Burg Stargard and back to the cemetery again to
give me a tetanus shot. And now the Sister is
running around in Mrs. Schön's mink coat, which
means she probably was cremated. Otherwise her
daughter would have put her in the casket wear-
ing that mink coat, I am sure.

Eventually Mrs. Kirsche discovered a picture of herself on the wall above a cabinet, we had hung there earlier.

"Why is my picture on Schön's wall?" she cried. "I wasn't even on a first name basis with that woman!"

"Retrospective falsification!" the Sister said. "That's what these people are good at." The Americans said it might have been "retrospective," but it definitely was not "false." Kirsche's portrait was an "original," they said. They had given a photograph of Kirsche to a street artist in New York and he made an original drawing of it with charcoal. It looked actually pretty good, like the Kirsche fifteen years younger.

"Do you remember the picture of you and your wife in the horse-drawn carriage we put in the photo album? That's Central Park. That's where the charcoal drawing was made," the Boss said to me. I didn't know what to say, my thoughts were

all in confusion. I did not want to get involved.
I wanted to go home. The baby boy started cry-
ing. Kirsche picked him up and rocked him on her
knees and the mother and the Sister kept saying
that he looked exactly like Peter Maier's son,
until Miss America got visibly angry and asked
them to stop such talk. His big sister put the
little potbelly on her shoulders and danced with
him through the living room, but that made him
cry even louder. Eventually his mother sat down
with him on the sofa next to Kirsche and breast-
fed him in plain view. I could not believe my
eyes. The Boss gave me a beer in a can but no
beer glass. I drank it out of the can (what could
I do?) and calmed down. And then they asked us
all to sit around the living room table. The Boss
put a bulging envelope on the tabletop and the
daughter opened it. There was a handwritten let-
ter in it, some tickets, a map, and photographs.
The daughter read the letter out loud. I forgot
what it said, but there was also real money in
one of the smaller envelopes. Green dollar bills
and coins.

The Boss announced that we wouldn't be able
to return to Germany by ship and that we would
have to stay in America. That's when I understood
why they had made such a big fuss about bringing
American food to Mrs. Schön's apartment. Those
were supposed to be the "details." According to
the story, they had abandoned us in New York last
summer and sold our cruise ship to Krater, the
King of Crooks, who probably kneels down every
night praying that we will drop dead so he can
take over our land and store more of his trash
on our parcels. The Sister told them that for a

whole year we had been waiting for them to return and get us out of this dreadful situation they put us in.

"Don't even think of air travel. I am never going to set foot on an airplane again to go home. Angels have wings. But I am not an angel!" the Sister barked at them.

The Boss explained that airplane tickets for all of us would be too expensive anyway, but that they owned a ten-acre plot in Nevada that they could bring us to in a covered wagon.

"And what," the Mother asked, "are we supposed to do in Nevada?" "You'll do what you always do and what you are good at. You'll grow vegetables — without water," the Boss said. Never being fooled by anyone any longer, the Sister immediately inquired, "And is that land made out of real dirt, or do we also have to start imagining the dirt now?"

They unfolded the map and put it on the table. America was so big, it covered everything. The Kirsche took the baby boy and rocked him on her knees. She sang: *Kam ein kleiner Teddybär aus dem Märchenwald daher.* The Boss showed us the path we would travel. He took a pencil and drew a crooked line all across America. He said we would cross the Mississippi at some point, and then he showed us the tickets for the boat. We agreed to come along. I could see on the mother's red cheeks that she was excited to go on another trip with them. We said we would meet them at ten a.m. the next morning in Dasdorf on Village Road and everyone looked happy. It would been a good moment to leave and have the boss drive us home for dinner. But no! The Sister got up and put another bag on the table.

She unpacked it venerably like a priest and for
the next two hours we had to look at these greeting
cards she had embroidered with thin threads more
than thirty years ago.

After we had introduced our plan to use the following week
for traveling from New York to our ten acre lot in Nevada,
we folded up our big map and agreed to meet the next morn-
ing in Dasdorf on Village Road at ten a.m. to start the journey.
"Not so fast," Mrs. Trautmann said, as she got up, put a floral
patterned bag on the table and explained in an awkwardly author-
itative voice that she had tentatively prepared a presentation of
cardboard greeting cards as an invitation, which would allow her
to forgive us, for not responding to the photo-album she had sent
us to New York City eight months earlier. The introduction was
cumbersome and slightly incomprehensible, but nevertheless trig-
gered a very clear sense of remorse in us. We felt bad for having
avoided telling Mrs. Trautmann how we felt, when we received
her photo album in the mail.

In the summer of 2009, after the land cruise had anchored
itself in the harbor of New York City and we had sold our vehi-
cle (the gardens) to Mr. Krater, we returned to our apartment in
Queens, where we thought of ways to pick up the storyline again
and advance it further. We compiled a list of sites we imagined
people new to New York City would want to visit: the Statue of
Liberty, Times Square, Battery Park, Coney Island, the Highline
in Chelsea, Central Park, Pier Twelve in Red Hook from where the
Queen Mary II takes off... We went to the locations with a camera
and took pictures and after we had collected about twenty different
motifs, we used these photographs to digitally insert photographs
of Mr. and Mrs. Study, Mr. and Mrs. Kirsche, Mr. Trautmann and
even Mr. Krater into these locations as realistically as possible. We
sent the photo-collages to an online photo-service, ordered seven
standard sets of four by six inch prints, and mailed those to Mrs.
Kirsche in Dasdorf together with a letter, in which we told Mrs.

Kirsche to distribute the photo-sets and encourage the passengers to assemble the photo-collages in personal photo albums, write stories that would go along with the images and send those back to us. We thought that this would be a good way to continue. After about three months we received a package from Burg Stargard in the mail from Mrs. Trautmann. Full of anticipation we opened the package and sat down with her photo album on the kitchen table. It took about two minutes to flip through the pages and read the most generic entries one could write. Things like: "Something for everyone to see," next to Mrs. Kirsche looking at an iconic ice cream parlor on Coney Island. "New York City!" next to a free stress test table set up in the subway station on 42nd street and "Pretty big!" next to Mr. and Mrs. Study standing on Wall Street under a giant American flag. "Stroll through the town differently and more comfortable," written with pencil under a photo-collage of Mr. and Mrs. Study enjoying a horse carriage ride through Central Park. Nothing in the comments or in the arrangement of the photographs had achieved what we had set out to accomplish. Mrs. Trautmann, who had been the only one of the gardeners who had even tried to respond to the photo-collages, had been unable or unwilling to imagine herself in New York City, not even as a tourist. It looked as if preparing the photo-album had been a task she reluctantly had executed without any joy or sense of what NYC could be. To our own surprise we took her disinterest in the city we had been living in for almost fifteen years personally, but instead of calling and telling her that, we spent the next eight months pondering the question: Does it make any sense to continue this project in Dasdorf?

She had embroidered stars and curves and half moons and waves; the motifs looked like symbols they print in engineering books to explain the con-struction of big bridges or the movement of con-stellations in the universe. "This is a sixty-four point star," she said. "I got the form pattern from Mrs. Wehrmeister, and this is an eighty-nine

point star, this one took me twelve hours to make, and this one is a one-hundred-and-twenty-six-point star that took me fourteen hours to make. And this one I invented myself. It's an overlapping double forty-eight-point star with a right curved expansion. I still have the pattern at home. It's nothing but a piece of cardboard with holes. You lay the stencil flat on a piece of heavy paper and prick the holes through with a thin needle onto the greeting card. That's how you transfer the pattern. And then you start making the connections."

The Americans and their daughter said the cards looked very special to them, to which the Sister replied that they were special because they were "true." The positions the lines, she said, were determined from principles of geometry and there was not only truth in that, but absolute truth because the correctness of the designs depended on nothing else but a mathematical principle and the

accuracy of the measurements between the points, which could be re-measured anytime, even in a world otherwise made up of lies and illusions. Miss America told her that measuring the world accurately was nothing else but mapping the structure of ones own brain onto the world as meticulously as one could, and the Sister agreed and said she had secretly thought this all along for the last twenty years—that's why she never sent even one of them away as a greeting card. "There was no one I knew, who would understand what it means to get a card like this, I had to wait for you," she said and then she selected four of the cards, put them in an envelope and gave them to their daughter.

Sitting in Mrs. Schön's apartment on the sofa looking at Mrs. Trautmann's neatly embroidered greeting cards suddenly triggered the desire in us to order our thoughts, connect the free floating points in our timeline through lines, and therewith generate a geometric shape that would help us to understand what had happened since nine a.m. in the morning when we first had set foot into Mrs. Schön's apartment.

Back in 2006, the first person we ever had made eye contact with in Dasdorf was a cowboy on a horse. We had just gotten out of the rental car on Village Road and were walking up to the metal street sign that officially marked the end of Dasdorf, when he appeared in the wheat field behind the sign. He wore a white Stetson hat, a tucked-in denim Western shirt and jeans with a belt and a buckle and roper-style cowboy boots. We smiled at him and he smiled at us, it felt like we knew each other rather well, and then he turned around on his chestnut Morgan horse and the wheat stalks closed behind the two of them gently covering the entrance to a magic land. A mirage, we had thought, and completely forgotten about the encounter, until now, four years later, when he and the horse had materialized again - a few hours earlier.

We had been sweating when we saw them again. We had just dragged a heavy suitcase, two duffle bags, the baby boy and his diapers, three cardboard boxes with costumes and props, and several bags with food and bottled water up a narrow staircase crammed with biker and cowboy boots of different sizes, rodent cages and traps, whips, bike helmets, baseball caps, black leather jackets for riding motorcycles, blue leather jackets for riding dirt bikes, brown suede jackets for riding horses and a variety of dried herbs, such as sage, tarragon, peppermint and thyme that hung upside down from the ceiling above the staircase.

Mrs. Trautmann coughed and tapped us on the arm. "Here," she said and handed us a new greeting card, which depicted a set of three parabolic waves that formed a triangle. We used the fingernail of our right thumb to gently lift the threads that made up the triangles, one after the other and let them snap back onto the paper. We liked the barely audible snap, snap, snap – a sweet, little drum accompanying the Teddybär song Mrs. Kirsche had started to hum for our son across the table. A perfectly straight line connected every two points on the greeting card, yet the ways these lines overlapped resulted in waves or curves. How was that possible? How can a hundred perfectly straight lines turn into three curves that make up a triangle? We had seen this sort of geometric string embroidery before, had even done some of the simpler designs as children ourselves. If one repeated the patterm and didn't think too hard about it, it was actually easy to do. But at the same time, we suddenly realized, sitting in Mrs. Schön's apartment, looking at Mrs. Trautmann's greeting cards, practicing that sort of geometry was utterly absurd. As unpredictable as practicing any kind of art.

If it was a given, that the overlapping straight lines embroidered by a meticulous women like Mrs. Trautmann resulted in parabolic curves, we suddenly wondered, shouldn't we also simply take it as a given that we would end up in the cowboy's father's house, when three hours after we had arrived at Mrs. Schön's, it had become self-evident, that it would be absolutely impossible to sleep in Mrs. Schön's marital bed?

We couldn't decide. We had felt absolutely certain and utterly confused about the world and its workings as we stepped out of Mr. Schön's apartment to find a new place to stay for the next ten nights. We had felt concerned about the financials, had felt guilty about wasting money by going out to rent another apartment, but once we were on the sidewalk and the door to Mrs. Schön's apartment had fallen shut behind us, we knew it was the right decision. Instead of drilling a hole through the brick walls of her house, and feeding through a cable and installing a modem, Mrs. Schön had planted red geraniums in wooden boxes outside her windows. There was no Internet in her time capsule. The past would suck us in and eat us up in there. We bent down and smelled the scent of the geraniums to reassure ourselves that those red geraniums still smelled as they had always smelled. Heavy and slightly offensive. We picked a velvety leaf from one of the plants and started to rub it between our fingers and smelled again. After the two atom bombs had been dropped over Hiroshima and Nagasaki, Albert Einstein had remarked, how appallingly obvious it had become that our technology had exceeded our humanity. "$E=mc^2$" we started to mumble as we began to walk down the cobbled street, in which medieval German houses, painted yellow, blue and gray squeezed against each other like stillborn rabbits in a cursed nest.

Miranda offered to carry her baby brother. The two of them together looked like a very good equation. We passed by a small park. There was some grass, a bench, two trees, a white rock and a heavy-duty wire-mesh trashcan. Someone had crumpled up a piece of paper and thrown it into the trashcan. When we got to Main Street a few cars and trucks drove by. We kept walking towards the center and stopped in the middle of the deserted market square at a polished water pump – installed at the site in 1564, according to an equally well-polished metal plaque. Miranda pushed the squeaking handle up and down a few times until ice cold water started to flow into a basin with stone walls so thick, we thought, if there were to be a nuclear emergency, we would come here and use it as a fallout shelter. Next to the pump stood an oversized information board that

had its own red-shingled roof. The board was there to inform people new to the area that the name of the town, Burg Stargard, had been mentioned for the first time in 1170. It also showed a map that indicated that the layout of the town hadn't changed much since. On one of the wooden pillars of the structure hung an elongated transparent plastic box, and in it were copies of a brochure with names and phone numbers of people who privately rented out vacation apartments in the area. We took one of the least faded ones from the back. The clock was ticking; the gardeners would be ringing the bell at Mrs. Schön's apartment at three p.m. and if we didn't return by then to let them in, Hell would suck us up without a peep. We called the listings in the tourist brochures, yet none of the rentals were available on such short-term notice, until at our fourth attempt, a friendly, female voice said: "No problem. Come right over!"

And so, about four hours after we had arrived in Burg Stargard and set foot inside Mrs. Schön's apartment for the first time, we had also rented an attic apartment in a generic looking two family house on the outskirts of Burg Stargard, and had walked up and down the narrow staircase several times to carry up our luggage. Once everything was upstairs we had opened the dormer window in the apartment to get some fresh air and cool down for a moment.

And that's when we suddenly had realized that we had been to this place before, that we had just taken another entrance to what was actually Fohrs Farm, that it had been here, that we had met Anneliese in the Western Saloon three years earlier and that the cowboy we saw in the arena right below us, had been the one we had made eye contact with in Dasdorf on April 28th, 2006 around ten a.m. in the morning, the first time we set foot into Dasdorf. The beating of our hearts became noticeable. In the cowboy's right hand was a long rope, and at the end of the rope – temporarily actualizing itself in form of the chestnut brown Morgan horse with a blonde lady on top – was the universe, slowly and steadily revolving counterclockwise around him. Something stronger than gravity pulled us down the stairs to the sand in the arena, and once we rested our chin on one of the weathered fence poles we were convinced, that his blue eyes would sparkle like Pluto on a dark, cloudless night. We responded by booking riding lessons for Miranda, which, she told us afterwards, was embarrassing. He said his name was Uwe, and then he smiled that beautiful smile from another life again, this time holding it long enough for us to project a slice of our future onto the wide screen of his strong, shiny teeth. We saw ourselves turning into a single hair of Diana's mane, Diana being the name of his beautiful horse that also smiled, and in the spur of the moment, we began talking about it – about becoming a hair in Diana's mane, feeling the wind, when Uwe was riding across the prairie – but were stopped before we could elaborate. The blonde lady on Diana's back was paying by the hour and she wasn't interested in our story. She shoved the heels of her boots into Diana's belly, and then the universe resumed trotting counterclockwise around Uwe without us.

We left Mrs. Schön's apartment around nine that night. I felt hollow, like a gutted sheep. The Boss drove us. It was already dark when we got home and I could not find my flashlight to go out

and lock up the chickens and the ducks. "Let the
foxes get them," I thought.

Our first night at Fohrs' farm was the first night we ever slept well
in Mecklenburg-Western Pomerania. There was no feeling of angst,
no feeling of being suffocated by the bedroom walls, no feeling of
being haunted by ghosts. We woke up at six a.m. happy and rested,
made scrambled eggs, played with the baby boy who enjoyed bang-
ing a wooden spoon on a pot, drank coffee and then followed Father
Fohrs' suggestion to put on boots and walk along the muddy path of
hooves until we would reach a Western frontier town. "This piece
at the very end of my property was underutilized for many years,
until a few poor souls asked if they could put it to use," Father Fohrs
said. He didn't mind. "As long as it looked credible and would add
to the character of my land, why not? Go and see for yourself,"
Father Fohrs told us. "They should all be over there today."

The town looked like a small American frontier town from the
1800s, beautifully settled in a cozy corner of a Northern German
landscape, that most likely had been cultivated, cultured, pruned

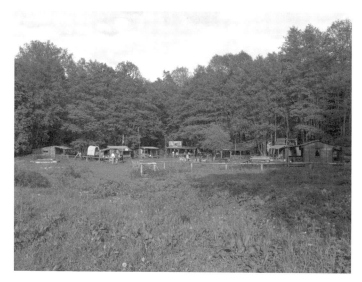

and clipped for centuries before this particular patch had been allowed to reinvent itself as "natural," and grown a little wild.

We walked through a gate; a horizontal tree trunk attached to the tops of two vertical tree trunks and looked around. The early morning sun was drying off the dew and warming up the cold air. Wooden chairs and tables, wagon wheels and benches were scattered around, still cold and wet from the night. There was a small fire burning in a pit, an iron pot hanging above it on a framework made out of branches. A woman wearing a fur vest and a long dark-blue skirt with a grey apron and wooden clogs sat on the small porch of a wooden cabin in the sun, spinning sheep's wool on a spinning wheel, another one was cleaning the dirt in front of a cabin with a broom made out of thin birch twigs. It had taken three years to condition the brushwood to make this besom, the women said, as we stepped closer and tried to take pictures of how she flicked some yellow leaves off the ground, before she disappeared into the cabin. We asked the wool-spinning women if we were bothering her, but she said: "Not at all." She introduced herself as "the wife of the blacksmith," and said she also

241

kept a little general store inside her cabin. "And you are the strangers?" she asked. "Mh," we replied. "I've heard about you from Mrs Fohrs," she said, and smiled a hearty smile that made her rosy cheeks look like tasty peaches. She said she would be happy to sell us a few things: eggs, honey, or hand-knitted mittens for the winter, and opened the door to her cabin. We could also order some woolen socks from her. She could knit a pair in a day. Our baby-boy, strapped to our backs with a cotton cloth began to squirm in the wrap, pushing his arms against our shoulders. It was time for his morning nap, but he was fighting to fall asleep. We started rocking our knees, and entered the cabin. The shopkeeper followed and closed the door behind her. A sunbeam shone through the small window next to the door. It was the only source of light, in the otherwise pretty dark shack. We kept rocking to calm the baby boy and looked at the dust dancing around in the light. The shopkeeper nodded when we pointed it out and said: "Mhhh." And then the mhh, turned into a mmmh, hmhhh, hmhhh, which turned into a humming, which eventually turned into a moody ballad that soothingly lamented about liberty, cheating, sorrow, ain't have this, ain't have that, poor, killer, soul, scorn and lie, die, cattle and the county jail, tombstone and tomorrow and repeated the words "hard times, and it's hard times" over and over again. We kept rocking the baby boy and watched how everything moved. Not only the dust particles in the light beam but also the sunbeam itself, how it flickered and got darker, when a cloud pushed itself in front of the sun, how it got lighter again when the cloud had passed, and how the beam's clearly defined edges inched themselves very slowly but steadily forward, from highlighting a patch of fluffy sheep hides to a handmade doll with long black hair that lay naked among her handmade clothes on top of neatly folded woolen blankets covering the hip-high wooden platform bed which took up most of the space in the cabin.

We realized that the song had ended, when we heard a horse galloping by outside. We wondered if it was Uwe astride Diana, and turned around. Our baby boy had fallen asleep. "Thank you,"

we said. The shopkeeper had lowered her head and fixed her eyes on something in the air above a small table that was made from tree branches. "This is where we have coffee every morning," she said, pointing at the two metal cups on the table. "I start the breakfast by saying: 'I say No to the demands of the world' and then my husband replies: 'I say Yes to the longings of my own heart.' It's been our motto since this spring, so I embroidered it in cross-stich and hung it up on the wall." The embroidered cotton motto looked very humble. Next to it on a wooden shelf were a few glass jars of honey, a little square basket with eggs, an almost blind mirror in a dark silver frame, the horns of an animal smaller than a deer, and the teeth of one bigger than a mouse. Her husband, and her three-year-old daughter were the only ones, among the six families that made up Stillwater, who were currently living here full time. Until March, she said, her family had lived in an apartment in Burg Stargard and they came out here mostly on the weekends, but at the beginning of January her husband had lost his part time job driving a truck. His company fired him from one week to the next, they struggled to pay the rent, so after talking to Mr. Fohrs they gave up the apartment, stored all their belongings in her mother's attic, and started living in Stillwater rent-free from her husbands unemployment money and her disability pension. "In character?" we asked, and immediately regretted the question. "I am Madeleine," the shopkeeper said with a forgiving smile, "mother of Rose. My husband makes nails. You should go around the corner and visit him. It's quite a fascinating process."

We went outside and watched John, the blacksmith forging nails. "It's the oldest form of forging, it goes back to Ancient Egypt," John said in the little shed that covered his workstation, without looking up while he kept hammering a heated metal rod and operated the bellows by pushing a foot pedal up and down. "It's a great way to practice better hammer control. In the 1800s when millions of Europeans spread out into the American West and began to build themselves houses there, nails were very expensive and difficult to obtain, so families often set up little

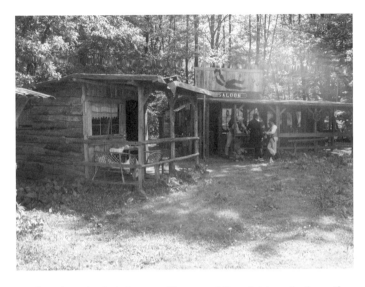

workstations in their homes. They used the nights or bad weather spells to make their own from iron rods. Thomas Jefferson had been a nail-maker. When he got back to his farms in Virginia in 1794 and saw how everything on his property had fallen apart he figured the best way to generate money to regenerate his farms was to set up a nail-manufacturing shop on Mulberry Row. Mostly because it needed very little investment capital. I would obviously never, like Jefferson, use a dozen nail boys between the ages of ten and sixteen to speed up my profit making," John said, "and therefore will never get rich nor famous from making nails, but I still would agree with Jefferson that nail making is like acquiring a title of nobility." We would have liked to stay longer and watch John, who had started to hammer a nail head into a nail header, but Mary, the wife of the doctor, a women with unusually thick and healthy looking dark blond hair in her fifties impatiently pulled us on the arm and dragged us away to show us how she cooked stew in a metal pot dangling above the open fire pit in the ground. It was rabbit stew. Ernie had slaughtered them and she had skinned and cleaned two of the rabbits Old Fohrs let her keep

in a box in one of the hay barns very early that morning. She had coated them with flour and browned them in a stick of butter. She then had added the potatoes, celery and carrots and a handful of purple blooming wild thyme she had picked on the meadow near the wooden bridge that led over the stream, and three cups of red wine. The longer it simmered the more flavorful the stew would be, she said, and we were welcome to taste it. Ernie would come too, maybe even Fohrs himself, she said, in about three hours for lunch. She slurped a bit of the broth from her wooden spoon and added a pinch of salt from a metal can with dark red rusty freckles and said her dream was to live like Madeleine and John full-time in Stillwater. This was the only place in this world where she could appear as Mary, she said. She used think that she had to save up all her money and fly to Mallorca for vacation once a year, but after the second time she did that, she had already fully succumbed to that vicious Mallorca vacation stress. In Mallorca her alarm clock rang at six fifteen a.m. every morning. She jumped out of bed, grabbed her towels and ran down to the beach to wait until the lifeguard would pull away the metal rod, so she could fight with a bunch of German Ballermann tourists over the best beach chairs for the day. Her Mallorca vacations were basically driven by one thought: figuring out how to get the best beach chairs in the morning and how to guard them during the day. For years she and her husband spent their summer vacation as well-oiled Bull Terriers chained to their beach chairs in Mallorca, and for those years she had always thought it was part of traveling outside the country that one would return home exhausted and miserable after pissing away a year's savings. Fortunately, in retrospect, in 2004 she got sick and had to cancel her trip and that's when they started coming to Stillwater. She had learned to embrace the spartan conditions and to cook on an open fire. There was nothing better to do but slowly stir a pot of stew and eat it outdoors together with the other townspeople and then lay back and look at the clouds or the stars. Stillwater was the reason she had prevailed through the hardships of her so-called modern life that she had to deal with in her day job

as a manager for this cancerous, capitalist customer-care-call-center in Neubrandenburg, she said. To that, her husband, the Doc, a tall, slim man dressed in a black tailcoat, dark gray pants and a black hat, nodded vigorously, before he invited us into their cabin, where he lit a home-made candle, put on small, round, wire-framed glasses and showed us three kinds of pliers, neatly lined up on a white cotton napkin next to a white ceramic bowl and a water pitcher, all necessary tools for extracting teeth, in case we were in pain. "And here," he said, opening up a little metal box, "are the replacements. Cost free. All salvaged from healthy animals."

We left the doc's office and kept walking around outside. An unshaved man in his late forties stepped from behind one of the cabins. He stopped and stood still, legs apart, with a cigarette smoldering between the index and middle fingers of his right hand facing us. His brown leather coat reached down to the spurs on his Western boots and he wore a matching cowboy hat. "Who are you?" he asked with the eyes of a leery animal. "Who is asking?" we answered. Hair so thin should have never been allowed to grow

that long, we thought, while waiting for his reply. He dropped his cigarette, pushed the glowing stump into the ground with the heel of his boot and said: "My name is Trapper John. Come over here."

We had watched enough Western movies to know what expression to put on our faces and where to keep our hands when walking over to Trapper John. It obviously pleased him that we played along. He showed us the cemetery at the end of Gunslinger Avenue, a pile of dirt as long and wide as a coffin with a crooked wooden cross on one end and two rotting leather boots sticking out of the other. "Don't ask me who is buried here," he said. We followed his instructions and kept silent. "Wanna see the jail?" he continued. "Probably not a good idea," we said. "Winning the West wasn't a good idea either," he said, winking his eye.

"I am the sheriff of this town," he said, after we had entered the small room that was his office. He pulled back one side of the leather coat to expose the metal star on his chest, and then pointed to a small key dangling on a leather string around his red neck and the shackles that were hanging on the wall. He grinned when he said that he always followed law and order, but that he always did it his way. The sheriff's office and the jail cell were separated by metal bars and a metal door. The cell looked cozy, there was a little wood stove, and on it was a rustic, enamelware cowboy coffee maker with a gray wavy pattern. Two narrow beds were neatly covered with brown blankets that featured wild horses, and a wooden donkey stood between them on a nightstand. We stepped into the cell and the Leather Coat followed. He closed the iron gate and let a big key dangle from his index finger – "just to give you a sense" – and then used the intimacy of the cell to let us know that he was "available" in case we were interested to experience what a wild prairie bull could do. "The Wild West, the real authentic Wild West," he continued, "was about fucking each other in unconventional ways! And that," he said, rapidly rocking his lower body back and forth, "is an authentic aspect that all these buffaloed Winnetou-weepers and whiny Western family reenactors

don't want to acknowledge. The Wild West was brutal and unfair, but occasionally there was primal pleasure in that brutality."

There was a framed photograph on the wall that showed him sitting on a rock with spread out legs holding a Winchester. Two women in Native American dress were resting on each of his knees. "Are there clubs around here where people emulate Native Americans?" we asked.

Yes, he said. There was a club that met pretty regularly about twenty minutes from here in Kleinwiesenthal, they had about twenty regular members, teepees, pow-wows, a bunch of horses, amazing weapons and dresses. Every year in late July they came over on horses and ambushed Stillwater. Last year they kidnapped little Rose and rode away with her. They had gone a little too far with that. Now Madelaine and John refused to have contact with them, so most likely there wouldn't be an ambush this year. "I used to be part of the club for almost ten years," he said. "Obviously it's much better for one's psyche to emulate an Indian and be on the right side of history, resist the oppressor

instead of sitting here on stolen land stirring the wholesome stew of hypocrisy, but I always had a problem with alcohol, and you know how that goes, I did really stupid stuff, so eventually the tribe kicked me out. My wife divorced me, she is still with them. Good for her. I was so bitter at the time, so depressed and fucked up, for a year or so I just roamed around by myself, I spent a whole summer building and laying out traps. You know what happened when I caught a rabbit? I used to sit there staring at the frightened animal, sipped Whiskey and felt bad for myself for being so pathetic. Eventually these people here took me in, they gave me a cabin, called me Trapper John, gave me the job of the sheriff. It's a really nice group; they just don't have the same spirit that we had as Sioux. It's too tame and boring for me here, to be honest. I'll do it a few more years, and once I am better again, in a year or two, I'll transition back again. There is a Mescalero group in Neubrandenburg, maybe they will let me join them. Meanwhile, what I discovered... you wanna know? My dick doesn't care about my morals. It cares about vaginas. They are all red from the inside, right?"

We thanked him for the introduction and looked at the time on our phone. It was almost nine a.m. We decided to return to the house, but were stopped by a man who introduced himself as the cattle baron, the unofficial mayor of Stillwater. He pointed at his silver belt buckle that featured a bear claw surrounded by hand-cut nuggets of turquoise and whispered into our ears that he was wearing "the only really authentic outfit, because it was made by real Apaches in Texas," before he swiftly proceeded to show us the rest of the town – the shed of the undertaker, an abandoned boarding house, the US post office, a bank, and the house of a dressmaker. Everything was created authentically without the use of power tools or credit cards, he said, built from foraged, natural or raw materials that hadn't any monetary value and were available for free, except for a few items in his lodge he had ordered from the Internet – a fire place, a rustic style leather sofa and a round skyhawk rug with bear paws – which had caused some quarrels and earned him the title of the cattle baron. But

he didn't care. Besides these few humble luxuries, he lived legiti-
mate like everybody else, without running water or electricity. "This
one hundred year old, iron Singer is shared by everyone," the cattle
baron said, pointing at the Doc who was pulling a mechanical sew-
ing machine out into the center of the town. Men and women used it
to sew their clothes on it, he said, emphasizing the word men. Some,
like John and the Doc, get all their ideas for their outfits and lifestyle
from history books and old periodicals. Madeleine, the shopkeeper,
keeps re-reading her *Winnetou* book. The cattle baron had studied
the fashion of the time by watching mostly American Westerns that
paid close attention to historical accuracies, he said. *Stagecoach,
The Searchers, The Magnificent Seven, High Noon, Gunsmoke,
Rio Bravo, The Last of Mohicans, Dances with Wolves, A Fistful of
Dollars, The Good Old Boys. Geronimo: An American Legend.* A
few years ago he actively started to memorize lines of dialogue and
sprinkle them into casual conversations. It had encouraged others to
do the same. "It simply makes the conversation around the fire pit at
night a little bit more interesting," he said.

His pants and shirt were altered from old shirts and pants he
had found at flea markets. His wife had made a beautiful bag from
a hand-woven tablecloth her cousin had brought her from Mexico,
using cowhides and furs. Madelaine had knitted his socks from
home-spun sheep's wool he had shorn off one of Fohrs' sheep
himself two years ago. "I have been wearing my pants for almost
three years now, day in and day out on weekends like the dirty
characters in the Old West did it. Every four weeks, whenever
the weather looks favorable, I go back there to the stream and
rinse those pants out as good as I can and then I sit back there
by the stream and watch them dry. Living in these pants is like
cooking in a well-oiled cast iron skillet: once the patina sticks, the
food tastes naturally seasoned while the iron keeps leaching into
the food in the right amounts. I absorb, I understand, I naturally
don't have to worry about any deficiencies here," he said with a
big laugh, slapping us on the shoulder, using the thrust to push us
slightly forward in order to get us going.

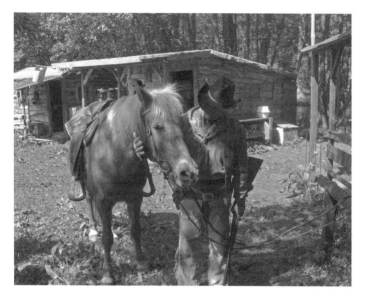

It was already nine fifteen a.m. We waved good-bye to everyone who was out there in the morning sun. Our people were waiting, we said, and promised to return in the next few days, in order to pick up the leather vest and a pair of chaps that the doctor's wife insisted she had to sew for our baby boy. On the way back to Fohrs' house we wondered what sort of circumstances promoted the rise of certain ideas and ideals. Washing pants in a stream and watching them dry, what is that about? Authenticity measured by the investment of time into an activity. Why? Wearing hand-knitted sheep's wool socks. Why? Authenticity and no monetary value. Why? Raw and natural. Horse manure. Not so much about being oneself, but more focused on doing it oneself, being part of every step of the process? Self-doers. Brooming one's porch. The moral voice that comes with a homemade broom, the authority to do it? Why not, we thought, and jumped into a puddle. The muddy water splashed to our hips. We liked the look of the splatters. We jumped again a second time and then kept going, overlaying our old footprints with our new footprints that pointed in the opposite

direction in the path to Fohrs' house with our sleeping baby boy strapped to our backs. Squish, squash, squish, squash. When living has turned into a predictable functioning, what do people do? They reinvent themselves and reenact their existence as a happy hobby life, we thought. Why not, we thought. There obviously are many more resources around to build a hobby life than a professional one. There is a treasure trove full of stories, legends, movies and songs one can use to make an invented hobby life easily relatable to others. Living a hobby life might be actually the only way to live life as a true hero, we thought, before we entered Fohrs' house, pulled off our muddy boots and put them next to the army of dirty footwear that lined the staircase up to our vacation apartment.

We woke up Miranda who had put in a request to sleep in the night before, quickly packed the lunches we had prepared earlier, the soda cans, the diapers, the rattle and the rubber giraffe that supposedly would help to keep the baby boy busy biting his gums on its neck, the water bottles, our two video cameras, the two photo cameras, two tripods and the audio recorder. When we stepped out of the house, the sky had darkened and a cold wind had picked up. The sun was gone, covered by thick clouds. Despite the dark sky we drove to Dasdorf to start the crossing of the United States of America from East to West in an almost jubilant mood, now finally with a real destination in mind. Instead of using the ten-acre lot in the desert of Nevada as an empty placeholder, we would travel from New York to Stillwater. While one of us had been in the shopkeeper's cabin, the cattle baron had told the other that the boarding house was available for newcomers. He had repeated several times that the town always welcomed greenhorns, as long as they dressed authentically, stayed in character and played by the rules.

When we arrived in Dasdorf Walter was already waiting on the left side of Village Road with the horse carriage. The gardeners, including Mrs. Trautmann who had come with her bike from Burg Stargard, were in position on the right side of the road like a group

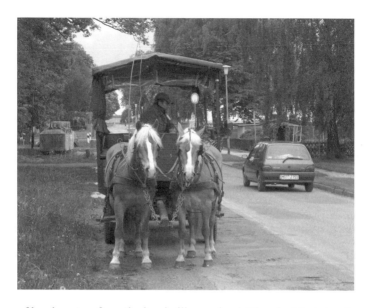

of headmasters from the local village school. They had their hands locked behind their backs and inquiringly looked into our direction.

"It seems to be happening," we said to Miranda, who looked out the window of the car with an expression that mirrored the flatness behind the housing blocks.

"Don't let moody Mecklenburg-Western Pomerania get you down," we said.

"I am tired. I am cold," she said "and it looks like it's going to rain. Did you bring the baby's hat?"

We reached into the pockets of our jacket. There was an extra charged battery for the video camera, an extra charged battery for the photo camera, a hard candy, a coil of tangled up headphones, a cell phone, three SD memory cards in little plastic cases, a pencil, a pack of tissues, the rolled up cash for Walter with a rubber band around it and – the baby hat!

The horse carriage arrived at nine forty-three a.m. in front of Kirsche's building. When I saw

him coming down the road I knew the Sister had been right. She had predicted that the coachman was the cousin of Edgar's wife and it turned out that's who he was. Walter Wegmann, Bernd Wegmann's younger brother. The Americans arrived two minutes to ten a.m. and we left Dasdorf around a quarter past ten a.m. Schneider got stuck behind us on L33 for fifteen minutes with his black BMW. He just wasn't able to pass by with the oncoming traffic. When he finally did, he waved and honked and we waved back and the Kirsche yelled, "Ahoy!" The weather-man on the radio had also been right, when he had announced that this year's Sheep's Cold would be rushing into our territory like the Niagara Falls rush into the US. "See," the Mother had snapped, "even the weather man starts Americanizing."

I just wish I had brought my winter jacket. The wind was harsh. And it did rush in like a waterfall. The baby-boy cried and kept crying. Why did the Americans have to do their adven-tures always during the sheep's chill? Every year the same affair. They could have looked it up on the computer. Beginning of June: the temperature drops by ten degrees, heavy winds start blowing south as the Northern Seas are warming up, it rains. And it did. It rained and rained. I leaned forward to not get soaked from the side again like the year before. I sat there like the metal rooster on the weather vane of the schoolhouse in Penzlin, stuck there since 1933. I could not even turn my head anymore, having had to hide behind Walter's back the whole time. The Kirsche said she was concerned for the baby boy's health, even though one could barely see his head, that's how nice and cozy he was cuddled under his sister's

woolen sweater. We made it to Spenholzen around noon, and Walter said we would take a break; the horses needed a rest and some water. We stopped in the little park behind the World War II memorial. Walter dried the horses off with a towel and fetched them some water in a bucket. They have an old hand-pump there, I didn't even know that it was still working, I only knew about the one in the town square in Burg Stargard, which keeps upsetting the Sister, because it cost the town nine thousand euros to restore it.

"They keep telling us there is no money to keep the street lights on at night and that running a bus from Burg Stargard to Dasdorf would lead to the end of the world, but then I open the newspaper and I see the mayor holding up a nine thousand euro check so they can pay someone to polish that useless piece of pump," the Sister kept aggravating herself. "Who is pumping this country?"

During the break Walter pulled down the plastic covers on the sides of the carriage, so the wind wouldn't blow in with such force any longer and the Americans gave us some dry white bread for lunch and crackers in an aluminum bag. They had

put cheese spread on the bread and some cucumber slices that were as thick as my index finger, but before I could even bite into the pale sadness, it started to smell like homemade liverwurst with pickles all around me. I must have sniffed very audibly. Walter turned around from his coachman's seat and said to me, "He who wants to eat in Spain must bring his kitchen along!" I looked at the Mother with big eyes and pointed at Walter's whole wheat bread with liverwurst, but she just shrugged her shoulders, and pointed toward the Americans. "Nobody looks a gift horse in the mouth," she hissed like a lazy snake before she took another bite. After lunch we took the Old Mill Road toward the old paper envelope factory.

"Progress!" the Sister cried. "Now trees are growing out of the chimneys!"

"Nobody takes care of anything anymore that's older than five years," the Mother said. She is right. Everything has to be newer and faster and better and bigger. More work, more stress, more

vacation, more stress, more holidays, more stress, more hobbies, more stress, more sick days, more stress, more eating, more dieting, more stress. Whenever I see my daughter she is stressed out from working or from planning another vacation with another boyfriend. I don't understand. I never understood. We never took a vacation. When it gets dark outside we go to bed. We sleep. That is our vacation.

We had booked Walter and the horse carriage for four consecutive days. We had told him on the phone from New York that on the first day we would like to get a sense of the vastness of the United States, the sheer scale of the landmass this country uses up on the North American continent. Maybe for the first day, we told Walter on the phone, we just ride through the landscape and experience distance. Walter had insisted that distance was not a destination and that he had to know where to go. "Westward from Dasdorf, and then a little South." we had told him. "Your choice, you are paying for it," he had said.

The baby boy did not like being in the horse carriage. He cried for the first hour, which was stressful mostly because it was so confusing. A horse carriage, we had imagined, in the confinements of our one room apartment in Queens when we had thought of this would undoubtedly be ideal for a nine-month-old baby boy. Fresh air, the sounds of trotting hooves, the gentle rocking, back and forth. We basically had booked the horse carriage to make the whole thing more bearable for him. But no. He couldn't fall asleep, he cried, he looked exhausted and miserable. So, did everybody else. What could we do about it? We handed the baby boy over to Miranda, who gently wrapped him under her sweater, where he finally fell asleep. We took our photo camera out of an insulated lunch bag and started taking pictures. It was difficult. We either had to underexpose the faces in the horse carriage to get the landscape in the background right, or we had to overexpose the landscape to

get the faces of the people right. The only compromise between these two unfavorable outcomes of the camera's automatic mode was to perfectly capture the raindrops on the plastic foil Walter had pulled down during the lunch break. We tried to switch into manual mode, but could not immediately find the menu or the button to do so, which made us nervous, especially once we felt Mrs. Trautmann's eyes on our hands and started to imagine that we looked unprofessional. Mrs. Trautmann had kept using the word "unprofessional" during the cruise the year before in an admonishing tone more often than necessary, until on the very last day of the cruise we snapped, stepped up close to her face and yapped like a little Yorkshire Terrier that we had in fact studied Fine Arts for ten semesters at the Bauhaus University in Weimar and had been granted a diploma in the category of Fine Arts, which we would be happy to send her a copy of, in case what we were doing here right now wasn't self-evidently professional. Mrs. Trautmann had been surprised by the directness of our confrontation as much we had been surprised by it ourselves, but once she had taken a step back, she had started smirking, which made us fear now, that our outburst from last year hadn't necessarily impressed her lastingly enough to stop her from falling into that old habit of negative commenting and questioning our practice again. We found the menu on the camera, which enabled us to manually adjust time and aperture. We focused on Miranda and tried. It did not do a thing, except annoy Miranda. We changed the aperture, the angle, the white balance, the shutter time, employed a flash. The preview on the built-in camera screen showed a tired, young woman who was freezing in a wagon covered by a heavy plastic covering. We stowed away the photo camera and took the video-camera out of the double-stuffed US mail padded envelope we used for protection, rolled up the plastic covering on one side of the wagon, stood up, held on to a pole, made Mrs. Kirsche move closer to the opening, leaned out as far as we could and tried to film Mrs. Kirsche's face in a different light from the outside, but again,with the rain, the bumpiness of the ride and the uninspired expression on Mrs. Kirsche's face… it

was pointless. We stared at the floor, like everybody else. About an hour later the baby boy woke up and it was time for nursing and a diaper change on the narrow table in the middle of the carriage. The soft poop cleaning triggered some commotion, packing and unpacking, and diaper rash powder advice from Mrs. Trautmann and Mrs. Kirsche, a little bit of nose-wrinkling by Mrs. Study, after that silence again. We pulled down the plastic covering at the back and tied it to the bottom of the floor. Pretty soon all the covers around us had fogged up and the landscape outside had disappeared completely. The rain got heavier, and started to hammer against the plastic, as if nailing shut a coffin with a thousand little iron rods. We reminded ourselves that we had booked the horse carriage for four more days, had invested the money of two big art grants meant to further our career into this endeavor and that we therefore needed to stay hopeful. We got up and changed seats and rolled up the plastic foil in the front. Walter was wrapped in a long water-repellent driving apron, he didn't seem to mind the rain, and the horses were trotting along without him having to do

much. We contracted the muscles in our eyes that enabled us to lock our vision into blur mode and listened to the clacks of the horseshoes. They sounded like the ticktack of eight metronomes pulsing through the rain like a well-modulated piece of mechanical music. If that's what it is, we thought, that's what it is. Nobody had asked for a spectacle. We kept going, entered a forested area. From time to time tree branches with dark green leaves pressed tightly against the plastic foil on the sides. "A little bit like in a car wash, when the brushes press themselves against the car windows," we said. Our travel companions shrugged their shoulders. They didn't know what we were talking about. None of them had ever been in a car wash, Mrs. Trautmann remarked dryly. Driving through the forest turned the interior of the carriage almost dark. Mr. Study, across from us, stared out the front at the incomprehensibility we called America. In the low light he was nothing but an outline filled in with black, a heavy shadow of himself, a region of spacetime with such strong gravitational force that nothing – absolutely nothing – could escape from it. Mr. Study contains it all, we thought, yet what he is and who he is, is so compact, it's completely inaccessible. It's purely physics, we thought. Nothing personal. As we keep moving forward, he keeps drifting away, his absence is gaining mass, his distancing is turning him into a black hole, and the bigger the hole becomes, the more dangerous it becomes for us to be sucked into it.

Mrs. Study's head had fallen over. She was sleeping. So was Miranda, resting her head on our shoulders, holding the head of her little brother who was sleeping on our lap under his beige baby blanket. It was now three thirty p.m. We were two hours from Dasdorf and there were almost five hours of daylight left in this gray day.

"That's how it is," Walter said. "Make horses your hobby." Oh Walter! we thought, and then he told us about horses and horse bites and how the ham straps are buckled and back-strapped, and that the pad and the crupper are put on with the bellyband. We nodded, and smiled a little, and he explained how the girth is

threaded through the loop and then buckled tight but left undone, until the horse is put in front, or two horses, or four, or eight. Mr. Study shifted from leaning his body slightly to the left to leaning his body slightly to the right, and turned his head in our direction. Walter continued to explain, and straightened his back. "It is more than a simple passion for me to put so many horses in front of a wagon," he said. "It is a real challenge. Sixteen horses can be a great triumph, but also a great tragedy," he said, "it has taught me the lesson that safety must always come first!" Mr. Study lifted his head slightly. We couldn't see his eyes because of the darkness, but when a strange sensation rumbled in our stomachs, we knew we were looking into them. He had never talked to us, and now we knew, he never would. We nodded and lowered our heads. It all made sense.

"It's easier to pass, step by step, the shafts through the tugs, if the belly-band is left undone until the horse is put in front," Walter said. "Then comes threading the reins through the pad and the collar until the bridle is put on, and the reins are buckled to the bit of that horse with the neck and the mane, and then the shaft

slips into tug and unloops and threads once more, one more time, trace back that belly-band again. And now hook up," Walter said, "Ha-ha," which made us chuckle. "Hook up both sides, hey-hey!" he cheered and made us laugh. "It takes a while to learn, but is not as difficult as it might seem. It's easier than spinning wool or knitting socks and more rewarding. Once the breeching straps are fastened and the bellyband is adjusted, he checks, corrects, tugs, and shafts the height, sit, and bellyband again. There are simple rules and golden rules, he follows all of them, he said, he himself, Walter Wagonmaster always does it all himself when he is harnessing up the horses.

When the Mother woke up she told the story of how Ernst's son ran over the Sister's cat. How many times had she told that story already? As if he had done it on purpose. It was an accident. Things like that happen. Cars kill cats. Cats kill mice. Mice feed foxes. Foxes kill chickens. Chickens come out of eggs. There is nothing to be done. Fuchs ran over Miezi when he backed up in front of the garages. He is an idiot, but so was the cat. The cat kept sitting there when the car backed up. Last year alone four of Keller's chickens were killed on Village Road, until Keller was number five himself. It was all foreseeable. He who is too drunk to keep his chicken off the street at ten in the morning won't manage to keep his car on the street at five p.m., either. Life is a bitter bitch. Every spring the Mother just hands me the basket and that's the last thing she will ever know about those little kittens. She puts a napkin over the screaming suckers, three or four or sometimes even five of them curled up, black and white or red and brown. It is the end of the story for her, while it's the beginning of the

nightmare I have to go through twice a year, when I have to push them down, one by one, and drown them. Schneider said he does it with a hammer on the chopping block. It would be much faster. But then you have to deal with guts and blood. It's a mess either way. Every time the same torture, until the Mother needs a new one. Then one of them is singled out and the rest get drowned. "I'll take care of this one," the Mother says, "you take care of the rest." When we got home that day, the Mother prepared me a hot water bottle and I went to bed straight away.

New day, new luck! Day two. "From now on we are counting down," we told Miranda. We arrived with the rental car in Dasdorf at a quarter to ten, relieved to see that after the strenuous trip from the day before they all were present, standing on the sidewalk, hands folded behind their backs, waiting in front of Mrs. Kirsche's housing block, Village Road #7. "A horse carriage wasn't such a bad idea after all," we said to Miranda as we parked the car across the street. We sorted, re-packed and partially unloaded the lunch packages and sodas, the crumb cake from the Wisdom bakery, the thermos with the coffee, ten of the twelve apple juice boxes, the bag with the warm clothes, the hats, the water bottles, not the baby's rattle but the giraffe, the maps, one of the video cameras, but none of the tripods, and half the diapers and the wipes and a trashbag from the trunk of the car. Walter arrived five minutes before ten. We stuffed our supplies beneath the benches in the carriage, the passengers crossed the street, we said "Good Morning" and then Miranda gave Mrs. Study, Mrs. Kirsche, Mr. Study, and Mrs. Trautmann a hand climbing up the small ladder. One of us followed with the baby and the other jumped into the car and drove to a location from which a wide-angle picture of the horse carriage in the landscape could be taken. Shorty before we were ready to take off, a man approached in a black Fiat Punto,

stopped behind the carriage, opened the door and got out. He was about forty years old, wore a gray suit and a tie, polished black shoes, the first time we had ever seen a man wearing business attire in Dasdorf.

"Where are we going?" he asked.

"We are on our way to Stillwater," Mrs. Kirsche shouted back.

The man raised his eyebrows.

"Stillwater in Texas, a southern state in the United States of America," Mrs. Trautmann said matter of factly.

"Aha," said the man in the car, turned around and drove away.

The Americans told us we were going west, but from what I could tell we were going to the North Pole. On the second day I was so cold from stiffing up in the open wagon that I got dizzy and had to keep my eyes shut, otherwise I would have thrown up. When I opened them again, I saw that we were past the five-hundred-year-old oak already. There was fog over the fields and in the fog I saw a woman who looked like my mother, bent over, gleaning for leftover potatoes. First I was not sure it was her, but then . . . She waves at me and smiles. The wind turns dusty and brings tears into my eyes. I get dizzy again and have to lean back and close my eyes again, listening to the horses trotting on. When I wake up, I am in our old kitchen and Grandmother Lene stands in front of the wood stove in her long gray skirt, her blue apron tied in the back over her big butt, and stirs a pot. The whole kitchen smells like warm cow's milk with honey. I am lying on the green kitchen bench. It is rocking, and I am shivering, I am afraid to fall off, so I grab the wooden seat of the bench and hold tight with both hands. Grandmother Lene comes over and smiles at

me, I start counting the thick, black hairs above
her upper lip as she hands me the blue metal cup
with milk, but I can't grab it because I have to
hold onto the bench and count the hairs. So she
bends over, lifts my head and feeds me the first
sip, and it tastes so sweet and creamy — and then
all the milk spills, and I shake and that's when
I realize that the road is bumpy and the wagon
keeps shaking and I am getting wet. I opened my
eyes again, when we turned into the Heubachweg
and I heard the Sister say to Walter, "Last year
when we went to America we had a private cook, now
we have a private chauffeur." And then the wagon
stopped. I thought Walter would turn around and
give the Sister an answer, but then I realized
we had stopped because the Americans went behind
a bush to do their business. I was still dazed.
My Grandmother Lene. She was the one who spoiled
me, my mother used to complain. I hadn't really
thought of her for probably thirty or forty years.
Now she had been back, I had smelled her, and I
had seen my mother, whom I had not really thought
of in at least twenty years either, not even when
we decorated her grave in Marterhof. I had thought
of her, of course, as one thinks when one thinks
of someone's mother, I had thought *mother*, but I
had connected it with nothing else but the word,
had not even assumed I would remember the way she
used to look at me when I was a little boy. I did
not even know I had been a little boy once.

And while the Sister asked Walter how much he
had charged the Americans for the trip, it sud-
denly came back to me: The leather shorts, I could
feel them, on my skinny, long legs. I had been a
happy little boy. I reached into my pocket and

felt my Swiss Army Knife. Walter didn't give the Sister an answer, he just looked straight ahead into the fields. I do not want to die, I thought. My fat old body, my hurting bones, my aching heart — I couldn't care less if what was left of me was above ground or below. But not that boy. Not as long as one hint of him was still within me, I suddenly thought to myself. I didn't want to die. The Sister told Walter that she had heard that the Old Wolf had rented the same covered wagon for his sixty-fifth birthday last year, for three hours only, and that it had cost him fifty euros. "Oh, rolling wheels. Do the math," Walter said. And then the Sister told him that we were going on this trip because it was for free and the Kirsche said she was going on this trip because we were committed people. "Last year," she said, "when we did the cruise, we said A. And if you say A, then you have to say B. And after B comes C, so we'll see where we end up next year."

"That's how it is with commitments," the Mother said. "You say A, you get married, you say B, C, D, E for each child you bring into this world, and for the rest of the alphabet you don't say anything anymore. The letters roll by like numbered carriages on a cargo train and you sit there and watch and wonder. In the end you even stop wondering. And once Z rolls by it's too late."

When the Americans came back to the wagon we moved on. "The coronation of ugliness," the Sister said, as Quastenberg came into view. "Clown Villa welcomes you! A green house with a pink door. What a disgrace for the entrance of a village." To that the Mother and Kirsche made noises like a bunch of crows.

Quastenberg has never been a real village, they said. The Quastenbergers have never been real village people. They always pretend to be something they are not. They climb on their little hill behind the fire station and feel elevated. They look at the church spire of Burg Stargard, and think they are part of a bigger town and therefore should act like bigger townspeople. They drive to Neubrandenburg and think their houses should look like those houses. They think they are related, not by blood but by aspirations. They see that the ice cream parlor is painted green and when they get home they think, we can do that, too! We can paint our little house like a cucumber.

I can't believe that the Sister still rides her bike from Burg Stargard to Dasdorf through Quastenberg. Even in the winter. It used to take me only thirty-five minutes to ride my bike to Burg

Stargard. I always took what's now L33. But once
the Wall came down and everybody got a car, there
was no point in riding a bike anymore. I would be
dead by now, if I had continued. Six people got
killed on the L33 since they put the new tar on.
On every third tree there's a bunch of plastic
flowers and a teddy bear. "Car in ditch, driver in
tree. The moon was full and so was he."

We had locked our eyes at the brown hindquarters, focused on the
root where the horse's tail joins the rump. Walter had said, "It's
called the dock." He had explained to us that the horse's tail is
part of its spinal column, that the movement of the tail is governed
by thick muscle bundles that extend over the horse's rump and
attach to the vertebrae, that the thick, sturdy, protein-rich horse
hair of the tail is an extension of the horse hide. We wondered
what it did to Walter's worldview having to look at those horse
hindquarters for so many hours a day. "In order to sell his steam
engines to skeptical buyers two hundred and thirty years ago,"
Walter said, "James Watt came up with a method to compare the
output of steam engines with the power of draft horses by measur-
ing how fast a horse could turn a twelve feet grindstone in a mill.

James Watt multiplied the distance the horse walked by the pulling force," Walter said, "divided it by the time it took for the horse to do that, and thus came up with the measure of horsepower."

We drifted off. Nothing is more passive than being a passenger, we thought, nothing more passive than being a person who sits in a vehicle being pulled forward, nothing more phlegmatic than entrusting the direction of one's body in time and space to a coachman, or a pilot, who in turn entrusts this advancement to a bunch of engines, propellers, wings, or wheels. "In Watt's model, work" Walter said, interrupting our thoughts, "is the amount of force exerted over a distance, energy is the capacity to do the work, and power is the amount of work divided by the time it takes to do it." We nodded. While still in Queens, we had imagined that the mode of transportation would have an impact on how our journey would unfold, that it would be a less passive journey sitting in a horse-drawn carriage than sitting on a train, that we would be less detached from our surroundings and each other by being pulled by an animal instead of an engine. We had thought, that it would be easier to make a connection in a horse carriage where the benches were facing each other than in a mini-bus, where the rows of seats were behind each other. Connections, we thought. Connections with what? we suddenly wondered. While still in Queens we had told ourselves that the speed of moving forward would make a difference, that it would make a difference that we would travel without having to wear seatbelts. Now, sitting on a wooden bench in a horse-drawn carriage without a seatbelt, we wanted to think further about these things, but suddenly the enveloping smell of rape in bloom became sickening, and while it would be better, we thought, if there were windows through which one could see the rapeseed but not have to smell it, we immediately imagined the ineffectiveness of a pane of glass. It was the visual abstraction of monocultured land, we thought, that outrageous span of yellow fields in contrast to those small medieval villages, that was as sickening to the eyes, as the strange, fleshy smell was to our noses and its narcotic scent to our stomachs. Not speed, but sight was

the key, we thought. Mrs. Trautmann looked as if she was getting sick as well. She had pulled out her handkerchief and pressed it against her mouth. Maybe the rapeseed was rotting because of all the rain, we thought, maybe it was not rapeseed flowers in bloom we smelled, but rotting rapeseed roots.

"The low-lying fields are waterlogged, not enough oxygen for the plants to breath anymore," Mrs. Kirsche said as if reading our minds. "A few days in waterlogged soil are enough to kill the canola plants."

"All that work for nothing," Mrs. Study remarked.

"Is that the rapeseed smelling?" we asked.

"No, it's the sulphur leaching into the soil," Mrs. Kirsche answered and yawned, and after a little while she said: "Give me the baby boy, I want to hold that cute package for a while." We handed her our child and she rocked him on her knees until he started laughing. She started humming a song for him. He smiled. That's how it is, we thought. In front of this rotting landscape of canola flower jaundice, they look happy together.

We tried to reconnect where we had left of. The human body is the slowest part of humankind, we thought, much slower than the brain, and the only chance a body has to keep catching up with the brain's capabilities, is to entrust itself to rigid machines that overcome its slowness and protect its softness. That a woman swam across the Atlantic, that the a human mind is confident enough to take on that challenge, that a human body is physically able to overcome the distance, but needs to do it in a cage in order to defend itself against a shark, that is absurd.

"A human being is capable of about five horsepower at peak power production," Walter said. Each of his horses was capable of fifteen and if we wanted to, we now had all the information we needed to figure out how many people would be necessary to pull the wagon at the same speed, he said, in a somewhat challenging tone. What's the difference between being pulled by a person and being pulled by an animal, we thought, without even trying to come up with an answer to Walter's question. What's the difference between travel and transportation, we thought, between us

and Walter, between conveyance and convenience? What if it was the food being served during the journey that would make all the difference, what if the travel companions mattered more than the weather? One would think, we kept thinking, that it must have an impact on the traveling body if one moves forward while staring at two muscular horse buttocks in real time, instead of watching an old Western movie embedded in the back of the next seat in an airplane.

Mrs. Study joined Mrs. Kirsche singing a song for the boy, which sounded like an old German folk song. Mrs. Kirsche held his hands and clapped them, and Mrs. Study pedalled his feet.

One has to be careful being pulled by those horse-drawn thoughts, we thought, those horse-drawn thoughts are easily over-ridden by nostalgia, that softens the past and turns it into a Trojan Horse, we thought, the cleverness is dangerous, the perspective mis-leading, especially when one is surrounded by nothing else but the emotional register of monocultured fields of yellow rape in bloom. And then Walter turned around again, and said that Mecklenburg-Western Pomerania had been mostly a swamp with barbarians and mosquitoes living in it before Frederick the Great brought in the

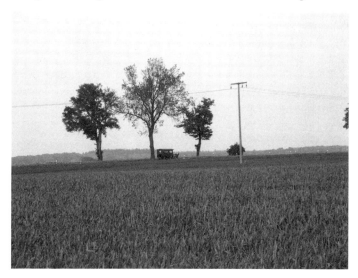

Dutch to drain and gentrify the land. The Dutch replaced the marsh-
land with fields, he said, and the barbarians with religious farmers,
the German tribes were separated and outlawed by the dykes of the
Dutch in the seventeenth century, like the people in Berlin were
divided by the Wall in the 1960's, he said. In 1806 the Prussians
lost the war against Napoleon, and after that Napoleon began lining
all major roads with cottonwood and horse chestnut trees. The tree-
lined streets are the remains that make Western Pomerania, what
Western Pomerania is today. Napoleon thought of the alamedas as a
continuous roof, which eventually would protect his soldiers from
sunshine and rain, and always provide a point of reference for a
soldier who got disoriented in battle. So it goes, he says. All a lost
soldier in unknown territory had to do was to get up, look around,
spot cottonwood trees in a row and follow them south, until ulti-
mately the network of roads would lead him back to Paris.

　　But soldiers don't walk anymore, Walter says. Civilians don't
walk anymore either, and when, on a sunny day, the people get into
their cars, the flickering light that breaks through the narrow tunnels
of leaves and branches is so intense and disorienting that they can
lose sight of the paved portion of the thoroughfare. While Western
Pomerania is the least populated region in all of Germany, Walter
says, it has the highest per capita rate of deaths by car accident.

```
On Wednesday I wore my cardigan under the
jacket. The Mother wore a scarf. Kirsche wore
a hat. The sister a hoodie. It was nine degrees
Celsius when they picked us up. It got a little
warmer during the trip, but the whole day, I wore
my cardigan. On the way back, before we got on L33
we stopped at the hunting stand. The Americans
said we were lost, someone should climb up on
the hunting stand and figure out the directions.
Nobody moved. Walter just shrugged his shoulders
and said he was getting paid by the hour. It did
not matter to him. I shrugged my shoulders as
```

well, but then the women played along and made me get out of the wagon and climb up the ladder onto the platform to find out where we were. It had been an eternity since I'd been on that hunting stand. More than three quarters of the fields were yellow. One hundred years ago we used twenty percent of our land base for fuel — that was to feed the horses, but with all the pointless driving and flying everyone is doing nowadays, it's idiotic to even pretend. We'll never be able to produce enough biodiesel, no matter how many truckloads of nitrogen fertilizer they dump on these fields to get the rape to bloom like that. For three weeks Schneider's son-in-law did nothing but spray nitrogen over the fields. There is nothing ecological about that. It all ends up in our water. Just a week ago, they wrote in the newspaper that the Tollense Lake is on the verge of collapse. Almost turned over, they wrote. In a last attempt they installed fountains that spray the water from the lake high into the air to enrich the water with oxygen. Otherwise the algae will kill the lake entirely. It's a mess, whichever way you look at it. "Which way to go?" the Sister yelled. "When nothing goes right, go left," I told her, because that was where we were heading anyway.

Slowly and steadily, one step at a time, Mr. Study climbed higher and once he was up on the platform and we saw a hint of a smile on his face, we reassured ourselves, that it actually had been a good idea. It felt good to look up to him like that and see the others do the same. The long, stretched out morning swaths of heavy gray that had been towering over the fields, had given way to roundish shapes of almost white that had risen high up into the sky. The women got back into the wagon. Mrs. Trautmann pulled

273

a deck of cards out of her pocket and then she, Mrs. Kirsche, Mrs. Study and Miranda played *MauMau*.

Walter walked off into the fields. The horses, heads down, stood still. We padded their soft, warm noses with the backs of our hands. We felt their breath and pulled back their lips a little bit to see how big their teeth were, and if they were yellow. They were. We saw the hunting stand reflecting in their bulging eyeballs under their long eyelashes. What would life be like as a prey animal? How can a creature live with the ability to see backward and forward simultaneously? What would an equine three hundred and fifty degree vision do to our nervous system?

We took a couple of random pictures with the photo camera – fields, sky, card game, hunting stand. Was the constant photographing preying on our minds? Was living with these thousands of photos like being able to see backwards and forward at the same time? Was time our predator?

A few steps down the dirt road a white, hairy caterpillar, the size of our index finger, hovered in the middle of the road at eye-level. We walked around the hairy worm. It had a black head and pointy legs and a few stiff hairs were sticking out like spikes in a symmetrical fashion, most likely to repel those out there to eat it. Bending left, contracting, pushing, contracting, bending right the worm was in the process of gaining height, with every contraction getting higher up into the air. We stepped closer and tried to focus our eyesight, lowered our head, turned and turned again, until for a brief moment we could see the hint of a silk thread, a glittering line in the light. The line must be attached to the tip of the branch of the tree, we reasoned, looking up. By the time we had made that connection the caterpillar had already climbed above our heads, it probably worked up a voracious appetite doing it. There was a breeze, and like an aerialist in a circus the worm started spinning around its own center point clockwise, then unspinning itself counterclockwise, without stopping to climb upwards, an acrobat in a snug leotard quickly gaining height for the flying trapeze act.

Mrs. Trautmann called, they had finished the game, she had

won, it was time to go. Mr. Study sat on his usual spot behind Walter, who snapped his tongue and off we went. Everyone was in a good mood. We told them about the caterpillar on the invisible thread, how it had spun around clockwise, and then counterclockwise while climbing up. We asked if anybody knew who had tied the invisible thread to the branch of the tree?

"It was more important to look at that caterpillar than playing a card game with us?" Mrs. Trautmann asked using her accusing tone, then crossed her arms in front of her chest and looked away.

This is going nowhere, we thought. There is no "could," no "may," no "might." This is going nowhere all at once, all the time. Always has been, always will be! We can't deal with them, they can't deal with us. As long as we are together in this horse-drawn carriage like this, it suddenly dawned on us, the most we can do is keep accepting and ignoring each other, and stay within that numbing equilibrium, keep trotting through the flatness of this landscape like a bunch of domesticated animals on their way from one abandoned farm to the next. The horse-drawn carriage, we thought, is nothing but a living monument commemorating the hopelessness and helplessness of uniting what can't be united. Sitting for days together in the horse drawn carriage with Mr and Mrs. Study, Mrs. Kirsche, Mrs. Trautmann, and Walter, the horses paving the way, is nothing but an indication, we thought, that our capacities are always curtailed, that our advancement is always too slow, that we will always be far behind in trying to understand what happened a long time ago, and what exactly led to the current conditions which make it so unlikely that our future will be something other than the immediate future as it presents itself in front of us in the horse-drawn carriage.

"Show us the Mississippi!" the Kirsche had cried from below when I was on the hunting stand, and I just pointed toward the Teschendorfer Lake. "How long will it take us to get there?" the Kirsche had yelled. Zornitsch, Little Hill, Altenberg,

Normes Weg. "At least half a day," I had guessed,
and when I got back into the wagon, the mother
first padded me on the shoulder and then on the
knee. We unfolded the map. They asked me to show
the way to the Mississippi River on that map
again, but how was I supposed to know? The first
time I had heard about the Mississippi was when
Goebbles or Himmler, maybe even Hitler himself
announced it on the radio that the German people
needed to push East like the frontier settlers
had pushed West in America, that we needed to
expand and conquer like they had done it when the
West was won and that their Mississippi would be
our Volga. That was when America was still a role
model with lots of green grass and big prairies.
Of course after the war the Russians painted it
all black, The United States turned into a black
blotch on all the maps. America is black, Russia
is red, that's what I was supposed to know about
the world of maps during the cold war, while
our propaganda ministers kept pointing out the
advantage us people in the Russian sector would
have over the American occupied zone. Russia
is much bigger, they said, it has many more
resources, the Alliances will have run out of
coal when the Russians haven't even started dig-
ging through the Urals. And now when they show
the world on TV, the red blotch is gone, the
black blotch is gone, and it looks like a carni-
val procession has marched around the globe and
covered it in confetti. All is cut up and color-
ful and every country and county can choose its
flag and coat of arms and in the end none of it
matters. If there is money to be made, the people
with money buy the politicians and all together

they start a new war anyway. If not in their own
country, then in some other poor devil's back-
yard. Every five years the big fat armchair farts
give themselves another name and come up with a
new brainwash for the people. The emperor, the
Nazis, then the Russians, the East Germans, the
West Germans, and now we are sitting with the
Americans in a covered wagon trotting west and I
just hope we'll make it to their Texasland before
the Chinese arrive.

Before we got to the Moorheide, the women
started to sing *Hoch auf dem gelben Wagen.* The
Americans knew the lyrics, including their daugh-
ter. I hadn't heard people singing that song in
thirty years at least. How time flies by. Five
years ago the Kirchheimer dropped dead in her
garden because of the summer heat wave. "A heat
wave is a golden opportunity, but who knows if
we are ever going to get another one like the
one the Kirchheimer took her leave with," Erwin
had said. He is right. One never can count on
the weather. If I have learned something in my
life, that's what I learned. "When the rooster
sits on the dung pile and cries, the weather
changes or it stays, like the flies." No one is
going to help anybody in the end. No doctor, no
band-aid, no saint, nobody stopped us when we
finished those men off in the mud near Kaluga.
In the freezing mud with a kick in their faces.
What disgusting animals Hitler's war had turned
us into. If the Mother knew, if anybody knew ...
well, the birches know, those goddamn birches.
We all should have died during that war. I should
not have waited. I should have dragged Ernst out
right away. Should have, should have, should

have. I thought about it five seconds too long.
Four seconds. Maybe even just three. Forgive
me, Ernst. Forgive the fat, fearful coward that
I am. I lay there at night, and play it through
over and over again, the scream, the flames, his
eye, night for night I wish I could be like that
American pilot who dropped the atomic bomb on
Hiroshima and kept saying until the day he died
that he had no regrets. "Hogwash," he said, when
the reporter accused him of killing a hundred
thousand people. "Hogwash!" I am trying, but
it's of no use. There is no hogwash for me. There
are bananas I can eat for breakfast, but that's
all. It's that sinister patch of moor that makes
me think of all of it now. "When these birches
start shivering, evil is close by," my grandfa-
ther used to say. "Hear how the birch trees are
shivering? It's the *Erlkönig* waiting to take
you to the beach," he used to say when we went
through the swamps. Maybe I'll die singing the
Erlkönig as my lullaby. That's how my mother
died. Singing children's songs in her delirium.
"A little man stands in the forest, silently and
still. He wears a red cape, all velvety red. Who
is that little man in the forest, wearing such
a nice, red cape?" In the end she didn't sing
the whole song anymore, screamed only scraps and
snatches. She would scream and then laugh. Inge
and Irmgard sat with her through the day and
through the night. For three days she was in that
delirium, haunted by the creature in the red vel-
vet cape, which, as far as I can tell, and as far
as it is common knowledge, is nothing but a rose
hip. A rose hip. In the end she lost her voice.
But her lips kept moving until her heart stopped.

What kept our spirits up during the first stodgy traveling days from the East coast towards Stillwater were our interactions and observations at Fohrs' farm. In the mornings we left to advance our travels with the passengers and when that was finished, we returned to the farm to recuperate.

The name Uwe, father Fohrs explained to us one late afternoon when the sun was beginning to set behind the stables, means "the busy one, the dashing one, the one who is full of zest for action." It was obvious, that father and son both liked to work a lot. Uwe did a lot of shoveling with his strong arms, mostly manure. Old Fohrs himself did every task requiring heavy machinery, most often with his six-year-old grandson Jack on his lap. "Sitting on a school bench is a waste of time," he shouted when his wife and daughter-in-law came by one early morning with concerned faces to remind him that school attendance was mandatory for a six-year-old in Germany. Father Fohrs had just laughed. "There can't be a better place for a boy of age six to sit and learn than the back of a horse, the lap of a grandfather, or the branch of a tree." Father Fohrs liked to nail it down straightforwardly. He liked to

sit on the porch, feet up on the railing, smoke a pipe and say things like: "Never criticize someone until you have walked eight hundred meters in their shoes. That way, when you criticize them, they won't be able to hear you. Plus, you have their shoes." His big body emitted a sense of generosity in giving, dispersing and in dealing out. Uwe, on the other hand drew in. His steely frame was rather slim and magnetic, able to fill out the larger über-shape that destiny had carved for him through local myth and legend instead of body meat. Toddlers, teenagers, young, middle aged and old women flocked to the farm to take Western riding lessons with Uwe, while Ernie, a mute and deaf man, who lived and worked at the farm limped around the muddy compound from dawn until dusk with buckets full of pellets or baskets of hay to feed the animals the family liked to surround itself with. Stallions, mares, goats, donkeys, sheep, cows, llamas, pigs, dogs, turkeys, pheasants, cats, ducks, swans, chickens, squirrels, rabbits, hawks, guinea pigs, turtles, tortoises, iguanas, fish, a snake, and pigeons. They had acquired a higher concentration of animals, free-ranging, semi-free ranging, tied up or caged in, pecking beaks, scratching claws, trampling hooves, and sniffing snouts than the average front-lawn owner in a North Eastern suburbia had blades of grass. Every animal had a name and some kind of feature that, once it appeared in his field of vision, inspired Father Fohrs to tell a fable: the kind of animal tale that has a moral lesson attached. But the visuals were captivating even without Mr. Fohrs' voice-over. A lamb jumping up and having all four legs in the air, a peacock chasing a bulldog around a gooseberry bush, a cat hunting an injured sparrow and eating it, a fawn chasing the shadow of a butterfly. Sometimes the undomesticated parts of animalistic instinct led to spectacular fights fought to kill the competition. Other times, the survival of the species seemed to depend on experimental mating with whoever came along. Those who adapt will survive, we remembered. It's not the strongest of the species, or the most intelligent ones that will survive, Darwin had began to theorize on the Galapagos Islands in the eighteen-thirties, the

species that is most responsive to change will survive. What used to be natural selection is now selective breeding, we pondered, on the evening we joined the extended Fohrs family to attend the artificial sperm collection of one of their prized, black stal-

lions in an artificial vagina. There had been a few failed attempts. First the estrous teaser mare had come too close to the stallion, he jumped and almost injured her by striking her head with his hoof. Then, something had not been right when the stallion mounted the two-legged home-made phantom, so naturally, according to Father Fohrs, the stallion had made use of his unique ability to ejaculate while withholding sperm, which Uwe confirmed with a quick look under the microscope in the barn. A man working for UPS had been on stand-by holding on to a styrofoam box in which the lucrative semen would be shipped climate-controlled to a mare near Frankfurt, who was about to ovulate within the next seven hours, according to a text message Father Fohrs had received on his mobile phone. "If that damn stallion doesn't ejaculate properly within the next ten minutes, I am going to lose my job," the UPS driver said. "This is the price you pay for thinking you could live the American Dream by driving a brown truck in a matching uniform," Father Fohrs replied calmly, while Uwe cleaned the collection tube and then washed the penis of the stallion with a sponge again in order to prevent contamination. Uwe walked the stallion a few times around the arena again, then Ernie led the mare out of the barn and close to the phantom. Once the stallion smelled the mare, Uwe and the stallion ran towards them, the aroused animal mounted the dummy, and Uwe pushed the

artificial vagina tube towards his penis, the stallion ejaculated, there were a few pulses. When the stallion rested, Uwe pulled off the tube and once the stallion had dismounted the phantom, Uwe led him back to the barn.

There was something about the scale of the farm that didn't relate to its actual size, a sort of other-worldliness that occasionally turned the Western- Pommeranian rain puddles in the mud into Olympic-sized swimming pools in Gatsby's West Egg. Maybe it was Father Fohrs' unstoppable curiosity, his habit to keep the gates wide open for the outside and the outsiders to sweep in like ocean waves, so he could laugh and cry about the ways they crashed on his shore. Maybe it was a personal reaction to whatever else was going on in Mecklenburg-Western Pomerania, or maybe he simply was a really good business man who knew what would sell best in this part of Germany in terms of tourism and local hobby culture. Maybe the farm had just evolved, an imperative that had grown out of Mr. Fohrs childhood obsession of reading books about cowboys and Indians, maybe it had been his never being able to travel outside the GDR. Whatever it was, and whatever it had caused it, the aura of the place provided a possibility to everyone who wandered through the batwing doors into the Western Pomeranian Frontier Town Saloon, which Father Fohrs had built because he didn't like to drink his beer alone in front of his TV. Mrs. Fohrs, a small women with red curly hair occasionally operated the bar, supplying her husband and his entourage with beer, schnapps, or sweet green woodruff sodas from the tap whenever people came together. Mrs. Fohrs never acted in ways that would increase the likeliness of other people liking her. Everybody knew, that Mrs. Fohrs had the capacity to serve beverages on demand, but never smiles. If she was in a bad mood, that mood was granted the right to make itself felt all around her. Hence when she smiled, it had a similar effect as looking at a rainbow after a really bad thunderstorm had passed – one marveled at the wonder of being alive and having been birthed by a woman. She was a

rebel in resisting busyness, simply not receptive to the driving
rhythms that were generated by anything else but her own heart.
Every morning Mrs. Fohrs climbed up the stairs and put a bas-
ket of freshly collected eggs in front of our door. And when we
returned the empty basket in the afternoon, she put our baby boy
in it and said: "Its easier to ride the horses without the baby in
the backpack. Leave him with me."

As usual, Walter picked us up at ten in the morn-
ing. Once we got going, the Americans gave us
rye buns with butter and Gouda cheese and apple
slices for breakfast that had already turned
brown. "If they could manage some liverwurst
we would be in business," the Sister said. "We
don't eat meat," their daughter said, whereupon
the Sister lectured the daughter on the pale-
ness of her face. Her sleepiness, she said, and
her apathy, was due to an iron deficiency. The
daughter definitely needed to eat red meat twice
a week because of the iron, the Sister insisted.
Leave her alone, for God's sake! What use is it
to bother the daughter? The daughter is the last
one to be blamed for anything, how can anyone
be bothered by that angel-face of hers? Always
kind, attentive, gentle as a lamb, helping us get
in and out of the wagon. But people have no sense
anymore. How embarrassing last year, when Krater
looked at her and felt inspired to tell blonde
jokes. One stupid joke after another during the
cruise, when the Americans had brought her along
for the first time. "How do you know that a blonde
has been sitting in your cellar?" he asked. "If
there is lipstick around the cucumbers," he
cried. "And why didn't the blonde in the cellar
eat the pickles? - Because she couldn't get her

head into the jar. What will the blonde say when
she finds out she is going to have a baby? - I
hope it's mine." Every day before dinner he went
back to his computer to look up more. There are
more than five thousand blonde jokes on his com-
puter, he said. Wherever you go, you'll run into
a bunch of idiots, and it takes its toll on you.
That's the crux when one is surrounded by seri-
ous derangement. It's infectious. Stupidity has
always been smart enough to find a way to walk
down Main Street in the light of the day cele-
brating itself. I am just glad that neither that
dumb Krater nor that mean Fuchs decided to come
with us to Texas.

Around eleven a.m. we arrived in Gaudok. Not
one of us had known there was a museum in the
former manor house. The Sister said in the 1920s
the original landowner had been a nephew of the
Pelvitz family in Tchechow, but she had not known
him. Just heard about him from her aunt one time
when she was a child. The mansion was renovated
with a lot of money. It looked nice and clean,
like they do it nowadays. Stiff and formal like a
corpse in an ironed Sunday suit, the Sister said.
First they completely gut the building, then they
suffocate it with insulation and triple paned win-
dows, and then they put flowers around the dead
remains to bring the building back to life. The
museum belonged to a retired judge from Cologne
or Stuttgart, the Americans said. I actually for-
get where he was from. A big judge with a big wal-
let stuffed with old money from the West, that's
all I needed to know. Walter let us off and the
Americans rang the bell. It was dark inside and
smelled like floor wax.

The nephew of the judge was in his forties or early fifties. It was hard to tell. He looked young and old at the same time. His hair was cut perfectly straight along the top of his shoulders and half black and half gray. We paid him for the tickets and the permission to take pictures. This was the biggest private collection of Native American artifacts in the world, the nephew said two times in a row, before he led us up the wide wooden staircase to the first floor where he explained that the glass cabinets had been custom designed and built by a local crew of three certified cabinet makers over the course of two years. Only in this way, he said, the four thousand items of the collection could be exhibited properly. His uncle had looked for a location in Berlin for many years, but after he could not secure an appropriate building and government funding there, he searched the greater surroundings of the capital, and that's how they ended up here in Gaudok. After a costly renovation the museum had been opened eight years earlier, but unfortunately his uncle's lifework had turned out to be out of reach for regular museum-visitors. Nobody came here. His uncle, the retired judge, lay isolated in the private wing, deadly ill,

bedridden for a year. There had been weeks with one or two vis-
itors only. The nephew spoke quietly so as not to disturb anyone,
which was irritating, because there wasn't anyone there. After his
introduction we slowly walked around from one room to the next
filled with handcrafted glass cabinets displaying life-size manne-
quins in buckskin dresses and beaded regalia, stuffed animals, a
taxidermy Grizzly bear on his hind legs, a taxidermy bison head
over a door, a teepee, models of a wigwam and a sweat lodge,
blankets, bows, arrows, spears, baskets, jewelry, toys, masks,
pipes, knives and arrowheads. The hallways between some of
the rooms displayed boards in dark wooden frames that summa-
rized the migration routes, the climate changes or the population
growths and declines of North America's indigenous population
from the Mesozoic era, about two hundred and fifty two million
years ago up to the more recent developments in the 21st century.
Two hundred and fifty two million years summarized in a hallway
panel, we thought. According to the nephew, his uncle's father, his
great uncle, had started collecting artifacts towards the end of the
nineteenth's century, and his uncle had continued the family fas-
cination for Native Americans and hunting. His uncle had visited
the Pine Ridge Reservation in South Dakota, the nephew said,
his uncle had spent his summers there for more than thirty years,
had gone fishing and hunting with his friends in the Cheyenne
River reservation and in the Battle Mountain Reservation of the
Shoshone Indians in northeastern Nevada, had purified him-
self in a sweat lodge and participated in many Pow-Wow's.
"Pine Ridge Indian Reservation - free Leonard Peltier!" Mrs.
Trautmann interrupted the nephew and raised her fist in the air.
Irritated and seemingly annoyed, the nephew ignored her and
continued. Many of the objects on exhibit had been given to his
uncle as tokens of trust and friendship by tribal leaders in North
America, he said, in an even lower voice now, "each one a cher-
ished testament to a spiritual life lived in harmony with nature in
a universe free of greed and self-indulgence." Mrs. Trautmann
bit her lips. We wished the judge would crawl out of his bed and

tell us these stories himself. Maybe it was the nephew's mor-
alizing tone, or his know-it-all attitude; the more he talked, the
more repelled we felt by the authority he wore like a fake fringed
jacket that didn't suit him. What was on exhibit before everything
else could even be considered, we thought, were not the Native
American artifacts, but the nephew's antiquated lordliness that so
perfectly matched the floor plan of this properly renovated village
castle in Mecklenburg Western-Pomerania. The deadly goodwill
of private wealth, we thought, an aristocratic *Indianermuseum*
in the poorest part of Germany with the lowest population den-
sity. Mrs. Trautmann said she wanted to ask a question about
the glass beads in the other room and talk about the *Indianistik
Klubs* in the GDR, but the nephew cut her off again by putting
his finger in front of his mouth and said: "Shhh. Quiet," as if Mrs.
Trautmann was six years old and needed to go to bed right now.
"The objects in the glass vitrines have power. Their fragile state
can't be disturbed any further." He himself had witnessed, several
times, how some of the hunting knives his uncle had received
during his travels in 2001, had turned and changed their configu-
rations in the glass cases when bad things were happening in the
world. The year before, in the spring of 2009, he said, the Federal
Government, on behalf of the people of the United States, issued
its very first official apology to the Native Peoples, in which it
acknowledged the official depredations and ill-conceived policies
regarding Indian tribes. At the time of that apology the braids of
two of his ghost dance dolls in the glass vitrines had tangled them-
selves into a knot overnight. Mrs. Trautmann raised her eyebrows.
Mrs. Study yawned. Mrs. Kirsche had seemingly tuned out all
talking and was happily engrossed looking at the contents of the
glass vitrines, and so was Mr. Study, spellbound by the taxidermy
bison head over the door.

"The objects here are watching you!" the nephew said, and
pointed his pale finger first at us, then at Mrs. Trautmann, for
what felt like a very long time. We turned around, walked out
into the hallway and looked out of the window. A majestic horse

chestnut tree stood in the center of the neatly mowed front yard, which was laid out as a circle, surrounded by a road. Near the entrance was Walter with the horse carriage reading a newspaper. The chestnut tree was probably a hundred years old. Even though it was just the beginning of the summer, many of the palmate leaves, usually green and beautifully radiating from a center like a spoke, were wrinkled and had already turned yellow and brown. We had read about the invasion of the leaf minder moths from Macedonia a few days earlier in a newspaper and once we had learned about the spreading of the disease in Germany, we had become aware of horse chestnut trees that had turned yellow and brown all over the place. The passengers had talked about it in the horse carriage too. The trees wouldn't necessarily die from the plague, but the stress the invasion caused made them more vulnerable to other diseases, a botanist had explained in the newspaper. American Indians were eating American chestnuts long before the European immigrants brought their stock to the US, the article had said. Then, in 1904 the "chestnut blight" happened. It was a fungal infection, accidently introduced into the US from a Japanese nursery stock in 1904, first identified by a forester in the Bronx Zoo. The European chestnut trees were susceptible to the plight, but less so than the American species. By the 1940's all mature American chestnut trees had been wiped out, an estimated four billion American chestnut trees were killed by the disease, while some of the European species survived. We stand in the *Indianermuseum* in Gaudok, we thought, and look at a horse chestnut tree and think about massacres. We stand here and look at this German horse chestnut tree and think about the forced removal of Native Americans in North America. We think about it in a very detached way.

It's no wonder that the biggest private collection of Native American artifacts is located in Germany, we kept going. This affinity with American Indians has been engrained in who we are for generations. Sons and daughters of farmers, doctors,

welders, priests and brick layers have related to American
Indians in one way or another, German culture wouldn't be what
it is today without hundreds of years of imagining, consuming,
researching, avenging, meeting, glorifying, reenacting, emu-
lating, denying or laughing about Apache, Sioux, Comanche,
Lakota, Shoshone, Navajo and other tribes. It's been part
of who we ideally want to be, or definitely don't want to be,
every German group had their own ways to relate to the North
American Indians, and every generation's ideas of how to relate
best were very varied and malleable, we thought, as Germans
in general have many ideas. Idea - we thought. "Einfall," the
word that also means "invasion," "raid" and "incidence." The
German invasion of Poland on September 1st, 1939 – that was an
"Einfall." Through the window we watched how Walter folded
up his newspaper and jumped down from the coachman seat. A
moment later he appeared in the back of the carriage again and
stretched himself out for a nap on the bench.

It's very German, we thought, that we immediately feel skep-
tical of the nephew telling us about Native Americans, as it has
always been an integral part of German culture to be skeptical
and quickly pick out the shortcomings in regards to the accuracy
of knowledge in other Germans and discuss or defend one's own
version, and even more importantly one's own motivations and
one's own relation to a story as the rightful and authentic story,
authenticity being measured mostly in commitment, in sincere,
earnest and heartfelt emotional and intellectual investment. The
German version of authenticity happens when a story has been
absorbed, when it has become a lived experience. It's authentic
when the gut feels it, and the gut feels it, when it gets there.
Ingested, digested, processed. Then it's authentic because it's
been worked through and can be employed intuitively, then we
can improvise, then we can handle the knowledge without hav-
ing to think about it, even though we are aware of the fact, that
our whole construct, of having a Native American experience
for example, is impossible and wrong. But at the same time we

depend on it. Because of who we are, our sanity occasionally depends on needing to forget of who we are, we thought, looking at Walter's chest, going up and down evenly as he breathed in and out. We are happy when we don't know, happy to be innocent, happy to to figure it out on our own terms until of course we witness the ignorance that comes with not knowing, which makes us doubt again, and once that doubting has started grinding our thoughts again and has pushed itself into being the main principle of our existence, we reach out for certainty, and we pursue this need to be one hundred percent certain again. We know there must be a balance in all of this, but then – we don't know! We are constantly consumed by trying to achieve this balance of being in doubt and being certain and because all of this is too much to manage for one person alone, because all of this has never been caused or resolved by one person sitting on a rock in a forest, we naturally reach out to think it through with others. We reach out to act it out with others, we have learned to perform our thinking things through with others, even though we already have understood, that there is no way to fully understand things such as love, courage and benevolence. But "No," has never meant absolutely "NO." If we can't say certain things ourselves, we express it in character or encourage others to do so. Not just as someone else, but as that other part in us. We dress up as fictitious hobby Indians on weekends, we build ourselves a museum and do it as self-educated Native American experts, we visit the Karl May Festival in Radebeul and watch staged battles between Indians and white settler colonialists, how we try to find out depends on our class background and our education, our financial means and how much time we have.

"The objects have power," the nephew had said, and because he owned them, he assumed he had the power to tell us so. His uncle had been a powerful judge, educated and trained in interpreting and applying the rights and wrongs of a powerful country with powerful laws. In contrast to the adversarial system in the US, the German system of criminal procedure is

inquisitorial. The court is actively involved in investigating the facts of the case. The bedridden judge had been trained to audit and proof and judge, we thought, it had been part of his professional duty to examine every detail of the case. That duty probably swapped over into his vacation time when he spent his summers in the Indian reservations, observing, asking questions, taking notes and taking part in what was going on in the legal designations of land managed by Native American tribes as federally recognized by the Bureau of Indian Affairs, an agency within the U.S. Department of the Interior. "The burden of proof is on the one who declares, not on the one who denies," we thought, while one of the sick, wrinkled yellow leaves detached itself from the horse chestnut tree and spiraled to the ground in loops and curves that used up much more energy, movement, space and time than would have been necessary for its downfall. We cling to our ideas like trees to their leaves. We sprout them, we grow them, and once autumn comes, or a disease invades, or the weather changes, we adapt, we detach, and let them spiral down. One of Walter's horses urinated. A big splash hit the gravel on the ground; we could almost hear it, even though the window was shut tightly. We had asked him about it on our way coming here, and Walter had told us that the average horse produces a ten liter bucket full of urine per day and about nine tons of manure per year. We wondered. The moment we had entered the circular driveway and looked at the art deco manor house, we had labeled it "a private mansion" and consequently, once inside, couldn't get beyond the fact that this cultural heritage, the four thousand artifacts in the custom-built glass vitrines, were the judge's private property. Mrs. Schön's mostly mass-produced stuff will stay in closed drawers, until the day her daughter dies and then it all will be thrown into trash bags and go into a landfill, while the judge's mostly hand-crafted stuff will be kept and displayed in these glass vitrines long after he will be dead, we had thought, instead of looking at any of the artifacts more closely. Was that our ignorance? We wondered.

We come here with our class background and our personal history, we thought, and find the renovation of this building stifling, walk through the rooms and find the vibe deadly, do not like the bourgeois red carpet that leads up to the headdress hung up high on the neatly plastered German brick wall. We do not like how the particular heritage of the indigenous population of North America is presented to us as a private collection. We listen to him preaching three sentences in High German and find the nephew annoying and pretentious, we feel uncomfortable in his private museum, feel our own incomprehension taking over and are troubled about that, troubled about being implicated in all of this and deeply related without knowing how we are related, nor how we should relate to all of this, are helplessly stupefied when we realize that we are actually lost because we miss references to *Winnetou* in all of this, not only references to *Winnetou*, but *Winnetou* himself, that we still love *Winnetou,* the fictitious Apache chief, that we still find inspiration in simple stereotypes such as wanting to be good instead of evil, wanting to act brave instead of cowardly, wanting to live in harmony with nature in respectful, reciprocal ways instead of consuming and destroying it. Every one of our thoughts in regards to Native Americans is filtered through Karl May's romantic, stereotypical *Winnetou* filter, we thought that has been screwed into our brains from the time we read the novels. As they evolved, our brains most likely learned to discharge most of what we had fed into them, we forgot most of the novels and stories we read as children, we forgot most of the stuff we had learned in school, yet for some reason our brains never discharged *Winnetou*, we suddenly realized, our brains must have grown around *Winnetou* and encapsulated this idea like a treasured rhinestone. Americans always wonder why Germans are so conscious of environmental issues, we thought, why they have this ecological awareness, they say it's due to the population density and Germans wanting to keep energy costs low, while in reality its most likely *Winnetou's* relationship to nature that has been engrained early on, that has become part of

us, we thought and looked at Walter, who seemed to have fallen asleep on the bench in the horse carriage. We most likely think Native Americans are so enduring, because our stereotypes of them are so enduring, our minds went on, like millions of others before us, we obsessively read Karl May as children, and later watched the *Winnetou* movies. For three consecutive summers, it suddenly came back to us, we were fully engaged with a group of neighborhood kids, with whom we had nothing else in common, but this one passion: playing Indians. There had been no fixed hierarchies, we recalled now, we had seamlessly switched roles, genders, locations, names and characters, turned from being a horse into a human into an antelope, an eagle, a tree or a spirit, we used invented language and wanted nothing else, but for it to go on, especially when towards the end of the third summer our grandfather began issuing warnings that playing Indians wasn't compatible with our age any longer. His warnings were like oil to the flames of our campfires at night. We would resist, we told each other, we would make it last, our way of being in the world would continue, no worries, if they would take the peace away from us, we would be smoking peace without the pipes, we would find a way. One evening when we returned from the forest with armfuls of dry branches for the campfire, our paternal grandfather stormed the encampment, ripped down our teepees and the totem pole and sent our friends home. While they grabbed their belongings and started running, our paternal grandfather kept yelling that they never should show up in a headdress again and ride imaginary horses around his yard. They never did, and we never really talked to them again. We did not know what there was to talk about any longer. We were embarrassed when we saw each other. We felt shame for having been exposed in that way by our grandfather. As a replacement for the "stupidifying, stereotypical Christian pathos, that teaches nothing else but utterly simplified versions of good and evil," as our paternal grandfather summarized the only time in our lives we had played happily in a group, he slapped a non-fiction

book about Karl Liebknecht and Rosa Luxemburg on the table. Stoically we sat through the days of our re-education, learned about the leftist Spartacist uprising of 1919 aimed to overthrow the Weimar Republic and start a socialist revolution and formed the conviction that non-fiction was the shovel heartless white men used to beat up and flatten down what was soft and tender in their off-spring in order to fortify, harden, and numb them for the future. Everything can be learned, and everything can be unlearned, our paternal grandfather said, when he quizzed us about the facts in the book.

Oh *Winnetou*!

No one embodied the German idea of the United States of America more than *Winnetou*, the Mescalero-Apache chief invented by Karl May, a man born in 1842 in Saxony's Ore Mountains into a poor, starving family of weavers. Throughout his life Karl May wrote more than seventy books, most of them Travel Reports about the American Old West, the Orient and the Middle East. His most famous ones, the *Winnetou* novels, were published in the 1870's and 80's and slowly replaced Natty Bumppo and his Mohican brother Chingachgook from James Fenimore Cooper's *Leatherstocking Tales* many Germans had read until then.

The second horse urinated in an equally big splash. We had never learned their names, we suddenly realized. We had been in the horse carriage for three days and talked about their tails, and manes and their yearly manure production, but we had never bothered to learn their names, we thought. It's very typical for people like us to remember that *Winnetou's* horse was Iltschi and that Old Shatterhand's horse was called Hatatitla, but don't know the names of Walter's horses.

Throughout the hundred and thirty years of their existence, the *Winnetou* books sold more than two hundred million copies, mostly in German. With a currently estimated population of about eighty two million, we calculated, every living German would own at least two Winnetou books, if all the copies would still exist.

The horse to the left stamped its feet, tried to brush off a fly or a mosquito with its hind leg from its belly.

Oh, *Winnetou!* Romance mixed with realism, mystery associated with love, the inspiring attitude to accept a situation as it is and deal with it accordingly has guided generations of Germans on their imagined or real journeys through the world. *Winnetou* may have brought home what German tribes had lost or left behind in the forests and swamps of their origin a long, long time ago, when the Holy Roman Empire started spreading its powers and Christian faith, and now it was almost as if the figure of *Winnetou* had turned into a German survival gene, almost as if pieces of *Winnetou* had been passed down like hereditary crystals from grandfather to grandson, father to daughter, aunt to nephew, brother to sister, and cousin to cousin.

And it had always been more than a family affair, we thought, while two red squirrels started chasing each other up the chestnut tree with incredible speed and athletic power. It was a national affair. Albert Schweitzer had supposedly read *Winnetou*, Fritz Lang had read *Winnetou,* Karl Liebknecht, George Grosz, Bertha von Suttner, Carl Zuckmayer, Rudolf Steiner, Franz Kafka, Kaiser Wilhelm II, Helmut Kohl, Heinrich Mann, and Hermann Hesse, Heinrich Böll, they all supposedly had read the books of *Winnetou* and so had Joseph Goebbels and Adolf Hitler, who had apparently taken the books of *Winnetou* to bed and called them "my Bible."

Oh *Winnetou*! We knew there was something utterly unresolved in our relationship with what *Winnetou* represented and it was highly alarming to realize now that an inner irrational force was able to shut down the rational parts in our thinking, that parts of us so easily slipped into worshipping that German invention of a noble human, as if we were still twelve years old and had not actually been living in the United States for fifteen years.

Now was the time, we realized. We had to break the spell of *Winnetou*. But how? We just have to tell ourselves, we thought, that ever since Karl May, the fifth of thirteen children with an

ambitious and tyrannical father, had written and published these stories, *Winnetou* has served not only as a collective escape from the built-in contradictions of the German identity, but also as a moral reserve fund. *Winnetou* enabled us to simultaneously generate and destroy, through *Winnetou* we could become invested in the delusional, completely detached idea that we were in solidarity with the oppressed, that we rooted for the victims, that we naturally identified with the losers of history, while in actuality we had no clue who these oppressed people were and how and where they lived.

As a young man, Karl May had been imprisoned numerous times for petty thefts and impostering, and in 1865 had started to serve a three-and-a-half year sentence in the penitentiary Oberstein in Zwickau. In the same year the American Civil War ended with the surrender of the Confederate States, Karl May started to read everything that was available in the prison library. While the so-called Reconstruction Era of U.S. history begins, Karl May sits in the penitentiary Oberstein in Zwickau and reads travelogues, adventure stories, Greek classics and fairy tales as well as non-fiction books about geography, botany and the animal kingdoms in Africa and North and South America, that eventually will become the basis for his own writing, we thought. And about twenty five years later, in the 1890s, a period in the United States marked by severe economic depression, Karl May's adventure novels gain immense popularity in Germany and begin to generate a serious income for him. The year that the Massacre of Wounded Knee happens on the Lakota Pine Ridge Indian Reservation in South Dakota, German novels that describe the struggles between white settlers and Native Americans become bestsellers in Germany. The year 1890, which has been historically considered to mark the end of the centuries-long armed conflicts between colonial U.S. forces and Native Americans, also known as the Indian Wars, marks the beginning of German people's obsession with the myths surrounding Plains Indians. Karl May buys himself a mansion in Radebeul, calls it "Villa Shatterhand," and places the two

thousand books he had read while writing his stories in his private library. He decorates the interior of his mansion with objects that have appeared in his novels, and slowly turns himself from being the author of his novels into being the first person narrator of his novels. Amazing, we thought. We stand here in the *Indianermuseum* in Gaudok, which houses the biggest private collection of Native American artifacts next to a taxidermy Grizzly bear on his hind legs, and think about *Villa Shatterhand* in Radebeul. We look at the teeth of this once-alive, now wire-framed and cotton-stuffed specimen, and think, what's sinister and threatening is actually not the dead bear itself but the so-called live mount of the dead bear. We look at this grizzly bear who most likely was specifically put to death by hunters in order to be preserved by taxidermists in a lifelike state and realize that his fangs are almost three inches long. We look at the nails on his paws, thick like cigars, and think that due to their thickness and strength and the way they are curved they look like the teeth on the shovel of a backhoe, which reminds us that a proprietor in Utah once told us that bears use their nails mostly for digging and uprooting shrubs in search for insects, lava and tubers. We look at these grizzly nails and try to imagine how this taxidermy grizzly from North America compares to the taxidermy female lion from Africa that Karl May supposedly kept in his study in Villa Shatterhand in Radebeul, where he sat on his desk and wrote his novels. We think of all this, and remember that Karl May eventually not only dressed up as his characters, very often as Old Shatterhand or Kara Ben Nemis, but actually turned himself into them, that he claimed at the height of his popularity that he spoke more than twelve hundred languages and dialects and that he had extensively traveled around the world. He insisted that he had actually experienced what he had written about in his novels, even though he had not been to the places where his adventures took place, never had left Germany. Instead he had hired craftspeople and manufacturers, who built the pistols, guns and amulets he had described in his books and then used those objects as actual evidence when he talked about his deep

friendship and his beautiful adventures with Winnetou during popular lectures he gave in front of big audiences. We had learned about these biographical facts, we remembered now, with a sort of resistance, had actually resented our paternal grandfather for gifting us a *Karl May Biography* for Christmas, as much as we had appreciated our maternal grandmother's commitment and generosity, using up some of her hard earned favors from people with connections to West Germany, to gift us *Winnetou III,* temporarily also entitled *Winnetou, The Red Gentleman III.* East German factories produced beautiful editions of *Winnetou* books, but only for export to West Germany and during East German times, we remembered now, the hunt for and the actual acquisition of an actual *Winnetou* book often turned into such a long-lasting, nerve-wrecking adventure, that it was almost a letdown to read the adventure story afterwards. East German communists weren't supposed to read *Winnetou* because the Nazis had been obsessed with *Winnetou.* Because Hitler had supposedly urged his generals, as a last resort, to find

298

hope and courage by reading *Winnetou* during the devastating battle of Stalingrad during which the German troops finally surrendered in February of 1943, a few years later people in East Germany had to trade and read *Winnetou* secretly, never sure of what would happen if the Stasi would find out. Yet no ban, no government control, no elucidation, no re-education ever helped. Our paternal grandfather had tried hard, but it wasn't Karl Liebknecht and Rosa Luxemburg and the Spartacist uprising, it wasn't Don Quixote, Sancho Panza and the windmills, it wasn't Dr. Faustus, the searching scholar in his destructive quest for the essence of life and Mephistopheles, the seductive demon from hell, who had made themselves a home in our sub-consciousness and stayed there – it was the romantic description of a loyal friendship between an Apache chief from North America and an immigrant from Germany and their fight to save Native Americans from being eradicated when the West was won. And now it was time to let it go and surrender to the idea that Hitler's obsession with *Winnetou* may have led him to imagine the Slavic

people in Poland as Indians who needed to be forcefully and systematically removed or kept in designated, fenced-in areas, so Germans marching into Poland during World War II, could expand their living space and culture like their fellow Germans had done by emigrating to North America in the 18th century. Now was the time to realize, we thought, that while Hitler had that one thought about the Indians, he was also capable of having that other thought. It's possible, we thought, that people are capable of living in two, strictly separated worlds simultaneously. It's possible, we thought, that actual people about to be killed or systematically removed can simultaneously serve as ficticious role models for soldiers or bureaucrats carrying out the actual killings. Let it go! we thought. This is utterly sick and horribly perverted and its unbearably sad to imagine, that German people who had participated in World War II and survived it, may have cared so deeply for *Winnetou*, his unsuccessful struggle to save his people and his ultimate defeat, because it had helped them to release their emotions in connection to the crimes that were committed during the Holocaust. *Winnetou* may have been the German guide to navigate the implications of a genocide. If there was no way to cry about the millions of Jewish people, and millions of Soviet POWs and ethnic Poles and Serbs and Romani and Freemasons and Slovenes and homosexuals and political opponents and all the others murdered in the concentration and extermination camps because the atrocities were too much to comprehend, it might be helpful, even healing, to cry about heaps of slaughtered people in Northern America, people in the German movie industry of the 60's must have reasoned. And they were right! The *Winnetou* movies were a huge success, a very well received outlet for all kinds of contradictions and emotions. We had been addicted to watching them as children.

Walter, still on the bench in the carriage, stretched his arms and then folded them under his head. He pulled up his knees and slowly started doing sit ups. Eins, zwei, drei vier, fünf... Walter kept going. Elf, zwölf, dreizehn...

We need to be honest now, we thought. We need to stop walking around this *Winnetou* thing like an academic cat around the hot pulp it has been served in history class and tell the voyagers from Dasdorf, that we have a suitcase full of Native American costumes at Fohrs' farm and that we had planned to set up an impromptu Native American gift shop as a road side attraction for them, as part of our journey through America, similar to the actual touristic Trading Posts we had visited during our travels through Arizona, Utah and New Mexico, but now couldn't do it anymore because we had realized that it was a stupid idea. We needed to tell the voyagers, we thought, that the night before, surrounded by framed photographs and oil paintings of German cowboys on horses in Fohrs' vacation apartment, we had painted a sign the size of a door that said "Native Gifts Handmade," while telling each other that it was important to represent American Indians, since most of the people we had encountered Mecklenburg-Western Pomerania so far were engaged in reenacting the American Wild West and had slipped into emulating the white frontier settlers in cowboy towns. We had not brought any handmade gifts though, hadn't made the clothing ourselves, hadn't studied the original patterns, or befriended zookeepers and collected eagle feathers in zoos of NYC like other Germans had, we hadn't actually done much research into this very particular German tradition of emulating Native Americans at all, but simply purchased the cheapest and most stereotypical outfits and wigs we could find online from a Halloween store and the handmade gifts in a ninety-nine cent store in Chinatown NY and now felt pretty stupid about it.

Walter had gotten up from the bench, turned around and started doing push ups now. Eins, zwei, drei, vier fünf…We held on to the window handle and closed our eyes. The American windows slide open right to left, or up and down, while the German windows swing open. There usually are no window handles in America, we thought, only in Germany is this possible. For hundreds of years, there have been hundreds of *Indianerklubs* all over Germany,

thousands of socialist, fascist, communist, catholic, proletarian, aristocratic, atheist, Russian-occupied, American-occupied unified Germans have dressed up in handmade Native American style deer skin clothing and spent weekends in teepees meticulously and happily reenacting Native American dances and ceremonies, for hundreds of years. There have been Native American-themed festivals and outdoor shows, and in 2001 more than eleven million people went into German cinemas and watched *The Shoe of Manitou,* a mindless parody of the *Winnetou* films from the sixties, that did nothing else but update old clichés and stereotypes while earning its makers sixty five million euros making it one of the most successful German movies after World War II.

But was it really Winnetou we needed to get out of our system, or was it rather Old Shatterhand, Winnetou's blood-brother, who had ultimately survived and went on living to tell dead Winnetou's tale as the protagonist in a first-person narrative?

Old Shatterhand was the German immigrant who had crossed the ocean to reinvent himself. Old Shatterhand was the former elementary school teacher from Germany who had staggered around the North American prairie as a clumsy greenhorn in search of adventure and a better life, until he began witnessing the white land grabber's injustices toward the Native Americans and decided to join their fight for justice on Winnetou's side. Old Shatterhand, we said out loud, as we pictured our extended families sitting around our grandmother's black-and-white TV, watching the scene when Winnetou dies.

There he is, Winnetou, as he helps Apache children, women and old people to retreat further into the mountains. They will be safe, Winnetou says to them, Winnetou will guard them, and while the people of his tribe disappear into the background, Winnetou, Old Shatterhand and a few allies, guns in hand, take cover behind some rocks and await the arrival of the greedy bandits and desperadoes, who have been roaming the Old West ruthlessly for oil and gold and have driven a wedge into the supposedly well- working relations between the soldiers of the US government and the

Natives. When the bandits arrive together with White Buffalo, the chief of the Jicarillo's who had been tricked by the bandits into believing that Winnetou had killed his son, Old Shatterhand appears on the edge of the cliff and gives a heroic speech, in which he encourages White Buffalo to take off his blindfold so he can see that all these white land grabbers want is wealth and power and that once they have it, they will throw him and his people out. Winnetou and Old Shatterhand don't want to fight, Old Shatterhand shouts into the beautiful green valley below him. They believe that all men should live together as brothers and try to understand each other without hurting and killing. At that moment the US soldiers arrive, the battle starts between bandits, Natives, and US soldiers. One of the bandits climbs up the cliff and aims his gun at Old Shatterhand. Winnetou sees it and throws himself in front of Old Shatterhand, catching the deadly bullet with his heart. We all start crying and sobbing, when in the next scene Winnetou lies on a makeshift stretcher on top of the cliff, while in the valley below the US soldiers stand in a straight line in front of two rows of white military tents paying their respects to the dying chief. Winnetou is breathing heavily, a military doctor in a blue uniform examines him and then states without showing any emotion, that the bullet is lodged close to his heart and that Winnetou's faith now lies with God. Old Shatterhand has a flashback and our tears run like waterfalls as the most iconic and beautiful moments the two men had shared are being replayed. Then Winnetou wakes up. He looks helplessly, and with a hint of terror at Old Shatterhand, who calmly assures him that his brother can rest in peace because the Apache people are safe and secure. Winnetou smiles with relief and says he hears the bells ringing, hears the bells that are calling for him. My brother. My brother. My brother. "I never heard such ringing. Good bye." By now we children are wailing, hugging our cousins and crawling to the feet of our maternal grandmother, who has turned the yearly TV screenings of *Winnetou I, Winnetou II and Winnetou III* into highly dramatic family gatherings, during which she insists,

against the approval of our parents, that her grandchildren wear Indian headdresses. As a result of this insanity, or maybe even as a sort of revenge for setting up this excessive, emotional outburst our maternal grandmother, the only Catholic among her atheist, communist offsprings, would be periodically forced by her children (our parents, uncles and aunts) to stand up and reenact in the form of a slapstick routine the moment, she had patted Adolf Hitler on the shoulder and made funny faces at him and supposedly stuck out her tounge at a rally in 1936, in order to prove how little she had cared for Adolf Hitler. When her grown up children demanded, sometimes physically forced her to reenact the story, most liklely once they got heavily drunk and their moods turned sinister and violent, they would hysterically laugh at her, slap each other on the shoulder and call her "Our Red Mother," which had always confused us children, because we never knew, if the "red" referred to actual blood, North American Natives, or communists fighting the Nazis.

The nephew told us that his uncle had bartered with them and had promised the Native Peoples that he would build a museum and keep all their stuff under glass, that's why they gave him a lot of those things. That's how our government works. Everyone who sits behind an oak desk writes themselves a big monthly check, long vacations, and a nice pension, so they can take time off, leave the country they are supposed to serve and be with the Indians in the woods. And after they retire, they build themselves a museum and then they get angry when nobody comes to visit. "We have the biggest private collection of authentic artifacts in the world and nobody comes and visits," the son said. What do they think? That Gaudok is different than Dasdorf or Marterhof? That anybody in the world would care and think it's worth coming

304

here, except the fox to say goodnight to the rabbit? The politicians don't even grant us our own zip code any more. We are not even worth a five-digit number. They call this a civilized country, and then they turn off the streetlights. Last winter they let them burn until eight p.m., and this year they turned them off completely. I need a torch to walk down the street after eight p.m. This is not Germany anymore. This is Germania.

In the native languages words like greed and jealousy didn't exist, the nephew said, and if we would take on just a little bit of wisdom from the Indians, we would be much better people. The boss started arguing with him because he would not let them take any pictures in the room with the dolls. "That will disturb the ghosts," he said. They reminded him of already having paid for the photo permission, the sister said yes, ten euros, she was a witness, but the nephew said, ghosts can't be paid. How about twenty, the boss said, and the nephew nodded and said, the boss had obviously learned the main lesson in America. The boss gave the nephew a twenty, but then he did not even take a picture. What do I care? All a hen sees, is that a dog has a beak and all a dog ever sees, is the hen's tail. The bison head impressed me. Never had I seen an animal like that in all my life. Just to imagine them thundering in herds across the prairie… When we got into the last room, the Sister took a look at the beaded bags and told the nephew that there was nothing authentic about these beaded bags. "The Native Peoples only started using beads after the Europeans landed in North America and gave them cheap glass beads in exchange for their gold

jewelry." The Sister definitely knew more than the nephew wanted to know. That much was clear from the look on his face. Obviously that did not stop her. She had beaded many belts, medicine bags and knife sheaths, she said, when she was part of the "Little Snakes Club", that's where she got her knowledge. "The Thunderbirds", "The Eagle Wings", "The Bear Paws". For more than twenty years she had been part of several Clubs for *Indianistic Culture* in Burg Stargard and Neubrandenburg. If they were not beading, they were crafting breech-clouts from deer hide, spinning their own wool and dying it in beet juice and bee pollen to weave blankets on handmade looms. Eventually they sent some of their belts and blankets to Native tribes in America to show their solidarity, because these poor people were so oppressed by the US government, she said, they didn't believe in their own traditions anymore. In the late sixties, she said, some members of "The Little Snake Club" even contacted the US embassy in West Berlin and they recruited a student to transcribe and translate their instructions on how to weave the traditional patterns and make diagrams. "Maybe your uncle bought blankets from the Lakotas that were made right here in Burg Stargard by East German women in the Indianistik Clubs, maybe one of the belts in your glass vitrines is one of the many belts I made on the Low Bow in the 60s and 70s," she said. The nephew looked upset. He did not want to hear any of the sister's stories. "The comrades knew all about the *Indianistic activities* but rarely interfered," the Sister said, at least that's what we thought. "As long as we debunked the American capitalists and weaved all

the wrong-doings of the US government in our blan-
ket designs, everything we did was tolerated. All
the packages we sent to the Indian reservations
in America were checked and approved by the com-
rades," the Sister told the nephew. "Only after
the Wall came down did we find out that the Stasi
interfered with what was going on in the clubs,
basically every club had several unofficial infor-
mants, many times they were the chiefs themselves.
That was bitter. Very bitter medicine. Many clubs
fell apart because of that in the early 90's.
I watched this documentary on TV," the sister
said, "and what I remember from it, is them say-
ing that the Stasi had written and documented more
about the life and the activities of the hobby
Indians in East Germany than the rest of the world
together had written about the Native Americans in
the US. I don't know. Those reporters were twen-
ty-five-year-old university students who needed to
deliver some TV catch phrases. Who doesn't have a
dog hunts with a cat. But that is another story. In
1977 we organized a weeklong Pow-Wow in Stechlin.
About two hundred people came, children, old peo-
ple, most of them with homemade teepees, all in
traditional clothing, we beat the drums and danced
all night. Smoked the *Chanunpa Wakan*. In 1978 we
printed posters to free Leonard Peltier and nailed
them on the inside of our toilet doors at home.
He was an icon at the time. There are still some
old pictures of that protest and the tent cities.
You can go to Burg Stargard," she told the nephew,
"and collect some artifacts *there* before everyone
is dead and it all goes into the trash. Dedicate
a room to what *we* did. Just one room. That would
interest people here, then we would come."

307

While the sister was lecturing the nephew it came back to me how as a boy I made my own bow and arrow and headgear, how I had always tried to speak less and do more good instead. I wanted to be good. I wanted to be with Mother Nature, longed for Mother Nature to love me, living steadfast like a tall, upright tree in a forest among other strong and upright trees. Herman and I poked our index fingers and dropped some blood into the ground. We cut our initials in the bark of an oak tree to pledge allegiance to Mother Nature and her kingdom. In the forest we discovered who we were. Herman the German. I was the Indian, my tribe "the vanished ones". He had left Germany and come to live with us hidden in the forest. Nobody knew that we still existed. We had a few tents camouflaged by branches and leaves. The inside was covered with old sheepskins grandmother Lene had given to me. That's where we laid down and told each other tales about how we would survive. Against the will of the white men. They were doomed. Their god had a human face. We did not need any further evidence than that. When it rained, we went to the Tetzow cave and made a fire. No one ever bought us toys, but I always knew how to make my own from stuff I

found in the woods. Bows. Arrows. Little animals for the girls to play with. My only tool was the pocketknife my grandfather gave me for my fifth birthday. "All you need in life is patience and your Swiss Army Knife," he used to say to me. It took almost two years to collect all the feathers from a peacock. Actually more than two years. Each one was saved from the landowner's big green lawn behind the iron fence. After school we went over there and peeked through the iron gate, and when we spotted a new feather lying on the lawn, we approached the white man's fort. We despised them for their fences, for their masonry walls, their cowardice. Hermann and August, their faces painted with mud, lured the old German shepherd to the east side, dug a hole under the fence and occupied the dog with an old bone we kept hidden in a milk jar in the forest while I climbed over the fence to get the peacock feathers. After two years we had collected all the feathers we needed. That headdress was my biggest pride. I was the chief. Chief Teutebourg. I built myself a throne out of soft green moss and deer bones. We nailed the skull of a deer to a tree and Annemarie and her two little sisters tied the ankles of their hands with flower garlands to the tree and danced around it. I wish I still had at least a picture of that headdress. But the headdress is gone and the rest will disappear soon, too. Nobody will take care of our stuff once we are dead. They will probably keep the TV, because that's only two years old now, but everything else will go into the garbage. "Our bedroom is too small for that bed," my daughter keeps repeating. And even if they had the space, they still

would throw it into the garbage. What a disgrace.
My great-grandfather built that bed with his own
hands before he married my great-grandmother. He
cut down the oak tree his grandfather had planted
in front of their house in Marterhof. The bed is
made entirely out of that one tree. There are two
hundred and fifty years of family heritage in that
bed, and as soon as the Mother and I are in the
ground, some Romanians will collect it from the
garbage, load it onto their rummage truck, and
run off with it. It drives me crazy to think of
that. I should make my children sign a contract.
That I will disinherit them if they throw the bed
into the garbage. That bed would last at least
five more generations. But they don't care. They
have no pride in ancestry. "Being the last link
in our chain is like being the last in line at
the supermarket," my son said. What an outrage. I
could have slapped him in his stupid face when he
said that to me. Everything went wrong with this
brood. The way they turned out makes us look like
a complete failure, not just the mother and me,
our forefathers as well. That's the truth. I can't
get over the fact that I have never been able to
convey to these soggy sad sacks the fortune of
being able to sleep in that bed. How many times
have I tried? How many times have I explained to
them that my great-grandmother gave birth to my
grandfather in that bed, and that my father was
born in that bed and died in that bed, and that
all my sisters were born in that bed, while I came
out on the floor with my mother holding on to the
legs of the bed? "You almost killed me!" my mother
used to say. Right then she knew that I was going
to be a strong and stubborn one.

The nephew and his uncle had at least tried. The judge had traveled, visited, asked, accumulated, learned, talked, had followed his urge to preserve a culture that wasn't his own. What had we done so far? Rented a horse carriage. We turned around, walked back into the room with the bison head over the door, unsure what to do or say. The only person still present was the nephew who stared out of a window into the backyard. His lordliness was gone. He looked vulnerable and exhausted. We stepped closer. There was a small vegetable garden outside the window, strawberry plants, beans, carrots, peas, a few red currant bushes, zinnias and sun flowers on the edges, a few white and a few pink cosmeas starting to bloom, and on the side properly pruned fruit trees. Early for cosmeas, we thought, cleared our throats and asked the nephew a question about the arrowheads in the glass vitrine right next to us. He didn't answer and kept staring out the window. We asked him about the beaded belts and the headdress above the stairway. Silence. Staring out the window. "Nice garden," we said.

"Your friend, the feisty, old lady," he finally said, "told me about her *Indianerklub* in Burg Stargard and lectured me about the concept of solidarity. She said I needed to sell everything and put the money into opening a kindergarden on the Pine Ridge Reservation and hire tribal elders of the tribe to teach the children their native language. I could bring her along for a visit, she said. She would be interested to finally find out if anyone understood the few words of Lakota she had learned in the club.

"Would you take her?" we asked.

"I have never been to the US. I deeply despise that country for what they did to the Native peoples. I doubt I will ever go."

"That is…."

"Yes, it is tragic. A paradox. I know. See that apple tree out there? Before he got sick I got into a fight with my uncle. He pointed at that apple tree and screamed that the only Indian tribe that will ever really mean anything to German cowards like me are the *Apple Indians*."

"Who are the *Apple Indians*?" we asked.

"The invented ones. *Winnetou.* Outside red, inside white," he said.

"It may be the hardest task of all to come to terms with what grows in one's own backyard," we said.

He didn't respond.

"We don't even know what an apple is anymore," we offered, "with Apple Macintosh and the Internet and all of that."

He nodded and turned around. We shook hands, offered our regards to his sick uncle and walked out of the museum as fast as we could straight into the horse carriage.

"Done?" Walter asked.

"No," we answered.

Silently we sat in the horse carriage while Walter kept reading his newspaper. After about an hour Mrs. Trautmann, Mr. and Mrs. Study and Mrs. Kirsche appeared in the doorframe.

"We are ready for lunch!" Mrs. Study shouted across the lawn and waved with a big smile on her face. We crawled under the benches and unpacked the lunches. Whole wheat bread with cream cheese, tomatoes and apple slices.

Blankenhof, Chemnitz, Weitin, it was nice to see all that again. The last time I had been in Blankenhof was fifteen years ago at Gertrude's funeral. Gertrude, the first one I had ever kissed at the Blankenhof autumn festival. I was drunk, threw up from the beer and schnapps afterwards. That all my children were born in the hospital was possibly the beginning of the end. If the Mother would have given birth in our bed like everybody else before her, then we still might function as a family. She was healthy. She was young. There was no reason for doing it in the hospital, being separated right after the birth. But those were the times. While my children were

fed infant formula in the day care center, the mother was milking the collectively owned cows in the stable. It's even worse nowadays with the cows. They just cut them up. Every calf in that new stable up there has been extracted into this world through a caesarean. Not one natural birth. I don't need to turn on the TV to see how close we are to the end of the world. I just walk through the stable and take a look. All I see is udders. That's what I told Mr. Bülow when he was showing off his new achievement. Big swollen udders covered in shit. What am I supposed to say? These cows do nothing but chew hormones, shit toxic waste, and produce unnatural amounts of milk. If it were any other way, Mr. Bülow said, he would have to declare bankruptcy. It always has been bad, it always could be worse, why am I even getting agitated? At least these cows have a roof and enough to eat. When the Russians put a chain-link fence around the muddy meadow in that godforsaken forest after they caught us, we did not have a roof. We slept on the ground. On the bare ground in the open. A thousand men. A big hole to shit in, some wheat slime for breakfast that was supposed to last for the rest of the day, always starving, freezing. Especially during the night. In the morning they came around to collect the dead. But most of us survived. That is the most depressing part. That we were able to survive what we did and what was done to us. That we were able to adapt to those circumstances. Why worry about those cows? If men can survive, why shouldn't cows be able to? I should have just kept my mouth shut; I should not have said anything to Mr. Bülow.

We kept going through fields, through meadows, through villages, little towns, through forests, up the hills, down the hills. Dirt roads, cobbled streets, asphalt, half-tarred, gravel, grass. Trees, bushes, flowers, weeds, wheat. Birds. Butterflies. Dogs. Deer. Plowers. Mowers. Strollers. With hats on and walking sticks in hands. On tractors. With nylon shopping bags or woven baskets on their backs. Mrs. Kirsche and Mrs. Study and Mrs. Trautmann's favorite topic was talking about the prices in the supermarket in Burg Stargard. They analyzed the relationship between a product for sale, its monetary value, and the risk of buying it with such attention to local supply and global markets that we had to keep reminding ourselves they were talking about a tetra-pack of apple juice and not about investing in a house with three and a half bathrooms and central AC in the Hamptons. We played horse riding with the baby boy on our knees. Miranda painted her fingernails. Walter hummed a song. The sun was out and it was warm.

Mr. and Mrs. Study and Mrs. Kirsche had never been inside a McDonald's. All three of them just shrugged it off as another

banality that had come with the invasion of the free market economy not worthy paying attention to, while Mrs. Trautmann used the upcoming visit to remark on the global fast food epidemic and it's spread of obesity and diabetes. At the counter the travelers had a hard time figuring out how and what to order. They didn't understand the terminology on the menu board near the ceiling and were confused by the lights. What's a meal? What's a value meal? What's an extra value meal? What's a happy meal? What's a mix and match deal? What's a combo?

There were a few teenagers in front of us who ordered, paid and stepped aside a bit too fast. Our group wasn't ready yet. What's a triple breakfast stack? What's McNuggets? Battered ground up chicken? Fried? The whole chicken? With the beaks? What's McMuffin? What's a soft drink? The opposite of a hard drink? They put candy in ice cream? Why would they do that? What does one eat for lunch? A Big Mac? What's a Big Mac? How does one eat it? Why are there different sizes? Why is everything so expensive? Wasn't it supposed to be cheap? Who is paying? All together? Separate?

Once the cashier's efficient routine of taking orders and returning cash was stalled by the slowness of our traveling group in deciphering, discussing, and deciding how and what to order, she started to tap the countertop with an empty straw and stared into Mrs. Trautmann's face. Her slightly open mouth expressed a cowlike sort of disbelief. Mrs. Trautmann was unimpressed. "What's the difference between a hamburger and a cheeseburger?" The employee let her chin drop fully. We could see that the tongue in her mouth was pierced. She kept tapping the counter with the straw. A few young men in combat-style boots, whose entrance had immediately militarized the atmosphere, started to snap the suspenders attached to their jeans behind us in line. "Come on grandma," the leader, whose hair was trimmed uniformly short, said. His crew laughed approvingly.

Mrs. Trautmann calmly ordered a Caesar Salad. The employee rolled her eyes as she inserted the order into the system.

"Little Red Riding Hood, what the hell is Grandma doing at McDonalds?" the leader said and tapped Miranda on the shoulder. Miranda didn't respond and stepped aside and in her place stepped Mrs. Kirsche who also ordered a Caesar Salad. And then Mrs. Study said, "Me too." And then Mr. Study stepped up and also ordered a Caesar salad. "Grandmothers and Grandpa! Let me offer you a sincere and heartfelt Roman salute on this choice to honor the great Julius Caesar," the leader said. He stepped forward, straightened his

legs, pushed the left boot on the right one, and then bowed down his upper body, elegantly spiraling the index finger of his right hand down to the floor, as if he was greeting Louis XIV in Versailles. His subordinates cheered and clapped their hands. When the leaders head came up again, he gave us a menacing smile. We returned the gesture with a grimace, ordered five large French Fries and a variety of Salad Dressings, paid and stepped aside to wait for the food to appear on the counter, while Mrs. Kirsche, Mrs. Study and Mrs. Trautmann set a table in the back of the restaurant with plastic forks and knives and napkins. Once we had brought several trays with the salads and the French Fries to the table and the packages were distributed, Mrs. Study collected the empty trays in a stack

and then sent Mr. Study to return them to the counter. On his way he tripped. The trays fell down in the middle of the room. The woman behind the counter laughed hysterically. The leader put on a sincere, theatrical look and clapped his hands slowly. Miranda ran towards Mr. Study, picked up the trays and gave them back to him. When he returned from dropping them off at the return counter, Mrs. Study patted him on the right arm and said, "Good father, all is good." He let himself fall into the chair with a loud sigh. With some effort

Mrs. Kirsche, Mrs. Study and Mrs. Trautmann managed to open the plastic containers of their salads, but couldn't open the packages for the salad dressing. Mr. Study stood up again, pulled a Swiss Army pocketknife out of his pants, unfolded the built-in scissors, cut the packages open and fell down into the chair again. When Mrs. Study started to squirt the salad dressing, it splashed onto the tabletop instead of into the bowl. Miranda jumped up again and brought a stack of napkins. The baby boy didn't like the pouch of liquid spinach he was supposed to have for lunch and threw it on the floor. Mrs. Trautmann used the napkins to wipe her plastic fork and then her plastic knife. Mrs. Study followed her example, cleaned her set and then her husband's. We gave the baby boy a pouch of

banana-peach puree. "Guten Appetit," Mrs. Kirsche said and every-
one responded: "Guten Appetit!" Whoever ate salad, ate with fork
and a knife, and whoever ate French fries used their fingers, except
Mrs. Trautmann who picked them up with a fork and cut them in
half before she put them in her mouth. In the midst of this we sud-
denly had this desire to tell the passengers a personal story. We
leaned forward. "Every time we are at an airport," we said in a low
voice, "we purchase a fish filet from McDonald's. Eating the fish
filet in a bun prior to boarding a plane has become a ritual of such
importance," we said, while Mrs. Kirsche kept chewing on a big
lettuce leaf, "that not eating a fish filet seems to drastically increase
the chances of a plane crash. To us flying is a very ordinary activity
and yet on some level, it is still so abstract, absurd and artificial that
we need a fish filet served in a cardboard box to give our body a
chance to comprehend what is going on. The fish filets in their buns
are to our digestive system what our bodies are to the cabin of the
airplane. Doesn't it make sense to combine the two? Shouldn't it
be mandatory to eat a fish filet before boarding a plane?" we asked
and then looked at Mrs. Kirsche, who briefly stopped chewing her
Romaine lettuce leaf and then politely said, "Yes."

They couldn't believe none of us had ever had been
to a McDonald's restaurant before. But what did
they expect? That I throw my money away? Since
the Braustube in Dasdorf closed down we haven't
been to any restaurant at all, the Mother and me.
Why would I upset my stomach with this muck? Just
because somebody puts a list of unreadable names
on a menu, defrosts packages from the whole-
saler in the microwave, throws stuff into a
cardboard box, and sells it for a lot of money,
doesn't mean I have to buy it.

The castle in Burg Stargard could have been our
next stop. I keep confusing the order because there
was no structure to the whole trip. The Americans

kept repeating that we were traveling from east to
west and north to south, but that was just according
to their own logic, which we never could follow. In
reality we crisscrossed every back road and street
there is between Neubrandenburg and Dasdorf. One
day we were in New York and the next in Kentucky
and then at the Mississippi River and then in
Florida. The castle was supposed to be in Florida.
On the way up there I thought the horses wouldn't
make it. The higher the mountain, the harder to
capture the king. The poor beasts were sweating
and steaming. We had to stop a couple of times and
give them a rest, the slope was too severe. When we
arrived on the plateau at the castle Walter parked
the wagon right in front of the gate.

The Americans gave us some cake and a thermos
with coffee and said, we should wait here for a
surprise to happen soon. The gooseberry cake was
good, but the crumb cake was too dry that day.

The Sister said the same thing. "It tastes like too much baking powder," she said. We ate the cake and then we waited. Walter said he had no further instructions. When the Americans say ten minutes it means half an hour. "The rain clouds hang like a privy over the ditch. The moment they let us off the wagon it's going to pour down on us," the Kirsche predicted. And that's what happened. When they finally called Walter to let us off the wagon,

the sky was black. We walked toward the castle and were greeted by two Mickey Mice the same size as us. They shook our hands with their big white gloves, gave each of us a headband with mouse ears, and hung some paper medals around our necks. And then they dragged us over the wooden bridge through the first gate. We were all holding hands and when we had made it through the gate a bunch

of screaming children ran toward us. There were at least twenty of them, all running and screaming, but before we even got to the second gateway it started pouring down rain. Nobody had an umbrella. The children ran into the castle. The Mother said we couldn't go back without an umbrella. "If we get wet and have to keep sitting in the cold wind that's been blowing through the wagon, we will continue the journey as a bunch of corpses."

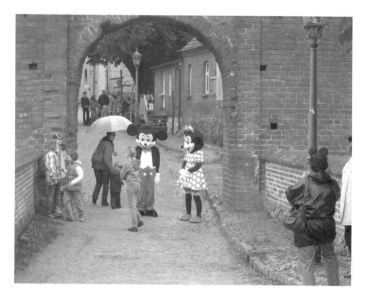

The castle, a partially-inhabited ruin, had been built in parts between 1236 and 1260 and sat surrounded by a dried-out moat on top of a steep mountain. The glossy threefold brochure that had been passed to us during our research trip the year before through a hole in the wall near the first entrance gate by a hand connected to a white arm with lots of black hair, pointed out that hundreds of witches had been burnt to death on big funeral pyres in the courtyard in front of us. The tourist industry called the years when the scorched world

was coming to an end "the ice age of medieval times." The temperature in middle Europe had dropped, there had been ruined harvests many years in a row, and the plague raged through the lands without mercy or remorse killing almost every second person in its way within a time span of about four years. According to a proverb-inspired peasant painting by Pieter Bruegel the Elder (the last thing we hastily looked at in the brochure before we had to use it as a temporary umbrella and run back to the car),the offspring of the survivors of that most devastating pandemic in human history were a bunch of grotesque figures bedoozled by their own wicked foolishness.

Now, a year later we had returned. Walter had parked the horse carriage in front of the castle. We supplied the travelers with coffee and cake, asked them to wait for a signal and disappeared with three black trash bags behind some bushes with healing properties from the 14th century in the historic herbal garden near the castle's moat. We changed into full body costumes including heads and approached the carriage again about twenty minutes later, dressed up as anthropomorphic mice with circular ears, who walked funny on two legs in oversized shoes and wore a set of shorts and mini-skirt. We were able to greet and smile reliably, but were unable to hold each other's hands, due to the blown up puffiness of the white, three fingered gloves that covered our front paws.

A group of children who had just finished a tour through the castle enjoyed the sight of the oversized, white-gloved rodents, and so did Anneliese and her husband Rolf and some friends of theirs, who had spontaneously decided the night before, when we had met them at their line dance practice in Fohrs' saloon, that they would also like to dress up as American amusement park characters and join us at the Burg. One of the castle's tour guides, a somber-looking woman in her sixties who wore a necklace with an amethyst so big and heavy it turned her into a hunchback, immediately took charge of the situation and arranged the children and the rest of us characters in a group sorted by height. She then kneeled down on the thousand-years-old cobblestones,

counted eins, zwei, drei, and took a picture with a disposable camera, then encouraged the bewildered guard and the ticket sales person at the entrance gate with a warm and reassuring voice to join the group under the archway, which they refused. And then, it began to pour and we ran up the hill.

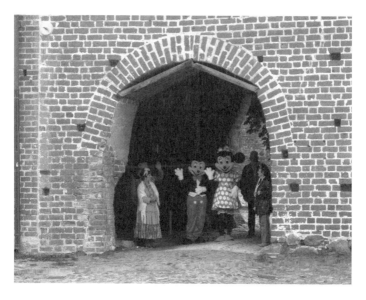

Slightly out of breath, we reached a third gate, the last one before we could enter the most inner courtyard around the actual castle and decided that we would stay under the archway until the rain stopped and took a few more group photographs. Our baby boy latched on and when he was finished nursing he quickly fell asleep. The density of the raindrops increased and it looked as if we would be stuck there for longer than we had expected. Or not. "No one ever knows with rain showers in the summer," said Mrs. Kirsche. Water drops were condensating on the cut stones in the archway. Slowly they swelled up, until some eventually broke and released themselves into a tiny stream that ran down the stones and left a thin trail. We sighed. Waiting for the rain

to stop was like waiting for the bus to come. It was hard to not focus on that one thought. When would it stop? Everybody, it seemed, was engaged in similar mental activities while staring into the pouring evidence that either supported or contradicted their hypothesis. From time to time someone stepped forward and peeked out from under the archway into the sky to collect further data. That someone usually also farted. Mr. Study had something stuck in his throat. He took out his cotton handkerchief and coughed something into it. Mrs. Trautmann had folded her hands in front of her belly and rotated her thumbs around themselves. It occurred to us, that if a thousand people had already walked through the archway into the castle, that would have been only one person per year. The idea was overwhelming, especially when we tried to picture them as individuals. A gruff, longhaired Germanic barbarian. A nun. A mother superior. A chieftain about to lose his tribal lifestyle. A happy dog wagging its tail. A barefoot boy with curls and a head full of woodland religion. A bare-breasted Germanic women with a child, firewood, and a sword wailing for victory. A mother duck followed by six ducklings. A pale peasant wearing a blue tunic and a veil, held in place by a yellow cord tied around her wrinkled forhead. A Franciscan monk in leather sandals, long brown cowls and a bald round spot shaved in the middle of his head. A grey hooded butcher with a slaughtered pig tied to his back missing a front tooth. A shy, freckled virgin with a white bonnet carrying a basket of quail eggs, some deep gold in color with lots of dark brown splotches, others a rather pale yellow with a few smatterings of grey. A red-cheeked market women with a straw hat, swollen lymph glands, and a tumor in her groin as bigs as an apple. A double-chinned widow with a black veil. A frog. A cat. A young innkeeper with brown eyes accused of having kneeled down naked in the forest, where she supposedly had held up the devil's tail and kissed his anus. After the trial she would be put in a custom-made oversized bird-cage together with seven black cats. The men of Burg Stargard would build a

large wooden structure that looked like a doorframe to hell in
the inner courtyard of the castle and hang the cage on it. The
women would build a fire underneath the cage. They all would
be clutching their crosses and rosaries, while the young women
and the cats would, as one of the sixty thousand people who
were publicly executed during the witch trial hysteria in Early
Modern Europe, burn to death. There was a professor of theol-
ogy who asked a mintmaker where all the money went. There
was a woman with a telescope. There was the Vitruvian Man
who rolled up the hill in a wheel. There was Martin Luther, strid-
ing slowly in a long black overcoat carrying his translation of
the Bible and a cat with a bell around its neck. Dr. Faustus sped
through on some kind of broomstick while Caspar Hauser was
dragged by on a rope uttering "Roiter Worst" and "Wois net." A
wheelwright's wife in a gray cotton skirt was running through
the archway with a bundle of spokes and a basket of apples,
whose skin had cracked like oil paint from the 16th century. And
then there was Mrs. Trautmann, who complained that there was
no place to sit down under the archway. Mrs. Study needed to
use the restroom but refused to get wet by walking through the
rain in search of the toilet. Miranda asked if she could take off
her mouse head. The toxic fumes inside the hollow styrofoam
shell had started to become extremely nauseating, she said.

If a thousand people had walked through this archway, we
calculated, that would have been only one person per year. If a
million people had walked through this archway already, that
would have been merely a thousand people per year – not even
three people a day. That's what time does, we thought. Things
spiral out of proportion while staying the same.

Stones stay, people disappear. It's no use to
resist. If you are hungry, you get something to
eat. If you are tired, you need to find a place to
sleep. If you are getting old, it's time to die.
The young people don't understand what it means

to have been, how it feels when all the future can offer is only further expiration. They are young. They can't comprehend the life of an over-aged fart. The goat has never cried about the dead lambs of the sheep. I didn't understand it when I was young myself, but at least I listened. All I really needed to know I learned from being around Grandmother Lene in her kitchen. She was in there from five in the morning until ten at night, and I just sat on the bench and watched life happening. Everything eventually ended up on that kitchen table. To know the road ahead, you ask those coming back. But today it's not in fashion to ask people anymore. Today's crowd gets their wisdom from the computer and old age has no value to young people anymore. In their eyes, anyone can get old. In their eyes everyone can live as happy a life as a Mickey Mouse. All one has to do is take the right medications and put on a funny

costume. I wish I could depart like Grandmother Lene. We had dinner as usual, boiled potatoes with butter and quark — I remember that like yesterday. When we were done, she cleaned the dishes and went to bed. Grandmother Lene always used to soak her breakfast oats and flax seeds overnight, but when Inge got up the next morning, she realized that the red bowl was empty. We went upstairs and there she was, her hands folded on her belly. Dead. Nothing was ever wasted during Grandmother Lene's life, not even a bowl of flax seeds and oats.

On Friday, when we got to the Tollensesee the Americans said we would have to take a ferry to get to the other side. Walter said goodbye and we went down to the landing stage. It looked like the water was frozen in time, that's how quiet it was. Not a ripple, not a sound. We could see the ferry long before it docked to take us onboard.

A bearded coxswain sat behind the wheel, the captain stood at the open door, and an old woman sat on the lower deck. From the back she looked like Trude Tetzow. "Doesn't she look like Trude Tetzow?" the Mother asked. The captain said that it couldn't be Trude Tetzow because fifteen years earlier, when the woman had appeared onboard for the first time, she had introduced herself as Mrs. Huhn from Neubrandenburg. They never talk much, the captain said, but every year on June 10th Mrs. Huhn boards the second ferry in the morning in Neubrandenburg, goes straight to her seat, looks out the window, and gets off in Neubrandenburg again one hour later when the ferry returns.

The captain asked us for tickets. Kirsche showed him the ones the Americans had given to us. He looked at them like a donkey.

"These are the right tickets but they are going to the wrong place," he said. It took him a while to figure out that the tickets were a fabrication and that we were on an invented journey. The Sister explained to him that we were on our way to Texas and that's why we had to cross the Mississippi and he should just drop us off on the other side whenever it was convenient. "It's not about convenience," the captain said. "The ferry follows a schedule that's also printed out and posted on all twelve pick-up piers," he said, and weather permitting, in the eighteen years he had been in charge of the ferry, it had always been on time. The Americans asked if he could exchange the German flag with the American one they had brought to give our journey more credentials. The captain went up to the coxswain and they discussed it. When he came back, he rolled up the plastic cover and exchanged the two flags. And then he disappeared.

The daughter closed her eyes and took a nap. Miss America nursed the boy and then laid the poor little piglet on the table so he could crawl from one side of the table to the other. I looked out the window while the women kept talking about the Sister's situation with her daughter. "It's still unbearable to think about the fact," the Sister

kept saying, "that I had to pay rent to my own daughter to live in my own house. I haven't slept for many years, what else am I supposed to do? I moved out, moved to Burg Stargard, my own daughter treats me as if I am the plague in person."

When the captain let us off, the Boss said that from now on we had to walk. There was no wagon anymore. Walter had received his money and was on his way back to the farm. The path around the lake was narrow. I doubt that the daughter knew where we were going, but we followed her one after the other, like a flock of geese.

After we had spent so much time on an imagined ocean the year before, the lake was our first shared experience of a real body of water. The water was so still it looked unreal. It was eerie. It had been in the local news that the Tollense Lake was on the verge of turning over, and that the local government had made a few last-minute

efforts to fight off the suffocating algae that was spreading rapidly underwater by installing fountains to artificially enrich the water with oxygen from the air. We could not see any of these fountains. There was nothing but the still surface, as straight as the line on a heart monitor after the patient's heart has stopped.

Mr. Study looked at us. "There is a river that starts over here, called the Tollense, that leads directly into hell," he said. We froze and looked at our reflection in the water. It rippled. Mr. Study had spoken to us directly for the first time.

We stood there and looked at the water. I almost
told them about Demmin, I was about to, but then
the Mother squeezed my hand.

When we got home that night, we asked Father Fohrs if we could use his Internet connection. He gave his access code and we did some research online. The Tollense River starts as an outflow of Tollense Lake and follows a path that, according to the Wikipedia entry, had never changed its course since the Bronze age. The river empties into the River Peene in a town called Demmin, a name that originates from a Slavic word meaning swamp area. From there the Wikipedia entry continued in the usual order: Name, Prehistory starting at 5500 BC, Saxon Wars to 10th Century, Middle Ages, Modern Age, Coat of Arms, Famous Residents, References. We scrolled through the information without getting interested in any details, until we saw an isolated link to "Mass Suicides." We clicked and read that Demmin was seized by the Red Army on April 30, 1945. That day, according to the "Mass Suicide Demmin" entry, a big white banner was hoisted on the tower of the church as a sign that the German forces were surrendering. The next day, on May 1st, three shots were fired during negotiations and the Russian negotiators sank to the ground. Half an hour later the remaining Wehrmacht units blew up all bridges leading out of town, leaving the civilian population of about twelve thousand people and the Red Army soldiers trapped on one island. The atrocities are said to have started

that evening. A wave of horrendous mass rape was followed by a mass panic, and a mass suicide and then a fire. Within three days most of the town had been burnt down and between twelve hundred and twenty-five hundred people — men, women, and children —had used guns, razor blades, poison, ropes, or put rocks into backpacks and jumped into the Tollense River, to escape the devastating realization that this was the very end of World War II, that Germany had been defeated and that some of the Russian soldiers would be taking full advantage of having been trapped in this situation.

According to the article, whole families hung themselves from apple trees that had just begun to blossom. There were whole orchards full of dead bodies hanging low from their necks. Frenzied children roaming the chaos in shock looted the pockets of their pants and jackets and took the jewelry off their lifeless limbs. Some mothers who had drowned their children in the river in a frenzy couldn't figure out how to drown themselves after they had drowned their children, and something back in our subconscious kept telling us that Aunt Lieselott had been one of them. Eyewitness reports stated, that weeks

afterward, bodies were still floating around, and the clothes and belongings of the drowned formed a thick wall along the riverbanks.

We shivered. The night was silent and the moon shone quietly as we sat in Fohrs' house in Burg Stargard and found out that these kinds of events apparently had happened not only in Demmin, just days before the official end of the war on May 8, 1945, but in the entire region, when the Russian troops marched toward Berlin. Burg Stargard – 120 suicides in one day. Neubrandenburg – 600 suicides. Neustrelitz – 681 suicides. Penzlin – 107 suicides. We started to freeze from inside. The muscles that made up our heart started quivering. It had happened to them! If not directly, they all must have had relatives, friends and acquaintances, who had been part of this.

Miranda was sitting on the sofa with headphones watching *Sex in the City* on her laptop. We grabbed a sweater and threw it over to her and then we closed our eyes and tried to remember.

There was that pump in the town square of Burg Stargard and an information board. There was a grave of an unknown soldier from World War I between Dasdorf and Marterhof, and hadn't we passed a crumbling monument for the Russian liberators in Burg

Stargard? There had been a plaque in Neubrandenburg stating that the town had burnt down when it was liberated by the Russian Army in 1945, but that the medieval walls had stayed intact. But where in the world were those mass graves from the suicides?

That's why we couldn't sleep at night in Mecklenburg-Western Pomerania. That's why everything about the flatness around Dasdorf was so haunting, that's why we felt that unsettling grinding in our guts when we looked at the landscape for too long. That's why we kept thinking about water, wanted to divine for water in Dasdorf and dig a well. That's why when we invited them to cross an ocean, the gardeners came along. They hadn't only stayed for the free food, and the entertainment. On the day it was dying, the Tollense Lake had transmitted the information.

The next day we got up early. We went to the cemetery, the Mother and me, at seven in the morning. It had stopped raining, but it was still misty. The Mother had complained about the geraniums all morning, kept complaining that I had gotten the white ones the week before. "We've always had the red ones, everyone has the red ones," she said. "I don't like the white ones, nobody likes them." I don't even know why I got the white ones. I got confused in that store. All the Mother sees now is the whiteness of the geraniums while I had to look at all the stuff they put in that store on shelves that are higher than my own house. Garden chairs on top of lamps and grills and tools and sinks, rows and rows of stuff nobody can buy because the price is even higher than the shelves.

When we got to the cemetery, Fuchs had already planted his geraniums. Nobody can beat that Fuchs. Last year we had such difficulties with the wind. The Mother almost cried because she could not light the candle. She used a whole package of

matches because the candle wouldn't burn longer than a few seconds. I stood behind her, opened my arms, turned myself into a shield as big as possible, but we could not manage. This year she brought an empty sausage jar. It worked with the first match and the candle kept burning while she sang the birthday song. When we got home it was just a quarter to nine o'clock.

They showed up with two ponies and two Morgan horses at ten thirty a.m. We had been waiting for half an hour already, and when we saw them coming up Village Road, the Sister covered her face with her hands. "I can't believe that's their idea of transportation for the final stretch to Stillwater," she said. Miss America was riding the one horse with the baby boy in a backpack, and the daughter was riding the other one. The Boss was walking behind them, leading the two ponies. They offered us the horses, but did they

really think we would get up on a horse? "If you are not going to sit on a horse, you'll have to walk," the Boss said. We started walking parallel to L33 through the fields toward Teschendorf. The Americans said that Stillwater would be near the Teschendorfer Chaussee, but I had no idea what they were talking about. It's been at least twenty years since I had walked to Teschendorf. Wheat left, wheat right. It smelled like a field of wheat, and when the wind blew through, it rustled like a field of wheat. The Mother looked happy. It didn't look like it would rain anytime soon.

It took us almost one hour to get to that little beech grove the people in Dasdorf call Amselsberg and the people in Quastenberg call Braunheide. A little farther in, we took a break. There was a wooden hut I had never seen before. Little windows with carved shutters, a chimney made out of sandstone, the roof was covered with moss and rotting leafs and one of the walls was leaning in. It looked like it came out of a fairy tale and was about to collapse very soon. The Sister explained to the Americans that the hut had been built as part of the *employment-creation measures*, the artificial work programs the unified German government had maintained for years after the inflicted breakdown of non-competitive former GDR industries, to deal with the high number of unemployed people in the East, so the people would feel like valuable and respected members of society and wouldn't turn into Nazis again, like they do today. The hut is an unofficial monument, the Sister said. In the nineties we had an unemployment rate of twenty percent in Mecklenburg-Western Pomerania, she told the Americans, the

highest in Germany, more than double the average of the rest of the country. Everything closed down and most young people moved away trying to find work in the West. In the spring of 1993 there was an announcement in the Stargarder Paper that they would be hiring men and women for a Forest Brigade, no particular experience necessary. A man from Eisenhüttenstadt, who had studied land-scape architecture in Berlin was leading the endeavor. He did interviews with about one hun-dred people in the mayor's office, and on April 1st, 1993, he gave the ten, newly employed work-ers a rake and they went into the forest to rake leafs, even through the winter. At the end of every month they received a paycheck. First peo-ple were jealous of those easy, healthy jobs, being out in the fresh air everyday, but after a year or so people in Burg Stargard started mak-ing fun of the Forest Brigade. They became the laughingstock of the whole town. For a while the members of the brigade, her son in law was one of them, the Sister said, laughed with everybody else about the ridiculousness of this new gov-ernment, but eventually the whole thing became macabre. Eventually the young boss of the forest brigade admitted, that the paychecks were noth-ing but camouflaged unemployment checks and that the work the brigade did in the forest was one hundred percent worthless. What a disgrace. The members of the Forest Brigade threw their rakes away and the next day they all appeared at the market square with shovels, marched towards the Five Oaks, and began digging graves instead of raking leafs. That's when Mrs. Steinhauer finally had enough. She convinced her husband to donate

money for building materials and he agreed and then the Forest Brigade switched from digging graves to building playgrounds for the twelve children that were still living in Burg Stargard at the time. They built several playhouses, a rope bridge over the Linde, a beautiful tree house in the Neumannsgrund. It lasted three years, then the employment-creation measure faded into oblivion.

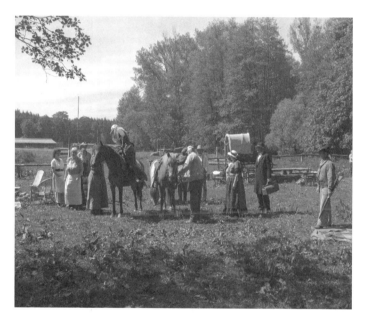

We were exhausted when we arrived in the cowboy town. There were about twenty people who greeted us at the gate. "Welcome to Stillwater," they said. "Instead of heirloom horses Fohrs breeds heirloom people and then sells them as a tourist attraction," the Sister hissed. We all sat down on a long wooden bench and the woman cooked coffee on an open fire. They told us they lived there

all summer long, and the men had built all the
houses themselves, and the women had sewn all the
dresses, They didn't have running water. Every
house was some business and everybody had a pro-
fession. One was the doctor and his shed looked
like a doctor's shed and they called him "Doc." A
long time ago his wife used to be a hairdresser in
Burg Stargard, and so she became the hairdresser
in Stillwater again, and when Kirsche heard about
that, she went over and got a haircut on the porch.

And then there was a blacksmith shop, where the
guy made his own nails from scratch, and an under-
taker, and I thought to myself, if the Kirsche
goes to the hairdresser, I could go to the under-
taker. It would be a good time to go now.

Eventually the Mayor of the town called us all
together and showed us the boarding house, that
nobody used anymore. He said the townspeople had
decided to let us use it, if we wanted to stay.
The Kirsche said yes, and the mother nodded, the
Sister declined, said she would be rather inter-
ested in joining a Native tribe. There was a
Mescalero club in Neubrandenburg, and a Sioux
club in Kleinwhiesenthal, one of the cowboys said,
he could introduce her, he said. Then the mayor
said, that we needed to get appropriate clothes,
otherwise we would ruin the image of the town. So
we went to the general store and the Americans
gave us some dollar bills and with that we bought
us some cowboy outfits.

I got a leather jacket with long fringes and the
Mother wore a cowboy hat and a vest and when the
Sister looked at us, she said, we didn't look like
American frontier settlers, more like people from
the Hinterland.

The cowboys showed us our little piece of dirt
in front of the gate and then one of the women
gave us a bag of potatoes and a pick and a rake and
a bucket and we started planting. I dug the holes
and the Kirsche put in the potatoes and the Mother
closed the holes with a rake. The guy in the long
leather coat came out to the fence. He smoked a
cigarette and watched us for a while and then he
yelled to the other guy at the end of the fence:
"John, I see you got some people plowing the fields
for you now. I am gonna get a whip, I'll be right
back." Is he a real idiot or is he just playing
an idiot? the Kirsche asked, when the man had
left. Right behind the field was a small stream.
There was a rope hanging over the fence, nobody
seemed to use it, so I tied it to the bucket and
went to the stream and fetched some water. If we
would start a new field here, everything would be
much easier, the water and the horse manure would
be right there, the mother said. She was right,
we would not have to worry about water and manure
anymore and I didn't really understand why these
people played cowboys all day instead of growing
a few vegetables in that field, where it was so
convenient. There couldn't be a better place for
a garden. Of course one would have to work on the
soil and it would take at least three years until
the soil would be consistently productive, but
what's the use of pretending to be a blacksmith
from two hundred years ago and hammering your own
nails when you could grow all the vegetables you
need for the year?

After we were done with the planting, we ate
a roasted pig. It weighed eighty pounds, they
said. The Americans had bought it from Mr. Fohrs,

who apparently owned the place. One of the cowboys had been at the grill since the morning, had basted the pig in salt and beer and turned it over the hot coals very slowly. The meat was very tender and they served homemade potato salad with it. If the Americans had not been good for anything else, I must admit, they were good at making a potato salad. Their potato salad tasted exactly like grandmother Lene's. They served beer with it and a nice loaf of freshly baked bread and while we were all sitting there together on the wooden benches with the other cowboys and ate that roasted pig with potato salad and sauerkraut, the Americans got on the horses. They said they were vegetarians anyway, and that there was only so much space in the boarding house, and so they had decided to keep moving along. As they rode through the gate, the baby boy tied onto Mrs.

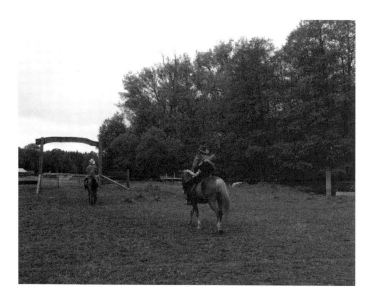

America's back like a little monkey, the Kirsche
said that this would be the last time we saw them.
She even wiped a tear away. The Mother was con-
vinced they would come back, but they never did.
The Kirsche was right. We never heard a word from
them again.

We returned the horses, packed the rental car, drove to Berlin, and
boarded our flight to JFK. Two days later we jumped into a black
limousine in Queens, got stuck in traffic, and missed our flight to
Salt Lake City, according to the inexorable display on the self-
check-in computer, by one minute. We went to the ticket agent,
who sent us to the security guard, who sent us to the missed-flight
agent, who sent us to the luggage handler, who sent us home.
There was nothing we could do. We would miss the beginning of
Bonneville Speed Week, the race for setting land speed records at
the Bonneville Salt Flats near Wendover in Utah. We boarded a
city-bound yellow cab, and once our seat belts were fastened, we

apologized to our children for having been late and disorganized. Miranda just looked out the window, and the baby boy slept in our lap, so we leaned forward and apologized to the cab driver. And then we told him basically everything that's been written down in this book. And then he told us everything that's been written down in another book. When we arrived in front of our apartment building in Queens, we kept sitting there talking.

"How about I drive you to the place I told you about tonight?" the taxi driver eventually asked. Miranda let out a pleading groan and pulled her hood down over her face.

"You serious?" we asked.

"It's closer than Salt Lake City," he said, got out of the car, opened the trunk, and returned with a big bag of potato chips and several cans of refreshingly cold soda.

Acknowledgments

We would like to thank the following individuals and organizations for their assistance in the production of this project. Things would have turned out differently without you and we are deeply grateful for your involvement: Mara Ittel, Hans Heinz Moderegger, Herr und Frau Kadagies, Frau Vogt, Herr und Frau Studier, Herr Kunze, Herr und Frau Ehmler, Herr Maier, Gitta-Doris Bahr und Joachim, Familie Gohrs, Reiterhof Wolter, Monika Rüth, Michael Duckstein-Neumann, Cat Chow, Sibille Roth, Detlef Drünkler, Liane und Heinz Heller, residents of Little Texas, Country Club Longhorn, Maik und Jule, line-dance group of VfL Burg Stargard, Arnold von Wedemeyer, Annette Gödde, Harald Sachs, Susanne Schröder, Henry J. Casolari, Robert Walton, Miner John, Sarah Gallagher, John Campbell, Dustin Cobin, and Jay and Claudia Nance.

Many people have read one version or another or parts of the manuscript and offered editorial, literary and conceptual advice along the way. Thank you Mara Ittel, Will Brand, Will Heinrich, Zack Newick, Porochista Khakpour, Em Rooney, Rebecca Wolff, Lynne Tillman, Nick Flynn, Paul Chan and the team of Badlands Unlimited, Olaf Breuning, Matthew Coolidge, Andrea Kleine, Barbara Ess, Layli Long Soldier, Brian Kerstetter, Hillit Zwick and Paul Monty Paret. Thank you Paolo Javier for connecting us with Nightboat Books.

This project would not have been possible without the support of Creative Capital, The John Simon Guggenheim Memorial Foundation, CUNY Research Foundation, The Center for Land Use Interpretation, the Corporation of Yaddo, Smack Mellon, and M29 in Cologne.

We owe a debt to many historians, journalists, and researchers whose writing has helped us approach the German preoccupation with American Indians, especially "Kindred by Choice: German and American Indians since 1800," by H. Glenn Penny,

"Everything You Know about Indians is Wrong," by Paul Chaat Smith, "Playing Indian," by Philip J. Deloria and the personal feedback of Layli Long Soldier, provided direction in cutting some paths through the complexities.

Lastly, thank you Stephen Motika for taking us onboard – and Lindsey Boldt – you were the one who dared us to move into difficult territory and helped us wade through. Thank you. And most of all, Louis Lamprecht, thank you for enduring and helping out in so many different ways.

Image Credits

All images by eteam except

eteam is a two people collaboration who uses video, performance and writing to articulate encounters at the edges of diverging cultural, technical and aesthetical universes. Tripping over earthly planes they trigger transactions between its occupants and establish wireless connections. Their narratives have screened internationally in video and film festivals, they lectured in universities, presented in art galleries and museums and performed in the desert, on fields, in caves and on mountaintops, in ships, black box theaters and horse-drawn wagons.

They could not have done this without the generous support of Creative Capital and The John Simon Guggenheim Memorial Foundation, Art in General, NYSCA, NYFA, Rhizome, CLUI, Taipei Artist Village, Eyebeam, Smack Mellon, Yaddo and the MacDowell Colony, the City College of New York and the Hong Kong Baptist University, among many others.

Nightboat Books

Nightboat Books, a nonprofit organization, seeks to develop audiences for writers whose work resists convention and transcends boundaries. We publish books rich with poignancy, intelligence, and risk. Please visit nightboat.org to learn about our titles and how you can support our future publications.

The following individuals have supported the publication of this book. We thank them for their generosity and commitment to the mission of Nightboat Books:

Kazim Ali
Anonymous
Jean C. Ballantyne
Photios Giovanis
Amanda Greenberger
Elizabeth Motika
Benjamin Taylor
Peter Waldor
Jerrie Whitfield & Richard Motika

In addition, this book has been made possible, in part, by a grant from the New York State Council on the Arts Literature Program.